Modern Whore

A MEMOIR

Stories by Andrea Werhun

Photographs by Nicole Bazuin

STRANGE
LIGHT

Library and Archives Canada Cataloguing in Publication data
is available upon request.

ISBN: 9780771098413

ebook ISBN: 9780771098420

Portions of this book were previously published in the first edition of
Modern Whore, 2018 by Virgin Twins (Andrea Werhun & Nicole Bazuin),
in association with IMPULSE[b] and designed by Laura Rojas.

Book Design: Lisa Jager with Nicole Bazuin
Cover art: Nicole Bazuin
Additional photo credits: Page vii, The Creators' Preamble photo by Will Pemulis
Author photo by Becca Lemire

Excerpt from page 5 of *Psyche as Hero: Female Heroism and Fictional Form* © 1984 by Lee R.
Edwards. Published by Wesleyan University Press and reprinted with permission.

Printed in South Korea
Published by Strange Light,
an imprint of Penguin Random House Canada Limited,
a Penguin Random House Company
www.penguinrandomhouse.ca

10 9 8 7 6 5 4 3 2 1

For Mamma & Oliver

And for the whores:
To thine own self be true, always.

CONTENTS

PART 1

MODERN WHORE

PART 2

POSTMODERN WHORE

THIS BOOK IS THE PRODUCT
OF ARTISTIC PASSION,
RELENTLESS HUSTLE, AND THE
POWER OF FRIENDSHIP.

Modern Whore spans a decade of my life and five years of sex work. From 2011, at the age of twenty-one, to 2013, I worked as an agency escort. At the age of twenty-seven, I began work as a stripper, and worked at the club until I was thirty.

In 2011, hired as a go-go dancer, I met Nicole Bazuin on the set of a music video she was directing. When I arrived on set, the other dancer hadn't shown up, so Nicole explained she'd be taking on the role herself. As we dolled up in the bathroom, a friendship was born. Besides being a top-notch director, Nicole is also an excellent photographer—and shot this entire book on film!

When I retired from escorting, I lived and worked on an organic farm. Nicole bussed out to visit, camera in hand. I regaled her with stories from my escorting years and posed for pictures on tractors and hay bales. We knew we needed to make art together.

We devised a collaboration that would bring my sex work experiences to life. A book that was like *Playboy*—if *Playboy* were run by the bunnies.

Over the next two years, Part One of this volume—the first edition of *Modern Whore: A Memoir*—was written and photographed. We crowdfunded more than $21,000 to print 1,000 copies of our book ourselves as Virgin Twins, in association with IMPULSE[b].

The memoir sold out within a year. In 2020, an acclaimed, award-winning short film adaptation—directed by Nicole and starring me—debuted at SXSW.

Part Two, or *Postmodern Whore*, is the story of my stripping career, which ended abruptly at the start of the COVID-19 pandemic.

With this fully-realized book, I am grateful to have captured my sex work journey, and Nicole is grateful, as an ally, to have the trust and opportunity to creatively document me. Our collaboration means my story—as precious as it is easily exploited—is told through a prism of friendship, mutual respect and admiration. It's not every sex worker's story, but it is mine.

We hope you enjoy *Modern Whore* as much as we delighted in making it!

ADOLESCENT CONSENT

A PRELUDE

First week of high school and I was standing in the middle of the library, peering at new classmates who joked and cajoled in their kilts and knee-high stockings on beanbag chairs. They were smart girls. Pretty girls. Wealthy girls. Girls on the debate team, girls who had been primed for professional success. I'd entered the hallways of Marshall McLuhan Catholic Secondary School with big dreams, too. I wanted to be the prime minister of Canada, forged by my working-class, unionizing parents to become the leader of the left-leaning New Democratic Party. Besides having the power and influence to enact positive social change, I wanted to be the prime minister because, well, I figured it was the best way to get Brandon Boyd, lead singer of the band Incubus, to notice me. I fantasized endlessly about marrying Mr. Boyd and singing duets with him onstage. I not only wanted to be Canada's first elected woman prime minister, I wanted to be Canada's first *singing* prime minister.

However, looking at those girls on their beanbag chairs filled me with a sense that I was out of my league. Did I even want to become a politician? I hadn't been bred to lie or make promises I wouldn't keep.

I suddenly became aware that those girls were smarter than me, better debaters than me, better liars than me. Why fight to be in their ranks? Besides, I wanted to be myself. Politicians always have to hide who they are and pretend to be upstanding citizens when we know, behind closed doors, they're just as freaky as anyone else. Maybe I didn't want to be prime minister after all.

So, I wondered, *what could I be?* I looked around the library, then at the books in my hand, eagerly collected from stacks around the room. It occurred to me as if it were the most obvious thing in the world. I wanted power. I wanted influence. I wanted to improve people's lives for the better. But I also wanted the freedom to live my own life fully and without fear; to go on adventures, to survive and tell the tale.

I know, I thought. *I'll be a writer.*

And the matter was settled.

I spent a lot of time noodling around the library. In a quiet, rarely visited corner was the magazine nook. I remember the day, sitting on the carpeted floor, when I pulled a copy of *Adbusters* off the shelf and into my lap—my eyes wide, mouth agape. A counterculture, anti-capitalist, beautiful, and thoughtfully created surrealist manifesto for eschewing the powers that be and fighting for the people, *Adbusters* felt taboo in my high school library. Like I'd come upon a forbidden treasure, a map showing the way out of mental mediocrity.

The year was 2003 and I was fourteen years old. I devoured the innovative spreads of *Adbusters* and saw the world with new eyes. I learned about issues as disparate (yet interconnected) as the military-industrial complex, the economic incentives of the environmental crisis, the ugly marketing of the beauty business, and the creative, mindfucky ways artists could make social change through art. I begged for a subscription for Christmas, and by grade 11, I was not only a member of my school's environmental club, but also the appointed Head of Responsible Consumerism. I observed and promoted Buy Nothing Day and organized after-school screenings of documentaries like *The Corporation* and *Wal-Mart: The High Cost of Low Price.* A little leftie in the making.

When I wasn't in the library, organizing for the environmental club, or hanging out with a fluctuating group of friends, I was on the internet. By the time I was sixteen, I'd been online for more than five years. I'd seen it all. Porn was passé and Rotten.com, with its casual spreads of mangled flesh and bodies in the morgue, was practically my homepage. I was both curious and desensitized. As a twelve-year-old, I'd cultivated a following by pretending to be sixteen on the message boards of Newgrounds.com, and was in search of edgier pastures. Like many other teens, I migrated to 4chan to become Anonymous.

Back in 2005, 4chan was more *Snakes on a Plane* than *V for Vendetta*. The trolling was ever-present, to be sure, but there was no high-and-mighty cause for Anonymous to hack the planet and save the world, and certainly no conspiracy-riddled QAnon. However, what was true then is still true for women in male-dominated online spaces, summed up by one phrase: Tits or Get the Fuck Out.

When I was sixteen, "Tits or GTFO" was a constant refrain on /b/, to the point of ceremony. When a girl would inevitably bare her breasts to the delight of the faceless crowd, she would be crowned with a name and offered her own board at an affiliate site dedicated to the camgirls of 4chan.

I lurked with bated breath as each young woman rose through the ranks and transcended mystery for fame. Of course, I was curious about what they'd say about me. As a teenager, I was quietly and surprisingly self-assured. I wasn't a popular girl at school, but I wasn't picked on either. I knew who I was, what I looked like, the effect I had on people. I read a lot, wrote in my journal, listened to music, took walks alone, performed in school plays, and generally kept to myself. But the fact of the matter was, I had huge tits. I always got attention, and yet I had a sneaking suspicion people were attracted to me for more than my body. I loved cracking jokes, challenging authority, and playing with words. When I spoke, people listened. So, what was it that people liked about me? My body or my mind?

Conventional wisdom—that is, an internalized misogyny deep within me and everyone else I knew—declared that a woman could not be hot and smart at the same time. A hot and smart woman was a myth. A fantasy. A statistical impossibility.

In the spirit of experimentation, I posted my nudes to 4chan without words. I sought answers to the following questions: Could I express my personality in image—or body—alone? Could the mind express itself through flesh? Could I show an anonymous mass who I was without telling them? Could they see me for who I was?

I got my answers—quickly. Yes, they saw me all right. The images were lo-fi, exceedingly quirky, and taken in my dining room and basement bedroom after dark. Not terribly flattering, even. Cleaning was akin to curating, which seemed besides the point. I was messy, unkempt, and natural. I wanted them to know it.

The comments rolled in: "You're so real," they said. "Beautiful, genuine and honest." Seen, seen! I beamed. Like the others, I was crowned with a name and a board, and soon developed a loyal following.

Who was my following, you ask? Why—men, of course. Full-grown adults consuming child porn. Child porn I made myself and on my own terms, but child porn no less. If it were found today, it would be called CSAM: child sex abuse material. I only ever showed boobs and a bit of bush, nothing terribly graphic. My images were playful and silly most of the time, like a girl walking around in her mother's heels, though my playtime went beyond games in the mirror. Yes, I was bold. Yes, I thought I was smarter than everyone else. And yes, most shamefully, I believed the reason men in their mid-twenties and older talked to me was because I was incredibly mature for my age. I became a woman the moment I realized these men were predators, but that didn't come till later.

I started meeting my fans in real life—in parks, on the street, for dinner, for weed. They'd say things like, "You tryin' to put me in jail?" and I'd giggle, power coursing through my veins. One looked

a nervous wreck on a park bench; another kicked me out of his apartment because his "ex" wife was coming home; and one guy, the webmaster of the camgirl board, almost raped me. I developed both fleeting and incredibly intense relationships with these men, teenage hormones raging out of control, curbing that desire to live and learn and risk it all with school, my environmental club obligations, and my increasingly dwindling social life.

Shawn was a prominent member of the board, a camboy himself. He was blond and ripped, funny and popular. A twenty-four-year-old virgin. I made a joke: "I could help you out with that." Soon, we were internet boyfriend and girlfriend. Soon, I was considering taking a gap year after high school to live with Shawn at his home in San Diego. Soon, he was on a flight to Toronto to take me up on my offer.

I was now in grade 12, a loner. I spent most of my time online, and most of the time depressed. I'd given up on a social life, since my "friends" at school didn't seem interested in inviting me out anymore, and I was tired of waiting by the phone. I skipped class, smoked weed, and hung out, headphones on and sullen, by myself. Besides my internet boyfriend, the only bright spots in my life were the refuge of the library, and my writer's craft class, taught by the school's beloved librarian, Ms. Boyer. Each class started with a prompt and fifteen minutes of automatic writing, with the option of reading our work out loud when we finished. I almost always opted to share my writing with the class. Sad, but a showboat.

One day, during a spare, I was sitting at a library computer simultaneously working on an essay about Emily Dickinson's poem "I died for beauty, but was scarce" and talking to Shawn on the board. Evidently, the school was yet to adopt a robust age-appropriate website blocker. Ms. Boyer approached, and I told her how much I loved Dickinson's work. She asked about my plans for university and recommended that I study English. I told her that I was considering taking a year off to live with my boyfriend in San Diego.

"*What?*" the sixty-something-year-old teacher asked, dumbfounded. "You have a boyfriend in San Diego? Where did you meet him?"

"On the internet," I answered, becoming squeamish. Mirroring her horror.

"Huh," she said. She was speaking slowly. "And have you met this person, *in person?*"

"Not exactly," I said. "But we talk every day. He's coming in a few weeks to stay with me."

"Well," she said. "All I can say is, don't skip a year of education for a boy you've never met. If you don't go to university now, you may never go, and that would be a waste."

With a pat on my shoulder, she walked away from the computer, and I took a moment to recalibrate. I had an inkling, right underneath my conviction that Shawn was a good guy, that Ms. Boyer was probably right. But I had to meet him first to find out for myself. I had to learn. I had to go through hell.

The bell rang. As I left the library for my next class, Ms. Boyer summoned me over to the book-return desk with her finger.

"Men are like buses," she said in a hushed tone, shaking her head. "There's another one right around the corner. Don't throw your life away to catch one. Remember that."

One sunny Sunday afternoon, my brother and I took a day trip to explore Kensington Market. A beautiful woman—a monk with a shaved head—stood at a table wearing a long burgundy-brown robe, selling jewellery. I was immediately drawn to her, for an embarrassingly *white* reason: besides thinking she was magnetic, I wanted to know where she was from. I got close enough to peruse the jewellery, purchased a piece, and then popped the question.

"Where are you from?" I asked.

"The same place you're from," she replied kindly. No hesitation. Hot went my cheeks.

I knew that I would never ask that question again as long as I lived. I would never again ask a stranger to explain their ethnicity to

me. Her answer was a gut punch of love. I thanked her, grateful, and went on my way.

That week, I got an *Adbusters* newsletter in my inbox, with a call for submissions: an open-ended request for a short piece on a recent transformative experience. I wrote about the woman in Kensington Market and sent it in.

Life at home was tumultuous. I was being bounced around from room to room in our tiny house. I shared a bedroom with my single mom until I was twelve, then I moved into the basement. There was no real privacy down there, no walls to separate me from family, who came down often to use our only shower. When I was sixteen, my mom decided it was finally time to put up a wall and a door. We hired a family friend for the contracting work, and while they were building, my mattress was moved to the only available space we had in the house: the living room floor. Now, not only did I have no privacy, it felt as if my entire life was on display. My bed was the family footstool.

Somehow, I convinced my mom and new stepdad to let Shawn stay at our place for a night, followed by a few more nights with him at a hotel. I had a way of seeming very sure of myself, certain this was a good idea, the best idea, the safest idea. "Don't you want to meet my boyfriend?" I asked, all coy and conniving. There was much back and forth, but eventually they consented. I couldn't believe I'd pulled it off. My mom always told me I'd make a great lawyer.

The day came, and after a long bus ride to the airport, I waited for Shawn at arrivals. His blond hair was duller in person. He didn't look buff to me. His skin was pale, like he barely left his bedroom. This was my boyfriend, and I was about to take his virginity. I gave him a kiss. Just as on webcam and in all of his pictures, I was looking at him straight on, when suddenly, as we walked onto the escalator, I saw him in profile: his neck jutting forward from his shoulders, his head looking heavy and enormous. Posture. His posture was the result of sitting in front of the computer all day. This

was my boyfriend—my *internet* boyfriend. Naturally, I'd never seen him from this angle. I was mortified, looking at what hid behind the digital curtain. I felt duped.

We got along well enough, joking about the board and its cast of characters on the subway ride home. I sensed his nerves and eased them as best an underage girl could, that is, with humour and innuendo. After another long journey by bus and household introductions—he was as polite with my family as he was awkward—we dropped off his gear at my house and took a long walk. To get to know each other IRL. He was pleasant enough, with the odd compliment here and there, but I noticed he was critical in his assessments of others, our "mutual friends" on the board. Mean, really. I let the words *I don't think this is going to work out* creep into my mind, but I still intended on taking his virginity. At this point, it was a matter of pride.

That night, on my single mattress that took up the entire living room floor, it happened. We left the TV on, *Latin Lover* on Telelatino, passionate softcore for Canadian audiences, muted. I moaned for full effect, only realizing after the act that my entire family probably lay awake in their rooms hearing what was going down. Next to Shawn in the "afterglow," I was embarrassed for myself. The sex wasn't good. He didn't know what he was doing. I was certainly doing him a favour. But what was he offering *me*?

At the hotel, with privacy and freedom, we more comfortably showed our true selves. His true self, it turned out, was an absolute asshole. He twisted his meanness towards me. He criticized my body as too flabby, and told me to eat less and work out more. He lashed out about my skin, too pale for his liking, and told me to start tanning. And my face—yes, my face—was a big problem. I needed to wear more makeup. He didn't like a natural look.

And I didn't like being told what to do. Now I knew for certain this wasn't going to work out. Shawn flew back to San Diego and I promptly broke up with him. I didn't mention the neck.

———

"Are these your tits on the computer?"

I woke up to my mother's face a few inches above mine. I pulled the covers over my head. Wept. A few feet away, my mom and step-dad sat at the family computer, clicking through my "secret" nudes folder. I had been found out.

I was defeated. Deflated. I didn't have a place to hide.

"How long have you been doing this?"

A year.

"Is this how you know that Shawn guy? I never liked him."

Yes.

"Do you plan on taking more photos?"

No.

I answered honestly. What did I have to lose? I wasn't interested in posting anymore. Taking photos had long passed the experimental stage into chore territory. I didn't need the validation of men. I knew who I was. I was attractive, inside and out. Body and mind. Hot and smart. I knew that now, for sure, and I didn't need to make any more CSAM for the pervs to get it through my head. They'd done enough harm.

I still had a few months left of high school before graduation. Now that I'd solved the mind/body dilemma, I had a new problem to grapple with: what would I do if someone at school found my nudes? I pictured the worst-case scenario: a few dumb boys printing out the photos, throwing them around the hallways, pasting them onto my locker. How would I defend myself against the truth of my own body?

The internet, as they say, is forever. I knew my nudes might disappear into the digital ether for now, but they could resurface in the future. What if I wanted to be prime minister, after all? Could a woman with online nudes be considered fit for office? Would my bare breasts disqualify me and my credentials? Perhaps politics was truly out of the question for me now. Name-calling and slut-shaming in the male-dominated House of Commons seemed inevitable. But what of environmental activism? What of speaking my mind and fighting for justice?

I always returned to writing. Ernest Hemingway was a drunk. Hunter S. Thompson was high on everything. Aldous Huxley, my hero after reading *Brave New World* in 10th grade, partook in peyote and acid. The writer, so long as they could write, was permitted to be whoever they wanted to be. I was a young, adventurous woman with nudes on the internet. I was a writer. Hot and smart. Sue me.

After much reflection, I concluded that no one was going to shame me for my body. *Confront me*, I thought. *I dare you. It's my body.* My body does not take away from my mind or my worth. Try to tell me I'll never amount to anything because you've borne witness to this flesh, as if your gaze has defiled me, as if you hold any power over me, but I know the truth. This body is mine. This body is power. This body can never be defiled.

I was at the water fountain when a fellow loner classmate approached me.

"Nice sweater," he said. "I think I saw it in a picture online."

I stopped sipping and wiped the water away from my lips.

"Uh-huh," I said coolly, facing him. "And where'd you see the picture?"

"4chan, I think."

"So"—I took a deep breath—"you've seen my pictures."

"Yes."

"Okay." I nodded. "Promise you'll never share them with anyone here?"

"I promise," he said.

I believed him.

I got an email from *Adbusters*. They were going to publish my piece— could I send them my address so they could send me my cheque?

Ms. Boyer proudly put the magazine on display in the library.

Seventeen years old, a real published writer, on my way to study English at university.

My words, the fruits of my mind, validated.

But the truth remains: there is no story without my body.

The 7 Deadly Prejudices Against Sex Workers

1. Sex workers are lazy.
 "Get a real job, you lazy bum!"

2. Sex workers are bad role models.
 "What will your children think of you?"

3. Sex workers are vain, immoral, and stupid.
 "You're nothing but a promiscuous narcissist."

4. Sex workers manipulate vulnerable men.
 "Only a complete psychopath would prey on lonely men for their money."

5. Sex work is only justifiable if you're poor and struggling to survive.
 "Your circumstances aren't desperate enough to resort to whoring."

6. Sex workers sell their souls.
 "How much is your soul worth?"

7. Sex workers are disempowered victims.
 "Who hurt you?"

1

MODER
WHORE

A WHORE'S
FIRST WORDS

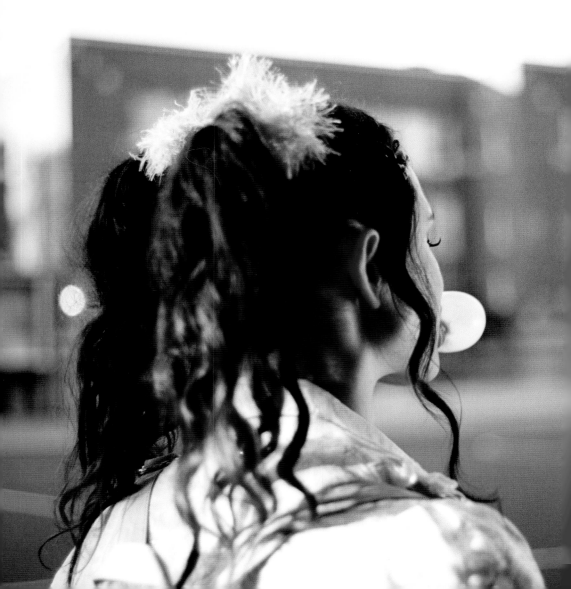

Oh, the horrendous things I'd heard about the strip club. Dead-eyed pole cats peeled from barrel bottoms. Women who hated their lives and wanted to die. Femmes forced by tragic circumstance to strip their pride and respectability before a jeering live audience of desperately lonely men.

Freshly 20 years old, I popped my strip club cherry at an east end joint where the dancers were nimble and missing teeth. The stripper onstage performed feats of strength that said nothing to me but *pure grace*. She slithered her way between two poles linking heaven and earth, and below her sat the eager worshipper. He sipped his overpriced bottle of Blue and awaited his lap dance communion. The price to be at one with this divine emissary? The neat tithe of $20 a song—what a deal! Oh holy, holy, profane union. Dancing naked women in a den of sin? *Pfft!* I think not.

For many, the strip club—or, dare I say, modern temple of the goddess—is shrouded in fear, darkness, and shame. *Why?* I wondered. Who decided there was something fundamentally evil about women embracing their own flesh? Poor woman! Eternally on the wrong side of goodness, intelligence, and holiness, with her seductive form, loose morals,

and perpetual hunger for carnal knowledge. And yet, my lived experience as a whore has taught me that the strip club—and the brothel, or anywhere else sexuality is exchanged for filthy lucre—is but a sexy church, as sacred as anything built in God's name. A place where the body is celebrated, not shamed; where desires are a source of pleasure, not pain; a place where bodily delights are considered as divine as those self-denying virtues of chastity and virginity. A place where whores are not only holy, but exalted for their wisdom.

That night, initiated into the mystery of sexuality as service, a seed was planted in my heart. I read stripper blogs and memoirs and convinced men to take me to clubs as "research." I took pole classes. At home, I swept the floors in neon yellow stripper heels and skimpy matching two-piece. I bought a pole for my bedroom. I carefully curated my three-minute stripper anthems. I visited all the clubs in the city and set my eyes on one dark temple: Paradise.

I was sitting alone at a café when a lawyer gave me his card. I thought the old man wanted to be friends. I thought the old man enjoyed my refreshing millennial outlook and witty conversation—*ha ha ha*. I thought the old man was harmless, so I accepted his invitation to dinner. While I munched ravenously on fork-and-knife pizza, he spoke of the cigars he'd smoked with Jack Nicholson, the hundreds of thousands of dollars he'd made defending big-time criminals, and the never-ending wellspring of his greatness. *Wow*, I thought, *this conversation sucks.* But then he mentioned that he represented some of the dancers at Paradise.

"Really?" I said, suddenly interested. "I think I want to be a stripper."

Did I now? Why, let's go there tonight, he said.

In the black-lit VIP section, bikini-clad girls gathered round to fawn over the lawyer. Sipping my fourth or fifth fluorescent G & T, a beautiful young bump-and-grinder asked if we wanted a couple's dance. He said sure, though I wasn't. I was pushed onto his lap, the stripper lifting my top and fondling my breasts as the lawyer got a handful.

"No," I said, going numb. "No." The big shot wordlessly dropped me off at home and we never spoke again.

But I didn't let a little lawyerly molestation get in my way. I celebrated my twenty-first birthday at Paradise. The next morning, I received a call from somebody's mother. My "hello" was met with "Are you the friend of my daughter who wants to be a stripper?" I said yes and presented my argument: I loved music, I loved performing, and I wanted to see how I could use my humour and sexuality in a creative way to captivate the audience. I expected her to wax poetic about how sex work would ruin my life. I was surprised when she responded: "Why don't you become an escort instead?"

"It's private," she explained. "You're protected by a driver, and you make a lot more money."

But I didn't want private. I wanted to perform.

In my third year of undergrad, I enrolled in a creative writing course. Every story I wrote involved a femme protagonist exchanging her time and sexuality for money. A trusted classmate endorsed escorting, too. Safer. More private. Better pay. Starting out in the sex industry, isn't that what I'd want?

I reread the stories I'd been writing with quickened pulse and eyes wide, because there she was—my whore self, eagerly working. The realization hit me like a ton of gold bricks. I cried, I tingled, I could barely breathe or eat or speak for days. Whoredom was my destiny.

I wanted to be like Persephone, Queen of the Underworld, fully in control of what happens *down there*. But a friend reminded me that Persephone had been raped by Hades into the Underworld.

"Why not be like Vesta instead?" he asked. "Goddess of the sacred fire. Fan the flames and keep the fire alive. Isn't that the ideal of the sacred prostitute?"

He was right. As I embarked on my journey, Vesta became my guide, though Persephone was never far behind, testing my strength and teaching me perseverance. One must continuously prove one's worth in the presence of a queen.

After some serious research, I settled on an agency, and called to ask for a job. An in-person interview was quickly arranged, but I had an important question to answer—what the heck would I choose as my escort name? I was taking a Romantic poetry class and had fallen

head over heels in love with William Blake. In *Visions of the Daughters of Albion*, a virgin goddess named Oothoon walks "in woe" on the plains of America, when her eye is caught by a "Marygold." When they meet, Oothoon asks:

> 'Art thou a flower! art thou a nymph! I see thee now a flower,
> Now a nymph! I dare not pluck thee from thy dewy bed!'

> The Golden nymph replied: 'Pluck thou my flower, Oothoon
> the mild!
> Another flower shall spring, because the soul of sweet delight
> Can never pass away.' She ceas'd, and clos'd her golden shrine.

When a virgin is "deflowered," she is seen to have lost something: physically, her intact hymen; spiritually, her eternal innocence. Here, the Marygold begs to differ. The golden nymph—both sexual woman and beautiful flower—gives Oothoon permission to pluck her. The hymen of innocence may be broken, but not the soul of sweet delight—*that* virginity is forever.

Oothoon places the Marygold upon her heart, "and thus I turn my face to where my whole soul seeks." Joy and delight guide the young virgin goddess on her journey. And that is how I chose to embark on my path of whoredom.

I met the agency co-owners, Trina and Pete—scrappy, raven-haired, sharp-shootin' romantic and business partners. It wasn't so much an interview as *You've got the job, and here's how it works*.

"So," the dynamic duo asked, "what do you wanna be called?"

"Marygold," I announced.

"Nah," Pete said. "How about Mary Ann, instead? You kinda look like the one from *Gilligan's Island*."

I ran through my Rolodex of associations—the Virgin Mary and her mother, Saint Anne; two generations of maternal divinity to protect me on this whorish path.

"Sure," I said. "Let's go with Mary Ann."

And thus I began my journey into the sexual underworld.

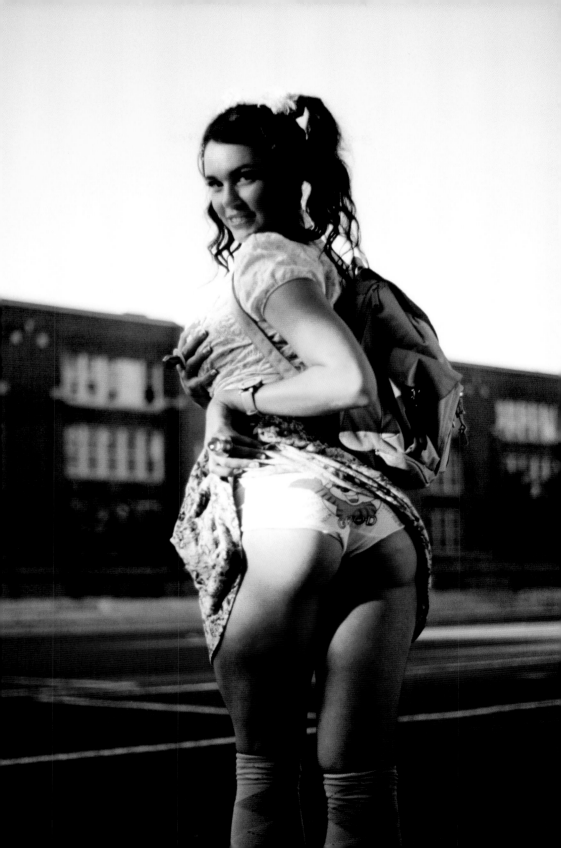

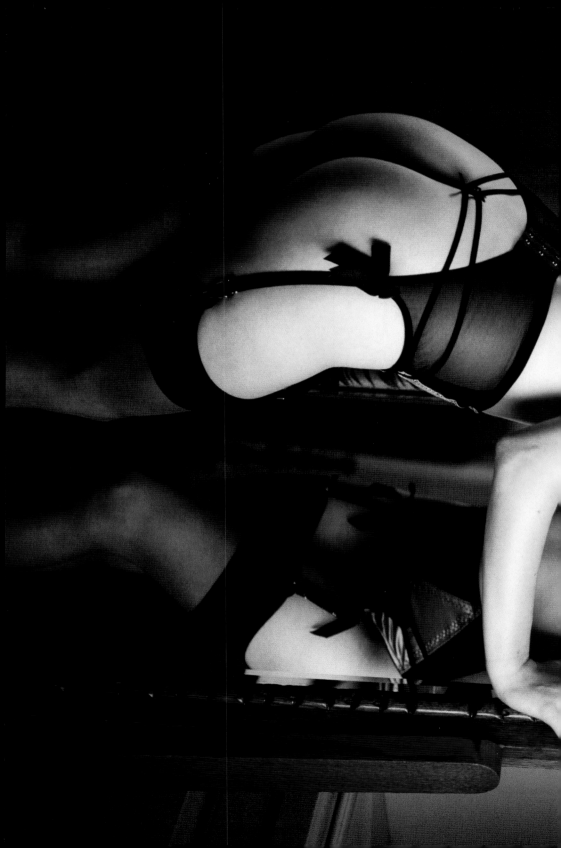

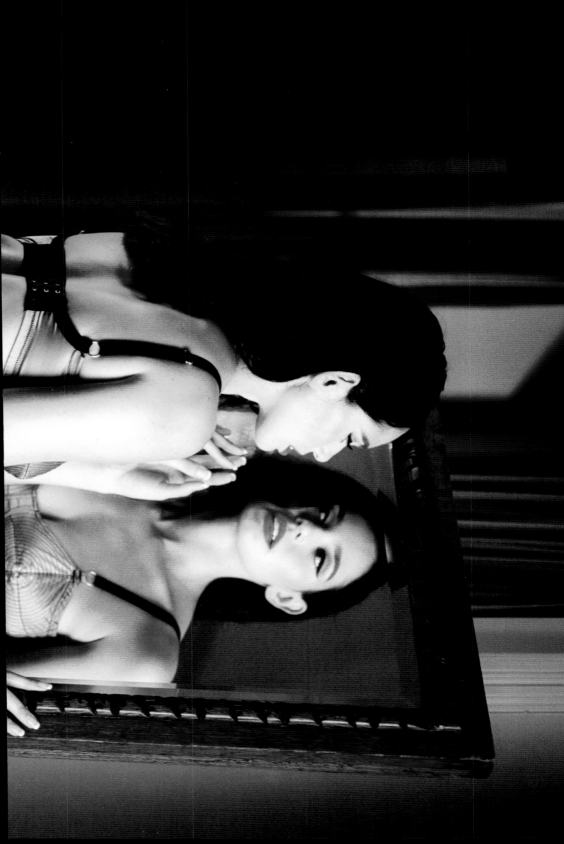

PRECIPICE

My first night as an escort was a series of thrills and revelations. Was it really me, this tousle-haired, makeup-smeared vision in the mirror? The post-coital beauty grinning and winking at her own reflection, giddy with the excitement of a girl doing something she loves but shouldn't be doing? It was me indeed, but also someone and something greater. A new friend, companion, and partner-in-crime smiled back at me, and her name was Mary Ann. She wore short skirts, thigh-highs, and high heels, loving each and every moment she fucked and got paid. Each man his own world, I embarked on a voyage of new bodies, new lives, and new ways of touching the other.

By the time I'd reached Max, my fourth and final client of that first night, I was a triumphant sexual queen. He opened the door and we were quickly thrown into a flurry of mutual interests, including poetry, religion, and politics. When he asked the dreaded "What's your story?" I stuck with a tale I'd pre-spun: I was a travelling painter only passing through—and no, I'd never gone to university, but I'd

read lots of books in my spare time. It seemed to work, though he maintained I was unlike any other escort he'd seen.

"And believe me," he said, "I've seen a lot of escorts."

Max was an addictions counsellor at a rehab clinic, and a former addict himself. We devoured each other's words. He asked me to dance for him, to give him a blow job, to mount his body to orgasm. I did all these things and read some tarot cards, too.

I carried the cards around with me at the beginning for two reasons: one, asking the cards what I might expect from the next stranger-cum-lover provided an invaluable frame of reference for me to work within; and two, everyone likes having their fortune told. I figured it was good business to add divination to my sexual repertoire.

After the night was over, I wondered about Max. He'd been marked in my mind as an "ideal" client: fun, good at conversation, and owing to our shared knowledge and interests, relatively low-maintenance. I yearned to see him again, to make Max a regular as I grew wiser and richer with every night that separated me from my first, but the call never came.

Months later, I was working the door of a university psychology conference—because I was indeed a post-secondary student, and not at all a travelling painter. There I was, a frumpy, makeup-less vision in jeans and old Doc Martens, selling tickets to intellectuals, when Max appeared in the queue, hot babe in tow. It was my first time running into a client off-duty: a seminal moment in every whore's life. Max and I locked eyes and went woozy, focusing with all our might on our respective goings-on: me, counting money and ripping tickets; him, suddenly enthralled by his companion's conversation. I sold the pair their fare, lightly shaking, heart pounding, eyes darting, and soon the secret john and his beautiful friend vanished into the auditorium.

I wished with every bead of nervous sweat that I could tell someone, anyone, that I had just seen one of my clients *in real life*, in my natural habitat, in my natural form—not as Mary Ann but as myself. But fear—immobilizing, isolating, humiliating fear—took hold. No

one wanted to know that I was a whore, I thought. No one would be proud of me and, more importantly, no one cared. Fighting against all instinct, I kept my mouth shut. Having finished selling tickets, I snuck into the auditorium to hear the lecture in progress on the philosophy of mind.

I was leaning alone by the balcony bar when I was approached by the man himself. Hushed words, darting eyes around the auditorium, secret looks at each other. Trying to not appear too close. I cut to the chase.

"Why didn't you see me again?" I asked.

"I was afraid of falling in love with you," he said. "I'm an addict so I have to be careful." He paused as a sly smile curled his lips. "But what are you doing tonight?"

I dawdled, juggling the question. He proposed an overnight. For a typical appointment, my agency charged $260 an hour, of which I pocketed $160. An overnight arranged with the agency cost almost $2,000 and, at my take-home rate, I'd make just over $1,200. Seeing an agency client for an appointment arranged independently like this was strictly off limits, which is why I knew that, if I was going to do it, I would charge full rate to make it worth the risk. I had never negotiated rates with a client before and felt like a novice. There was something innocent about a sleepover, and something about asking for $2,000 that felt like its opposite. I told him I'd think about it.

During the two-day conference, he and I skipped lectures to talk more about our real lives. I told him the truth about myself, now that he'd seen me in my plain Jane, everyday flesh, and I shared my real name and my dreams of writing. He revealed that he too loved writing and had been employed by a national newspaper—alas, until the deadlines were missed and the cocaine took over. The camaraderie I'd felt that first night returned, but I still wasn't sure if stepping out from the agency was worth it.

On the last afternoon of the conference, he smoked a cigarette in the alley while I jiggled to stay warm.

"You could come over, you know, just to write."

"You mean, you'd pay me?" I asked, taken aback.

"Yeah. Why not. Let's do a two-hour writing session."

Jesus Christ, I thought. Could my life get any better? We arranged a date and time and I went home, giddy as could be.

I took a cab to his newly built North Toronto condo in my regular clothes. Jeans, boots, and a loose, short-sleeved blouse. Makeup nearly nil. Instead of condoms, I'd brought a pen and a pad of paper in my purse. I sat on the couch, and he sat on his computer chair in front of me.

"Tell me about your childhood," he said, casually.

"What about it?" I asked.

"What *happened* to you—to lead you down this path?"

The more pointed and personal his questions, the more I realized I was not there to write but to expose myself for some strange, experimental, therapeutic practice. This was no creative writing session. It was an interrogation.

"Mary Ann," Max said, "I deal with people in your field every day. They either come from broken homes or have a long history of trauma—sexual trauma. You say you have neither, which I find hard to believe. You don't fit the mould of someone who usually does this kind of work."

I sympathize with self-described intelligent men who fail to fit the curvy, intricate pieces of a sexual woman together; men who desire wisdom but loathe true shifts of consciousness. I want men to understand my motivations. I want them to understand that I am a complex woman with a very simple desire to live happily and independently.

"That's correct," I said, responding like a good little woman on the stand. "My parents are great, and I was never abused. I do this work because I enjoy it."

"Interesting," he said, not buying it.

He turned to his computer to play "So Long, Marianne" by Leonard Cohen, and implored me to sit on his lap. I did so reluctantly. We sang the song together and a feeling came over me that this man

was trying to open doors to which he had no key. He was trying to barge in. Every fibre of my being said *do not enter.*

"Shall we go to the bedroom?" he asked. I protested but, in the end, and feeling duped, relented. I should have known. Only a naive baby-whore would be silly enough to think a client would be interested in having her over to write but not have sex. I got naked and lay down on the bed. As he ate my pussy, I felt myself on the edge of a great precipice, nothing around but a sign behind me reading "JUMP." The end of an old self. His tongue was parched and rough, short like that of a bird. I couldn't look. I fell and there was nothing. Propping myself up, unable to fake any more moans, I said, "Max. I'm not comfortable." He lifted his head from my cunt and triumphantly wiped his mouth.

I must have looked miserable.

"Do you want to go home now?" he asked. *Yes,* I told him. Yes, I did.

He gave me $500 and dropped me off a few blocks away from my place. I was shaken up for a few weeks and found it difficult to explain—even to my in-the-know friends—what exactly had been problematic about our encounter. I felt violated, exposed, and stupid.

Max and I didn't see each other for another month. Then, he booked me again, through the agency. I told him during the appointment how I felt about our previous engagement. He agreed it had been strange and, in a curveball move, told me that it just wasn't going to work between us: the fourth wall had been broken and there was no going back. I should call the driver now and go home.

I was somewhat flabbergasted because a part of me, there's no denying it, wanted to try again. But he was right. There was no going back to that first appointment, joyously revelling in our shared love of poetry, politics, and religion. That naive escort—the innocent version of Mary Ann—had jumped off the cliff. In her place stood the woman who had passed the point of no return, a self-possessed whore carrying a new world within her.

So long, Mary Ann.

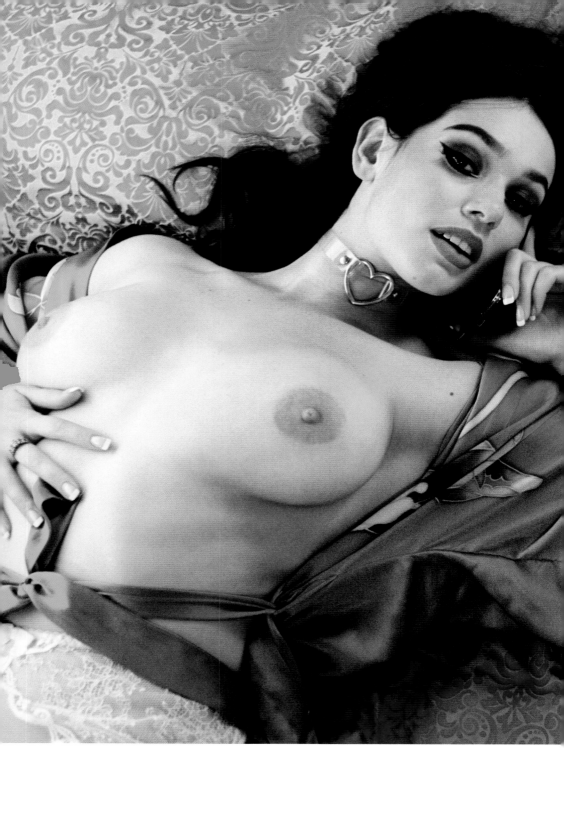

$2,015

Every girl has their Jeremy story.

He was the multi-hour legend of escort lore—all-night drunk-a-thons, multiple bars and restos, lines of coke. One of my close friends held the record for longest appointment with Jeremy: thirty-six hours. When Anika finally had to go, she was promptly replaced with another girl. While I was a semi-studious undergrad, time had never permitted me the opportunity to see this illustrious man, but things had changed: I was out of university, rarely had hard-and-steady obligations during the day, and was now happy to do overnights when, earlier in my escorting career, they had made me uncomfortable. No longer. Nothing is sweeter than knowing every hour spent in a luxurious king-size bed is another

digit added to that sweet, sweet sum I'd be receiving the next day. Paid to sleep? A sex worker's dream.

I was dropped off at Jeremy's demi-mansion at 12:30 a.m., where I stood knocking at the door, watching the light of a TV bouncing off the walls of his living room from the window. A quick phone call revealed Jeremy was still at the bar where he'd made the appointment, and that my driver would be coming back to drop me off there.

I'd been told Jeremy looked like a shorter Dr. House. It was true. Somehow, though, Jeremy had even less tact. As he hurriedly motioned me into the lounge, all signs pointed to last call. The chairs were up, the floors were swept, and only he, the barkeep, and a somewhat despondent woman sat at the bar. Were we overstaying our welcome? Either way, Jeremy was drunk and belligerent. He loudly told the quiet woman at the bar that she was a "stupid fucking idiot," and, as we were leaving, muttered—loud enough for us all to hear—this little tidbit into her ear: "Not a night goes by where I don't rest my head on my pillow and think, *Jessica is the stupidest fucking idiot that ever lived.*"

The bartender and I looked wide-eyed at each other.

"Let's go," Jeremy ordered, with a chorus of byes from him, the bartender, and even Jessica. I felt a pang in the pit of my stomach. This was going to be a weird night.

When we arrived at his home, he suggested we take a shower. Led Zeppelin blaring from the iPod dock, we showered in his state-of-the-art bathroom suite, complete with a Jacuzzi and two sinks. I began whistling, which caught him off guard.

"Why are you doing that?" he asked, which obviously caught *me* off guard. "*I* do that," he said, followed by a thoughtful pause. "What's your sign?"

"Scorpio," I replied, which set him off. Turns out Jeremy was a self-loathing fellow member of the scorpion clan, and I'd hit a nerve.

After the shower, we sat on the couch naked and watched TV. He asked if I smoked and I responded with the classic pothead's giveaway: "Not cigarettes." Ah, if only he could find the weed cookies his dealer

had hidden somewhere in his house! A man keeps a lot of secrets when he's got two ex-wives, a housekeeper, and a penchant for hookers. One working girl's jacket had been sucked into the vortex when Jeremy got word his ex was coming by. He'd begged the maid to stash it, stash it anywhere, and hadn't seen it since. Neither had the girl.

He asked me if I liked wine and I said I did. We went into the basement, past clear bags of children's toys, to the wine cellar. He picked a vintage from 1998. Never had wine *that* old! The perks, the perks.

We went upstairs and drank. He pulled out a bag of coke and we did lines off his bathroom counter. Fatigue gave way to alertness, groovy feelings, and a new desire to be cuddly and affectionate. We crawled into bed and kissed for a long time. He ate my pussy for a long time, too. He asked me what I liked. I said sex. He said, "Hmm, I don't know about that," but made an honest attempt at putting on a condom. No dice. This, right here, is another hooker dream: a man pays a lady to eat her pussy and she does practically *nothing* in return. I mean, I didn't even suck his cock! It doesn't happen often, folks, but when it does, especially during an overnight, *it fucking rules*. We lounged around on coke, talking about nothing, and when darkness became a light blue and the birds chirped good morning, we decided to go to bed. He demanded that we cuddle and I, the woman hard at work, said yes please.

I woke up around ten feeling happy to be alive. No hangover. Up and about, makeup touched up, looking like I could've been at a meditation retreat all weekend. He, on the other hand, looked haggard as all hell, his eyes and skin an alcoholic's bloodshot red. By eleven, we were back at the bar where we'd met, drinking Caesars and doing vodka shots.

Half in the bag, I read the *Toronto Sun* as the whole bar buzzed with old men talking about the man killed for his truck off Craigslist. Jeremy and I overheard one of them saying, "If I needed to get rid of a body, I'd use a wood chipper." We all had a laugh. Good times. Jeremy decided on an Italian joint for breakfast, and after we finished our drinks we drove off in his suv.

There's a certain suspension of reality in the time an escort and her john share. The time allotted is a sacred space in which both parties feel free to be themselves without judgement. And, further, the space is a magical one in which unreal things are rendered real. It's a little foolish and a tad fucked to jump into a car with a tipsy driver—but hey, if we die, we die. Call it the optimism of a nihilist. I'll face the consequences when it happens. *And it's not* likely *we'll be smashed to bits, right?* With only a few pauses to look at hot women walking down the street, we made it to our destination in our respective pieces.

Jeremy was suffering from some serious emotional issues, which I had gathered the night before. Around the five-hour mark I had asked him about his children, which prompted a trip to the computer room. On his wide-screen monitor, Jeremy presented a slide-show of photographs of his two sons in which he occasionally appeared, at a pool, a birthday party, and a restaurant.

"Drunk here," he said. "Oh, REALLY drunk in that one, holy jeez."

The final slide contained a photo of him and his ex-wife in happier times. At that point he was crying. "That stupid fucking bitch," he wailed. "She ruined my life!"

That's when we left the room on the main floor for the sprawling master bedroom upstairs and continued to snort cocaine. Some time before the blue light of dawn had breached the windows, he became upset. I had no idea why. I supposed it could have been for any number of reasons: his drinking and drug problem, his children, his former wives—who knows. I wanted to help without meddling, so I told him that Scorpios are ruled by Pluto, the planet of transformation, of death and rebirth, of new life. If there was anyone who could change his own life, it was him. He was sitting on the edge of the bed, Bon Jovi's "Livin' on a Prayer" blaring from the bathroom, and he looked up at me with sad, teary eyes and said simply, "No." I put my arms around him, kissed his forehead, and held him. He broke free and began pacing.

Now, at the restaurant, we sat at the bar and ordered our alcoholic drinks. We didn't talk much. Jeremy and I didn't have much in

common—unless, of course, we were discussing the fine art of being Scorpios. Soon our silence was interrupted by a phone call, some associate at the firm yelling about stocks. Jeremy had been left out of a deal. He began raising his voice, his tone increasingly incensed, unaware of the effect he was having on the other midday diners. He saw himself out as I sat there at the bar alone, sipping my Caesar and lightly forking my bowl of pasta. The waiter stood drying glassware behind the bar.

"Is he always like this?" he asked.

"Well," I said, "sorta."

Jeremy returned, growled "that son of a bitch" into his bowl of pasta, and asked, "When do you want to go home?" I told him I had plans that evening.

"Great," he said, and soon we were back in his suv for a wobbly ride to his place. I said a little prayer, wondering which saint it was that protects people from car accidents. A drunk driver is one thing to fear, but an angry drunk driver is another.

When we arrived alive, he looked at the time and asked, "Four o'clock okay?" It was 2:00 p.m. I said yes and called Pete, the agency co-owner, who would be driving me home. Pete had a good relationship with Jeremy and wanted to say hello when he picked me up. I got off the phone and found Jeremy tucked under a blanket on the big L-shaped couch in his living room.

"Let's take a nap," he said, his eyes already closed.

I grabbed a soft throw and laid on the short side of the L. Two hours later, Pete arrived at the door. Before answering, Jeremy gave me a hug.

"It's been a slice, darlin'."

I laughed the whole way home. I had been with the legend. Fifteen and a half hours, a $4,030 bill for Jeremy, and $2,015 in cold, hard cash for me.

TRUTHLESS GROUND

On escort review boards, johns share their reviews of a sex worker's services online. Some reviews read like erotica, some like the specs of a used car, and others like good ol' fashioned snuff. On The Erotic Review and other sex work review message boards, sexual objectification takes its most literal form. Sex workers (or "service providers"—SP's for short) of all stripes—escorts, rub-and-tuggers, strippers, phone sex operators, street workers, you name it!—are critiqued on anything from their appearance, attitude, and permissiveness, to their intelligence, "conversationalist" skills, and laundry list of available services. While reviews are undoubtedly helpful for the potential consumer—especially when one's hobby costs anywhere from a hundred to a thousand an hour—many sex workers are uncomfortable with having their body, mind, and soul criticized by some stranger with a big mouth, a few hundred dollars, and an internet connection.

"Hobbyists," as they call themselves—or "slobbyists," as we call them—write reviews that are unnervingly detailed and completely unverifiable. There's nothing stopping a hobbyist from fabricating a bad review out of boredom or out of spite. A bad review for a sex worker can have serious implications: beyond damaging their hard-won reputation, it can also destroy the sex worker's business by dissuading both new and returning clients. The threat of a bad review from a self-entitled hobbyist can, in turn, lead the sex worker into dangerous territory.

It should not be surprising, then, that hobbyists have a reputation for asking for more than what is being offered.

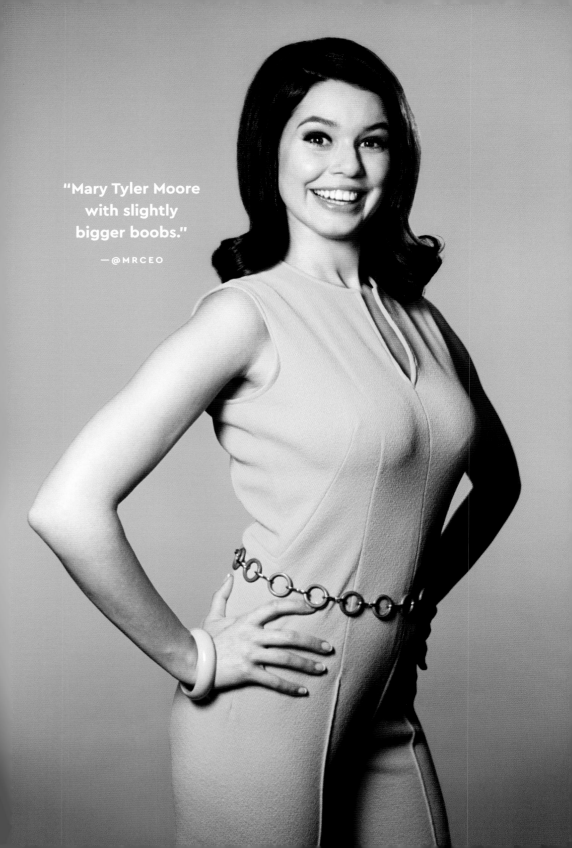

"Mary Tyler Moore
with slightly
bigger boobs."

—@MRCEO

If a client has a chip on his shoulder because a sex worker has declined, for instance, to do anal, the client-cum-critic can threaten, "If we don't do anal, I'll have to write a bad review." This puts the already vulnerable sex worker in a difficult position: say no to anal and bye-bye to her business, or say yes and get raped for a good review.

Thanks to the criminalization of sex work, crooked cops, and rape culture, a sex worker can't walk into a police station and have their rape case taken seriously by the authorities. "You shouldn't have been selling sex in the first place" may be the first piece of unsolicited advice they'll hear, perhaps followed by the question "Can a prostitute even get raped?"

In a society that shames sex workers, revealing one's occupation can have serious health and safety implications, especially when it comes to seeking justice. If a sex worker doesn't want to reveal their identity, they're unlikely to go to the cops, making them a fine target for slobbyist abuse. Unless the sex worker is willing to risk a bad review—or worse—by sticking to their boundaries and saying no, the hobbyist will always have the upper hand in situations of sexual coercion.

But hey, not *all* hobbyists are bad. In fact, a good few wrote glowing reviews about this li'l slut's performance. However, all of them either omitted details or flat-out lied about the course of events in our sessions. Their reviews read more like erotic fanfiction than objective criticism, and methinks that most hobbyists come for the fucking but stay for the writing. The literary genre produced is a circle jerk of mediocrity, with men yanking their chains to the sexual failures of their sexual providers—a collective battle cry of jizz-streams and acronyms employed to boost the power of the review over the dignity of the whore.

TERB Terms

A brief medley of scandalous short-form used on The Erotic
Review Board.

Bareback: Sex without a condom
BBBJ: Bareback blow job (fellatio without a condom)
BLS: Ball licking and sucking
CG: Cowgirl (girl on top)
CIM: Cum in mouth
CIMSW: Cum in mouth and swallow
COB: Cum on breasts
COF: Cum on face
DATY: Dining at the Y (cunnilingus)
DFK: Deep French kissing
Digits: Fingering
FS: Full service (intercourse)
GFE: Girlfriend experience (providing aspects of social
and physical interaction beyond the act itself, usually
offered with BBBJ)
LFK: Light French kissing
MISS: Missionary
MPOS: Multiple positions
MSOG: Multiple shots on goal (ejaculating more than once
during a session)
SOG: Shots on goal (number of times ejaculated)
SP: Service provider
TOFTT: Take one for the team (writing the first review of
a new escort)

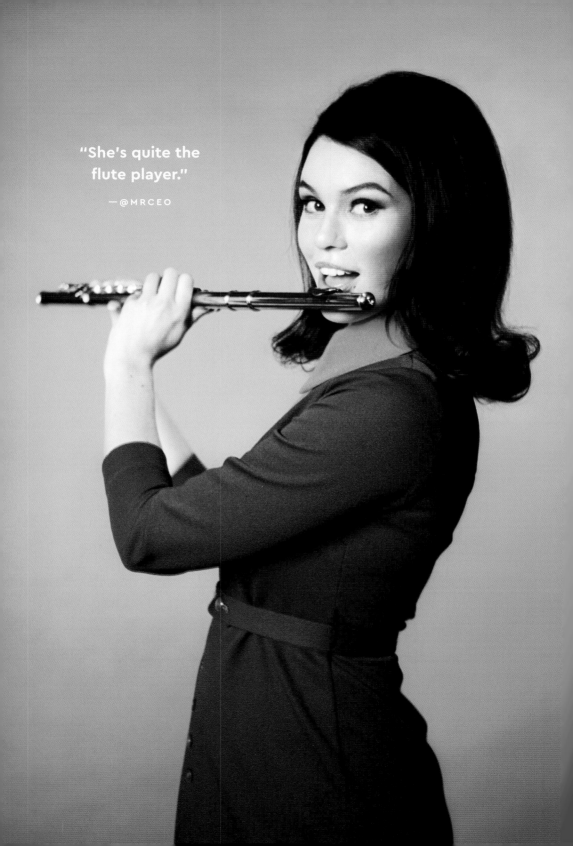

"She's quite the
flute player."

—@MRCEO

THE NEW GIRL AT TORONTO SIRENS BY @MRCEO

Type: Intellectual slightly bohemian young lady who has travelled in a time machine from the hippy era to the present. You could see this person running an art gallery or playing the flute in a symphony orchestra. And she is quite the flute player.

Attractiveness: 9.0 – Pretty brunette. Reminiscent of Mary Tyler Moore but with bigger top. Also resembles an early Aneta Corsaut in the movie *The Blob* before she became Miss Crump. Perhaps even a hint of Katie Perry. Pictures accurate? Mary Ann has been to the gym since the pictures were taken. I would say she is now a bit more toned and lithe but she has retained the good parts. You would do a double take at the beach from both back and front. An intellectual with big perky natural boobs and a nice ass too is a potent combination. Well dressed. You have the petulant lips of Mary Tyler Moore and Aneta Corsaut but larger perkier breasts under a top that were saying release me to the Chief. Pretty face and silver dollar lightest brown areolas are just like the pictures. No tattoos, kissable lips. Very nice hair and makeup.

Reciprocity Index: 9.0 – We spent a little time chatting first and breaking the ice with a little Skinnygirl Pina Colada mix and an easy does it approach.

Value: 9.0 – I always wanted to sleep with Mary Tyler Moore with slightly bigger boobs and a little less giddiness than Laura Petrie. Miss Crump always looked like she could be

a mind-blower after Andy warmed her up. The Katie Perry resemblance occurs when Katie is thin.

Personality: 9.0 — Warm and friendly. Excellent people skills. An easy to talk to but laid back woman, it is important to let each person be who they are.

Skills, moves: 9.0 — Full complete GFE. Made it seem like a third date. Satisfies on both physical and psychological levels.

Repeat? Very probable. You have the sense there is a little more behind the curtain and subsequent visits could bring additional dimensions to the encounters and reveal additional depth of this person.

After a nice warmup (without "pouncing" like a bear after a trout) there was sensual DFK and nice hugs throughout. Impeccable hygiene and a welcome reception induced prolonged dining. Mary Ann is quite generous and thoughtful in the arts of pleasure and gives a lot back. MPOS were available. Doggie was nice while squeezing those natural C's from behind. This is a really hot, thoughtful, subtle, and intelligent young lady. We left the black stockings on throughout the encounter because they looked and felt so good. I will roll them down slowly and pull them off on the next visit.

MARY ANN'S TAKE

MY MEETING WITH MR. EMBELLISHER-IN-CHIEF

Type: Single old Republican with erectile dysfunction and a big imagination. The kind of guy who dates himself by talking about having "always wanted to sleep with Mary Tyler Moore," and by spelling Katy Perry's name "Katie."

Attractiveness: 6.4 — Mr. CEO looked like a bloated old fish stick with warts all over his face and body. His eyes were beady, but exacting, which I liked.

Reciprocity Index: 7.5 — The conversation was engaging and I always love an amiable disagreement with someone I'm about to fuck. Keeps things interesting. The CEO agreed with then-Prime Minister Stephen Harper that the Keystone XL Pipeline was integral to the U.S. and Canadian econo-mies. He disliked my argument that the pipeline was an unsustainable environmental risk, countering that the pipeline would create jobs, which is far more important than preserving freshwater lakes. I appreciated the CEO's gumption but wholly rejected his opinion on the subject.

Value: 8.5 — Listen, we never had sex. Penis-in-vagina sex, anyway. It turned out Mr. CEO could not physically sustain a boner long enough to have sex, nor could he ejaculate. He attributed this fact to an unfortunate accident with a bicycle before he hit puberty. A bump in the road and the CEO's prepubescent ball sack slammed the frame, preventing the old man before me from ever ejaculating again. And so, my meeting with Mr. CEO was one of heated political debate, light pussy munching, and a blow job that never came to "completion." Sounds like a good time to me!

Personality: 8.0 — I like a man who isn't afraid to intel-lectually spar with a woman, even if his opinions were deliberately ignorant of the environmental implications of a giant cross-national oil pipeline. Meh. We did make each other laugh a little.

Skills, moves: 4.0 — This guy, besides getting on his knees at the edge of the bed to eat my "impeccably clean" pussy (was he my third or fourth of the night? I can't recall), was a complete beached whale. But at least he has moves in his review.

Repeat? Sure, why not. Let's argue about American politics while you eat my pussy. Sounds like a great way to create jobs without making a mess.

GO LEAFS GO!

I had been told by my madam and my co-whores, with absolute conviction, that if a client stank, it was my right to tell him to shower. I did not have to be ashamed of my "scentient" limits. It should not be a burdensome inconvenience for this stinky man to take a quick spritz before fucking me. It was *my right* to fuck a non-malodourous dude—my right! To think that I (a "dirty whore" by everyone else's standards) could tell a man about to unload his cash and his ball sack that perhaps it was *he* who needed the shower—why, it was down-right liberating. Many girls, I was told, asked men to shower *as a rule*. What confidence. What high pussy standards!

One dead evening, on the schedule without a booking in the world and seriously questioning my self-worth, I received a text from my driver: *Pick up in 15.* Music to my ears! Somebody loves me! Enough to fuck me for money!

The call was for a bungalow in Scarborough. I have a love-hate relationship with house calls. They tend to be the go-to for the, how do you say, *tightwad* looking to get his "money's worth." So when I saw

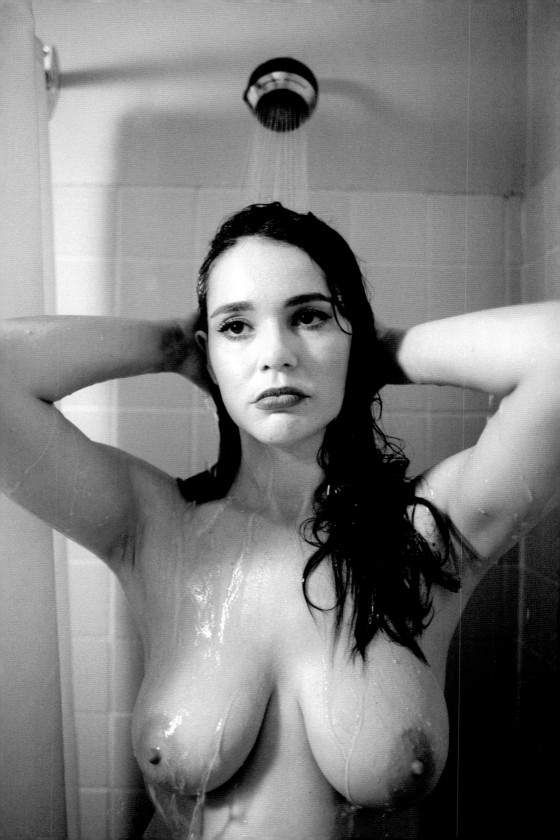

"enter through basement side door," I knew this wasn't going to be a classy night.

When we arrived, I implored the driver: "Wish me luck."

I knocked at the side door, and the man who answered appeared to me an oversized boy—not older, I guesstimated, than twenty-seven.

"Come in," he said, scarcely making eye contact, leading me down a creaky staircase. "Sorry, it's kind of a mess. I just moved everything down here."

It was a low-ceilinged basement. Around a corner I saw the projected light of a hockey game.

"From where?" I asked.

"Upstairs. My parents passed away recently and left me the house, so I've moved down here while I rent out the main floor."

"Oh." I paused. "I'm sorry about your parents. What happened to them?"

"Car crash," he said with a shrug, leading me into the bedroom—and what I saw in there nearly killed my lady boner into next year. Plastered all over the walls, tucked into the edges of his dresser mirror, right down to the print of the pillowcases and duvet cover, was the blue and white insignia of the Toronto Maple Leafs. Everywhere. When I caught a glimpse of the glassed-in poster of Cujo in his prime, I had to laugh. Where in Leafs Nation hell am I?

"You watch hockey?" he asked.

"Sorta." I smiled. "I see you're a Leafs fan."

"Yup, since I was a kid," he replied.

We laid down awkwardly beside one another, hands lightly grazing bodies. It was safe to say I'd be "performing" tonight. He slid off his sweatpants, revealing a small penis surrounded by thick stubble. A quick preliminary whiff conveyed notes of cheese and black mould, so much so that I wondered if his dick had died along with his parents.

And it is here I ask myself why. Why did I not tell him to shower? Why not take a page out of the confident whore's playbook and tell him to give himself a wash? Why did I let this man-boy's stinky baby cheese-string into my mouth?

To be honest, I felt bad for the guy. All this misfortune *and* a woman

he's paid to love him for an hour thinks his dick stinks? I'll spare him, I thought. Take one for the team.

I held my breath and applied all the saliva I could muster. Within a few minutes, I was reaching into my purse for the condoms and the lube.

"Oh," he managed, surprised the rank-brie blow job party was coming to an end so soon.

I reluctantly rode him cowgirl, the stubble of his pubes painfully scraping me raw like sandpaper. While I usually approached cowgirl marathons as a fitness challenge, I engaged in this grueling straddle with a little less sympathy, what with the missing layer of skin around my pubis and the signed Leafs paraphernalia I was being forced to stare at. Mats Sundin cheering me on was the last straw.

"Your turn!" I chirped, hopping off.

We side-fucked for a while. He was going soft, so I jerked him until that glorious moment in which he came and my servitude was brought to an end.

"You're so quiet," he said.

"How old are you?" I mustered.

"Guess."

"Twenty-seven," I said.

"Older."

"Really?" I asked. He said he was in his early thirties, but to me, he was a big child. I felt like a dirty babysitter. I excused myself to the shower.

"Oh," he said. "It's kind of under construction, so there's no door to the bathroom."

Even the towel he handed me was lightly dank. I stepped into the shower out of necessity, mildew and grime on the walls, black goo caking the corners. When I finally managed to leave, I called my boss to tell her that while my earning rate of $160 an hour was pretty good, I was not paid nearly enough to endure that kind of an attack on my senses. Never, ever again, I told her—no more shitty basement apartments. And never, ever again, I told myself, would I tolerate the stinky-dicked, stubble-pubed, orphaned members of Leafs Nation.

Opening Procedures

First day of work. You're getting picked up in two hours for an hour-long appointment. Boss sends a text ten minutes later saying *Got you another one ;)* and now you've got two in a row. You can freak out now. Put on your prettiest outfit, slap on the makeup, breathe, buckle up your high heels, and proceed to the vehicle.

At the hotel, the driver drops you off at the fancy entrance and reminds you to text him when everything's good. That is to say, when you have entered the room, collected and counted your money, and deemed the client safe. Your driver is your timekeeper: once he's heard from you, he will start the clock and call you when the hour is over.

Enter the lobby with poise and confidence. Don't assume because you're strutting straight to the elevators in a nice outfit that everyone thinks you're a hooker. Nah. You're a beautiful woman visiting a friend. You're an international lady going back to your *own* room after a night on the town. Or—who gives a shit. You're an escort about to make a wad of cash. Whatever your mantra, own it.

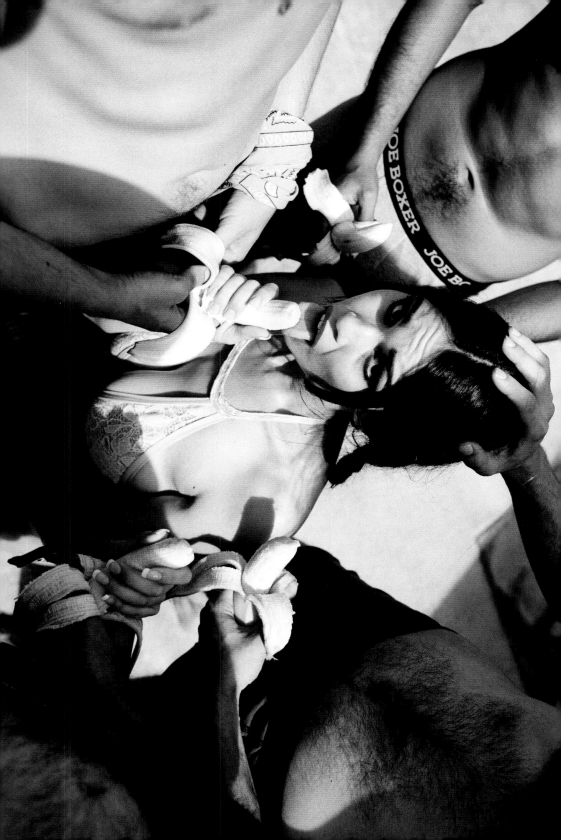

Banana

City of Toronto day camp. I didn't feel like eating the banana my mom packed in my lunch that day. A camp counsellor demanded that I finish my lunch—eat the banana.

"No," I said. "I don't want to eat the banana."

"Eat the banana," she repeated.

I protested. She unfurled the fruit and shoved it down my throat. I threw up.

I enjoyed the taste of banana. I loved banana popsicles, banana medicine, banana bread; but the texture of bananas on their own—no. Never again.

I was six years old.

WALTER WACK

He had a routine. I would arrive at his Lakeshore condo and leave my name with the concierge. Once or twice, when prompted, I responded "Andrea" before I hurled "I mean, Mary Ann!" from my lips, twitching with hot shame. Smiling to cover up the gaff, hoping with all hope that the concierge would smile back in some form of mutual understanding—that yes, Walter Wack was a profligate john and I was only one of the many working girls who came here to drop their name, real or fake, at his desk. And most of the time, the concierge who sat behind that desk, bored out of his skull, beholden to surveillance footage of the lobby and the parking garage, did indeed smile back. *We're just making money, right?*

Up the elevator to the fifth floor, I would knock at Walter's door, though it was already ajar. I would hear a voice yell from the bathroom over the sizzling sound of a hot shower.

"Come in!" he'd shout. "I'll be just a minute!"

Entering the carpeted unit, I would be greeted by the saddest little dog in the world. Lazily, she'd approach the stranger entering her domain—"Hi puppy!" I'd squeal—and just as lazily, without ever

coming close enough for me to pet her, she'd turn around and slowly walk away. To the left I'd behold the bachelor's kitchen, filthy and neglected, with discarded takeout boxes stacked ten or twelve high in the sink. To the right was Walter Wack's bedroom, a CD of moody electronic music beckoning me from a small boom box on the floor—I always seemed to enter on track four. A fan of $20 bills would be splayed on the brown fleece throw, which was neatly tucked into the corners of the king-size bed. Alone in his dim room, a lit lamp and burning candle on the nightstand, I would undress to my lingerie, apply lubrication, and wait, always a little too long, in a seductive pose on his bed.

Walter Wack would nonchalantly emerge from the bathroom in a white terrycloth robe, with a pack of cigarettes, a lighter, and a glass of rum and coke in hand. He would then, without acknowledging me, place his belongings on the nightstand and lie on the bed, lighting a cigarette.

"Kiss me," he'd say.

I found Walter Wack conventionally handsome. He was fit, in his mid-thirties, and his cock was huge—tense like a taut rope. In his stoic, detached, and slightly deranged manner, he addressed me with phrases repeated every visit: I was his beautiful little girl, his sexy little slut, his hot little piece of ass. Like the compliments and the entrance ritual, the sex followed a script, too. Predictably, we would kiss, I would blow, he would plow, and he would come. There was strange comfort in the pattern. One of his preferred positions had me on my back, thighs tucked into my chest, prone and vulnerable, like a fuck box. My hips always hurt after our sessions, but I made concessions for my most regular client.

One evening, on our way to our respective appointments in the car, a co-whore named Sarah brought up Walter Wack.

"He's so rough with me," she laughed.

"Yeah," I said. "He does this thing where he crunches me up and it really hurts my hips."

"Yeah, well," she said with another laugh. "He fists me. And he's rough."

"Okay, he's definitely never fisted me—"

"And he calls me a dirty, stinky cumbucket, trash whore—you name it! Weird guy."

"He's only ever called me nice things," I said, barely believing it.

"Well, I guess he likes you," she said. "He's mean to me, but he's psycho, like really messed in the head. So, whatever. And he does the same thing every time!"

"Yes!" I said. "It's like he follows a script!" Though I'd never considered the possibility that each girl played a different role. Sheepishly I asked, "Do you feel like he's abusing you?"

"Nah," she said. "He's just being Walter. But I think I need to take a break from him."

I reflected on her words and gave the image of Mr. Wack—unreachable and sullen in his white robe, ciggy hanging from his full lips—a suspicious side-eye in my mind. I no longer trusted the ritual: I knew that a client's roughness routinely operated within the framework of consent, but I had never known Walter Wack to ask—that would betray the script. I worried for the beautiful, bubbly, and funny Sarah; that he'd hurt her without either of them acknowledging it.

A few months into his stint as my most regular client, he did something he'd never done: he booked me twice in one night. I saw him first and I saw him last, bookending three other tightly packed appointments. Five appointments in one night. It was a lot of cock, but a lot more cash: $800, give or take tip. I didn't want to make a habit of it, but damn that money looked good to me. I showed up at 2:00 a.m. for the second hour with Walter, tired and not terribly in the mood for hip-hurting contortionism. A little mish and doggy would have been more my speed.

We fucked according to the script, never deviating; as always, it was painful. I tried my absolute darnedest to be a "trooper" and to see the job out for as long as I could. The thought of going off-script made me feel both guilty and nervous.

"Walter," I said, finally breaking character. "You're my fifth appointment of the night. It kind of hurts."

I saw the flames lick and whip inside his eyes. Betrayal, anger, disgust. Still thrusting, in a voice both harsh and quiet, Walter said, "That just makes me want to fuck you harder."

And so, he did. Relentlessly and with unforeseen fierceness, he pounded my painfully contorted body harder than ever. Whether it was fear or guilt or shame or duty that kept me there, I don't know, but I stayed, getting him back in tiny ways. I dug my nails into his back. I let my moans fall to teeth-gritting and silence. I looked at the clock—which I never did on principle, for fear of offending a client—and saw ten more minutes left. Ten more minutes of this. I could get up, but I didn't know what to say or how to leave. He called me all the names he'd called Sarah, and the worst part was that I could feel his hatred in every single word. I couldn't believe it. Walter had turned on his sweet little girl. All of a sudden, I was a no-good piece-of-shit slut no one would ever love.

When the psycho finally came, I rushed to my feet in tears and ran to the bathroom. Crying and shaking, I sent a text to my ex, with whom I was still romantically involved. I wrote, *Are you still awake? Something bad happened to me.* He promptly responded, *Too tired to talk. Trying to sleep.* My heart sank. I showered, cleaned up as best I could, and ran from Walter Wack's condo into my madam's car. Trina listened sympathetically and anger rose in her voice when she spoke.

"You never have to see him again," she said, comforting me.

He had been officially blacklisted. For me, anyway. Not for the other girls.

Oh, Baby Mary Ann. It wasn't your fault.

Yes, everything I'd learned about rape up until that moment was that whores—literal whores, do-it-for-free whores, dressed-like-one-for-fun whores, just-minding-my-own-business whores—get raped because they *choose* to make *themselves* vulnerable. How can rapists help themselves around such easy prey? Worst of all, I was a literal whore, a whore-whore, which meant I put myself in a vulnerable position *for money*. It was my fault—my fault Walter Wack raped me. Raped for pay. The shame.

Naturally, little Baby Mary Ann—with the stigmatizing voice of society blaring so loudly in her ears—questioned her own sanity, not that of the rapist, who really, when you think about it, was only doing his socially sanctioned duty. If it wasn't his duty, wouldn't there be laws to protect sex workers from abuse, and not laws that made it easier for abusers to get away with it?

Baby Mary Ann didn't know. She didn't know what to do, what to say, how to react, how to leave, and I forgive her. It wasn't your fault, young one, that some psychopath exploited you, and possibly hundreds of others. No one deserves to be raped. No one. Not a sex worker, not a civilian. No one. No one.

I heard months later that Walter still called to ask for me. Multiple times a day. My madam finally bit the bullet.

"Do you realize what you did to her?" she asked him. "You hurt her, Walter."

He claimed he thought it was an act. That I was simply "playing along." Yet another tragic actress who played her role until she couldn't. A whore gone rogue.

A year later, I received a text about a pick-up. The Lakeshore condo drop-off address looked familiar. Every moving part inside me ground to a halt. I called the new phone girl who had booked the appointment.

"Is the call for Walter Wack?" I asked, to which she replied in the affirmative. I was staunch in my position. I would not go. He was blacklisted—well, until a recent crashing of agency servers apparently reset each escort's personal info, including her blacklist.

"You know, it's funny," she said. "I've worked for tons of Toronto agencies and this guy is blacklisted from nearly every single one of them."

"Yeah," I said. "He's a predator. A complete fucking creep."

"That's what they tell me!" she laughed.

I didn't find it very funny.

DAYLIGHTING

If hookin's taught me anything, it's that there's no such thing as "the one," but a world of ones waiting to be found. Albert was one of my many.

Smart, funny, and remarkably old-fashioned, whenever Trina answered his call on her car speakerphone, we'd giggle as he'd say, "Hello there, this is Albert McArthur calling," in his classy baritone. What a ham! A gentleman ham.

An appointment with Albert was a thrill, due in part to the location: he lived a block south from my new "daylight" workplace. While I was moonlighting as a hooker, I was daylighting as a receptionist at a downtown comedy school. I both delighted and panicked at the risk of someone I knew seeing me step out of an SUV in a skimpy outfit and a full face of makeup, waltzing into the lobby of Albert's swanky condo. Delight in my own beauty; panic about anyone bearing witness.

I had a ritual for night shifts after a day at the office. With my whore gear safely stuffed into my purse, thigh-highs worn as long socks under my pants, and heels sported conspicuously as office flare,

I would lock up shop and take a quick stroll to the hotel across the street. There, in the ladies' public washroom, I would glam up as I awaited my ride.

Albert was a Bay Street banker and bachelor. He'd been married, had kids, and even grandchildren. We'd smoke the weed he kept in a large, overstuffed heart-shaped box and talk politics. I was the pinko; he was the stinko. We fundamentally disagreed on matters of the economy, social justice, and the environment, but we always heard each other out.

"Oh, Mary Ann," he'd laugh, "we'll never agree on anything— except, of course, sex."

We'd continue, laughing, to his dimly lit bedroom, climbing under the covers, giddy like teenagers. I'd caress Albert's sagging eighty-year-old skin with curiosity and joy, because the man himself was *alive*. I felt as if I were on a secret rendezvous with a lover. With Albert, I learned getting old was a choice.

I thought about him often in my spare time. I spoke about him to friends, family, and even to my boyfriend, who once asked, "Are you sure you don't want to date *him*?"

One evening, Albert asked if he could make a personal request: would I take a bath with him next time? The invitation struck me as dangerously intimate. I didn't have a straight answer.

"When I was in college," he said, "I was going steady with a beautiful girl named Mary Ann who happened to look an awful lot like you. She started avoiding me for no reason and I never knew why. Turned out she was seeing a guy on the football team. I bumped into her one day on the street and asked, 'Mary Ann, what happened?' and she said, 'Al, I found someone new. I'm leaving you.' And that was it. Mary Ann broke my heart."

I wasn't sure what surprised me more: that I was a surrogate Mary Ann or that he was still heartbroken about a love lost sixty years ago. Doesn't time heal all wounds?

He never called for me again. I, Mary Ann the Second, was left scorned, working on the other side of the street in broad daylight, asking, "Al, what happened?"

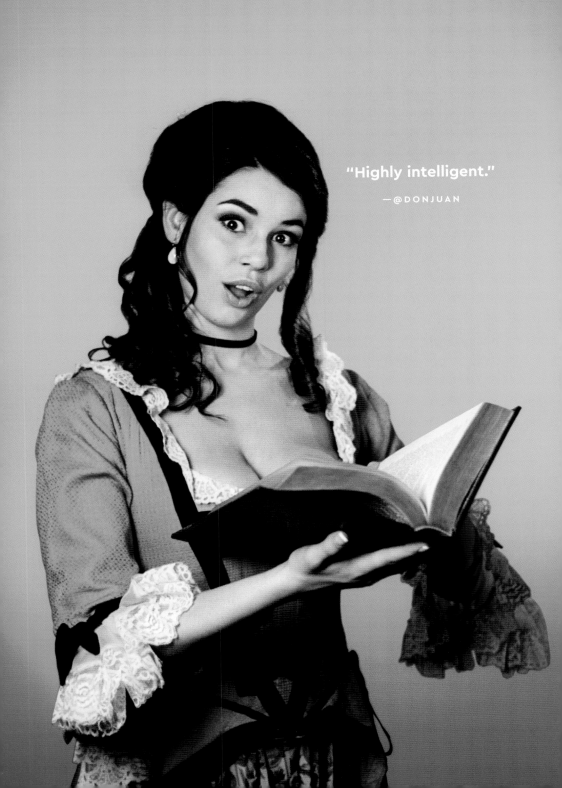

"Highly intelligent."

—@DONJUAN

WOW! TOFTT BY @DONJUAN

I had noticed Mary Ann ever since her photos first went up on the Sirens site.

Upon meeting Mary Ann, my first impression was, wow!

The words striking, and beautiful, first came to mind. She has an exquisite classically beautiful face, with a flawless complexion, a refined nose, sensual lips, and a warm smile. I was also struck by her figure, which I would estimate at 5'5", 120 pounds, 34D (natural)/24/35. She was dressed fashionably. She wore a very feminine top, which accentuated her stellar natural breasts, a very fashionable skirt, and high heels. Her hair, and light makeup were perfect. Her hair is naturally and softly curly. We exchanged smiles, a brief hug and a kiss. I told her that she looked fabulous. She smiled, as she thanked me. She also has a radiant smile, an endearing voice and laugh, and an extremely friendly manner.

I showed her a spread that I had prepared. The beverages were: champagne, Perrier, Riesling wine, Coca Cola, and Sprite. She opted for the champagne. I opened the bottle, and we toasted to a wonderful evening together.

Even though I really liked her photos, due to the fact that she didn't have any reviews, I initially booked for an hour. I liked her a great deal personally. She is highly intelligent, and an excellent conversationalist; she is also extremely well read. She is quite feminine. She did seem a bit shy at first. I enjoyed our conversation, and I was hot for Mary Ann on a physical level. At about the 10 minute mark, with her clothes still on, and except for our brief hug and kiss, as an initial greeting, I asked if we could extend for another hour. She asked if I was

sure, we hadn't been together very long. I told her that
I was absolutely sure. She made the call to Trina, and we
were good to go. I said to her, "Now we have 2 hours . . .
just relax and be yourself . . . I already like you a
great deal personally, and honestly, you are seriously
really beautiful."

I am not sure that it was absolutely necessary to extend
her, to make her feel more comfortable. She is very easy to
click with. However, with a lady who is as beautiful and
personable as she is, I would have been happy to spend the
time cuddling and talking with her, if she got 2 shots out
of me in the initial hour. I kind of look at it in that
case, as investing for the future and building chemistry
(I knew that I would be seeking her again). When she hung
up the phone, after talking with Trina, she was more at
ease. She did say, "I guess you really do like me." I asked
her if that had been a concern, and she said that it was.
I did say to her, "Honey, you are everything a guy looks
for: you have a strikingly beautiful face, an incredible
figure, you are highly intelligent, very personable, and
extremely down to earth; I am absolutely delighted with
you in every respect." She did blush, which was kind of
cute to see, and she did thank me for the compliments.

We went to kiss. We started with LFK, then we quickly
progressed to DFK. With ladies who are new to the industry,
I usually let them take the lead. She was on top, when I
unfastened her bra. I was gently massaging her breasts when
she said, "You intrigue me." I asked her why, and she said,
"Most guys want to get a look before they feel." I threw
my head back and closed my eyes, as I said "Honey, I am
pretty sure of what they look like . . . they are real,
and they are spectacular." She laughed. When I opened my
eyes, she was smiling, as she went to ever so seductively
remove her top. We had advanced to DFK, and it was abso-
lutely fabulous . . . my tongue in her mouth, her tongue
in mine, each of us sucking on each other's tongues, our
tongues meeting outside of our mouths. She is absolutely
a fabulous kisser in every respect. The area to both the
left and right of her thyroid, is highly sensitive, and

I spent a fair amount of time there on both sides, albeit
gently. It did get her wet. I moved my hand down below,
and I found her to be absolutely dripping. I spent a
little more time on her absolutely fabulous breasts. She
did ask me to suck on her nipples harder than I was; I was
pleased that she felt comfortable to express her desire,
and I did take direction well. :D

DATY was fabulous and very welcome. Her hygiene was
immaculate; she smelled and tasted great. As I made my way
down, I initially started on the inside of her thighs.
I could feel her body tense, as she arched her back, and
she said, "I was hoping for that, you have a very talented
tongue." Initially, she had both of her hands on my head .
. . then she moved her left hand to her left breast, where
she was squeezing her left breast and pulling at its nipple
. . . I did have my left hand massaging her right breast,
but as I looked up, she was doing a much better job than
I was, so I removed my hand and directed her right hand to
her right breast . . . then she really went at it, squeez-
ing both of her breasts, massaging each of her nipples, and
gyrating her pelvis. She was going absolutely ballistic and
I could taste her flowing juices, which was a huge turn on.
I too was kind of in a frenzy at that point . . . I asked
about a Russian finish and she was all for it.

We did have a nice conversation, and we enjoyed another
round of foreplay before moving on for the second round.
She gently made her way down . . . she paused briefly to
suck on each of my nipples . . . then she took me into her
mouth. Her eye contact was fabulous, and I did prop myself
up on some pillows to get a better look. I did say to her,
"Honey, as great as that looks and feels there is no way
that with a lady as beautiful as you are, and as much as
I like you, that I don't want to be inside you." We put on
the cover, and we went to missionary. The thought of cowgirl
did enter my mind. However, she was enjoying missionary,
and I was enjoying things as they were, so we opted not to
change things. I did tell her when I was getting close.
She told me that she wanted to taste me, and I thought to
myself, "I absolutely hit the jackpot with Mary Ann." She

removed the cover, and finished with a mind blowing CIM/ COF? CIMSW? I am not absolutely sure which . . . and I really didn't care . . . whatever it was, it was fabulous. I did let her know when I was close to coming, and she kept at it. I was writhing back and forth . . . eye contact was the least of my concerns at that point . . . when I finally got my wits about me, she was rubbing my anatomy along her face . . . which in itself was a huge turn on. She had an absolutely beautiful smile, as we looked into each other's eyes. We looked at each other that way for a good 10-15 seconds, until I finally said, "I really wish that I could have a picture of that." We both laughed, as we each knew that it was a memory that we would each have to keep to ourselves. Time was winding down. We cuddled and kissed a bit longer, until the call came that our time was up.

We got dressed and I walked her to her driver. We shared a farewell for now, kiss and a hug . . . until next time.

MARY ANN'S TAKE

RAMBLE ON, DON JUAN

Don Juan told me he was a plastic surgeon from Florida who had gone to Columbia University with Barack Obama. "Oh yeah?" I asked, faintly interested. When a grandiose thing is said by a john to a whore, her duty is to be impressed, not to sniff out facts. Though I did suspect the plastic surgeon thing to be true because he had a particular *technical* interest in the size and shape of my breasts. He said they were an ideal pair and that he couldn't believe they were real. You better believe it, honey! Been mine since I was 10 years old!

My first impression of Don Juan was, wow, this man is not attractive! He was a wide man with a wide mouth and

small teeth that cut across his face like a Jim Henson puppet, *blah blah blah*, his entire face unhinging backward at the jaw whenever he spoke. That's how I remember him, anyway. Yes, he did have quite the little display of unwashed strawberries, cubes of cheese and crackers, along with all the beverages he mentioned. I munched hard, having not had dinner, and opted for the alcohol on account of Don Juan's *Sesame Street*-like appearance. It helped. His voice was squeaky and nasally, like a chipmunk Danny DeVito.

I know, I know: Don Juan's review of my performance is highly complimentary. Perhaps I sound like a curmudgeonly, ungrateful bitch raining on a man's flattery parade. And perhaps I am. But perhaps you should also consider the fact that half of this "Take One for the Team" review—that is to say, my first review on the board—is almost entirely made up. Yes, we tried calling my madam to extend for a second hour, but that request was promptly denied because I had another client lined up immediately after our appointment. Everything he says in the review up until the blowjob with the eye contact is true-ish (I definitely wasn't as bashful and eager to please him as he suggests, but I suppose it couldn't have hurt my popularity for prospective clients to think of me as a big-tittied coquette). The missionary, telling him I wanted to "taste him," and the Cum in Mouth— or was it Cum on Face, or was it Cum in Mouth & Swallow?— *definitely* didn't happen.

"We both laughed, as we each knew it was a memory that we would each have to keep to ourselves," Don Juan writes. Until, of course, he wrote his review of my performance on a public message board, and I wrote my response to his review in a book called *Modern Whore*. Isn't life grand?

POPPIN'
CHERRIES

She was a whore of the most pleasurable order. An irresistible combination of sweet, stunning, and funny, Sarah's flesh was a voluptuous porcelain, her hair a fiery red, her smile a flash of light. A few memorable conversations in the car were enough for me to know I loved her. When I noticed we'd been scheduled to perform a "noninteractive duo"—that is to say, a paid-for threesome in which we would be giving our full attention to the client and none to each other—well, my heart skipped a beat. Not only would Sarah be popping my duo cherry, but we'd be fucking a client with whom we were both very familiar: Salvatore.

Small Salvatore was in his mid-fifties, with a high-pitched voice and terrible breath—breath so bad I'd refused to kiss him many a time, while other escorts refused to see him altogether. Stinky-breathed Salvatore insisted on French kissing and having his butthole played with in all manner of ways. Sarah always came prepared with a fresh pair of surgical gloves stuffed in her purse.

"Don't wanna get that stink finger!" she chimed, a true professional.

Sarah was dressed casually in a black tank top for her big braless breasts, a jean skirt, and leopard-print flats. With my high heels, elegant A-line skirt, and thin sleeveless blouse, it was as though we were performing the same play but for different audiences. Our madam described my style to new clients as "Queen Street." I once heard her say, "You're gonna love her, she's Queen Street, stylish, and a little quirky at the same time." Quirky! *Great*, I thought, *a regular Ms. Frizzle*. My fashion aim was to be slutty enough to elicit insta-boners, while also classy enough to be taken to a fancy hotel restaurant if necessary. Though presentation plays an important role in one's escort career, our job in the end is to take our clothes off.

Despite our stylistic differences, business was booming for both of us. Sarah and I giggled our way from our madam's car into Salvatore's Toronto Community Housing high-rise, having a little trouble with the buzzer system.

"Gosh," I said. "We're just a couple of dumb whores, aren't we?"

And we laughed, continuing our gleeful jamboree inside the rundown elevator with its busted floor buttons, amateur graffiti, and exposed lightbulbs, then up into the winding hallway fragrant with the smells of farts and cooking.

"Okay," Sarah said, clenching her fist, threatening to knock on his door. "Ready?"

I nodded with a smile. After a few moments of bated breath, Salvatore opened the door with a towel wrapped around his waist, ushering us excitedly into his bachelor apartment. The room was neat and organized, his books on rustic homemade 2x4 shelves, his bed resting upon a skid on the floor. I wondered how much of his disposable income fell into the coffers of escorts, and whether it would perhaps be better spent elsewhere. *Like it's any of my business.*

What I did know was that Salvatore wasted absolutely no time on conversation. He knew what he wanted, and it wasn't talk. As the door closed, Sal's towel fell to the ground, revealing a rock-solid cock. Sarah's clothes were already off. This hurried manner of getting down to business was so foreign to me I actually blushed. Where

was the affectionate preamble? The illusion of courtship? The excited build-up to the act? *I guess I'll get naked now*, I thought, and followed Sarah's expert lead. Very soon, Salvatore was lying on his back, Sarah and I kneeling at the edge of the bed, fawning over his rough-and-ready schlong.

We all have our own ways of servicing clients. Sarah, I could tell, was a real performer—nay! An entertainer. As soon as she got her hands on that small wrinkly pecker, she was talking dirty, moaning, rolling her eyes back in pure ecstasy. I was front row at the Sarah Show. Five stars! (I mean, she *was* already receiving a standing ovation, *nyuk nyuk nyuk*.) I loved watching her because big displays of pleasure had never been my style. I was more of a "let's be real" kinda whore, though I'd been known to exaggerate, after light pussy-munching, when prompted to answer the embarrassing "Did you cum?" question, usually followed by "How many times?" Oh honey, so many times. Gosh, I couldn't even count them all, but you need an exact number? I'd ballpark maybe two, borderline three *hundred*?

Sarah's services would be classified as the "porn star experience," or PSE: wild, horny, moanin', live and private entertainment. I might be considered too subtle, too difficult to please, because I didn't roar with sexual delight at the very sight of a penis. They called me a GFE, a girlfriend experience, 'cause I'm homey like that.

Salvatore specially requested that I tongue his freshly showered asshole, so with inward apprehension but outward enthusiasm, I took to his hairy anus like a kid forced to take a really awful-tasting medicine. *If I have to*. Gosh, I coulda flossed my teeth down there! As Sarah was going full glamour-whore on Sal's cock, deep throating and moaning, our eyes locked suddenly and we both broke out into muffled hysterical laughter. Of course, we couldn't *ha-ha* laugh like we wanted to, we had to *ohh-ohh* laugh, and make it look like we were just joyfully aroused by the body we were paid to service. From the forest of his cornhole, only my eyes were visible, eyes that clenched tight like they did back in elementary school when one of us made fun of the teacher behind his back. *Don't laugh don't laugh don't laugh,*

I heard again in my head, as loud as ever, and then, as now, I was always the first to buckle.

When the deed was done and we'd finally left Sal's place, Sarah turned to me in the suv and offered some on-the-job wisdom: "It's official. You can't laugh with a cock in your mouth."

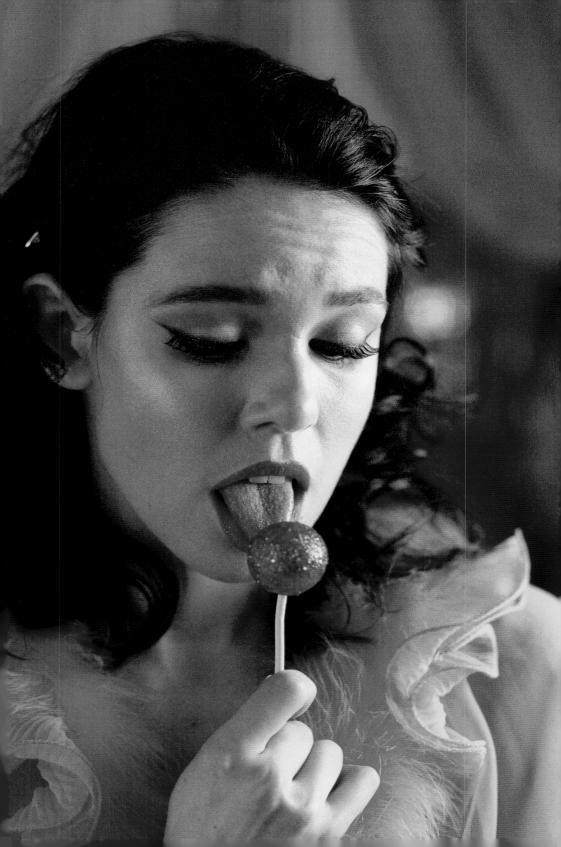

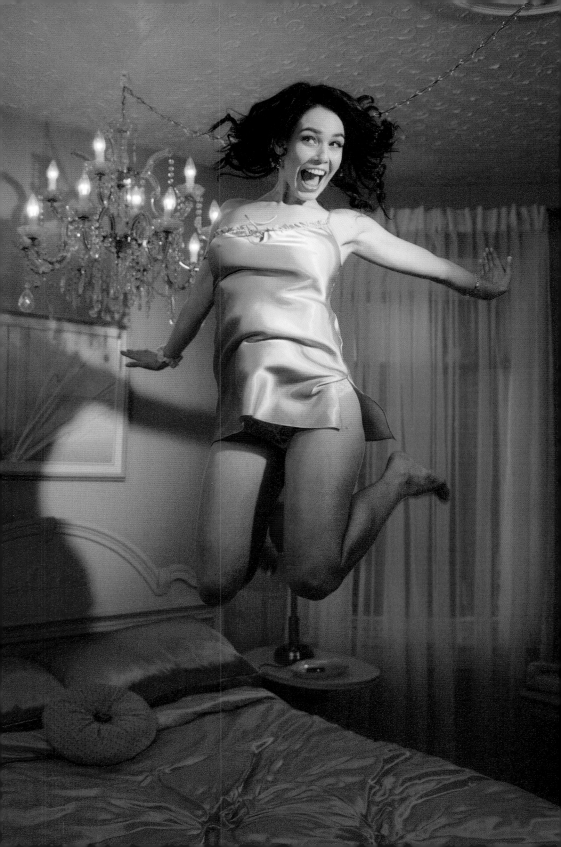

Attitude

As you walk the hallway down to your mystery client's room, repeat his name to yourself under your breath. Knock softly and purposefully at his door. He's an older man—salt-and-pepper hair, crow's feet, laugh lines. He glows at your beauty and your smile. Greet him with a warm embrace. Ask to settle business before the two of you get started, and he will hand you the money. Count it, whether in front of him or in the bathroom, and text your driver— *Good* will suffice. The clock is on, but the challenge now is to ignore the clock. One perceived glance at the time by your client will make you a "clockwatcher," an escort who appears bored and eager for the appointment to finish. That's a no-no, even if it's true.

Go with the flow. Tell him he's handsome. A sincere compliment from a beautiful lady is sure to make his day. Be appreciative and vocal when he does something that feels good. He is looking for a response. Give it to him.

For your next appointment, you're dropped off at a dude's place and it smells. His body odour is no better. He doesn't want to talk. He gives you the money, you text the driver, and he's already taking his clothes off. You're there for an hour and a half. Ask him to shower before you get started. Say no to bad breath. Disclose that his stubble is irritating your skin. Tell him the truth. No need to suffer. Tell it gently, but let him know.

Abusive clients are uncommon, but they definitely exist. If you feel you've been violated in any way, get the fuck out. Take that goddamn money and run. You are under no obligation to stay with a client who is deliberately hurting you in any way. It's not worth it, sister.

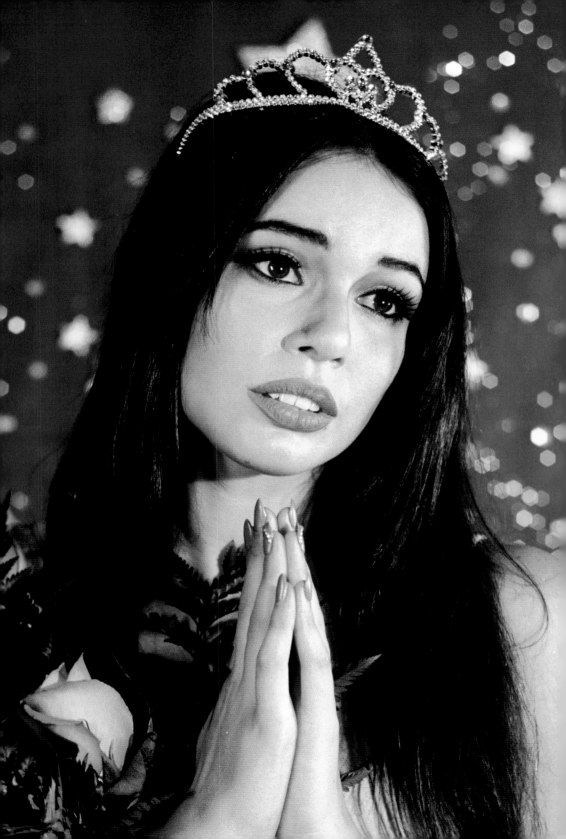

Holy Hooker

Yeah, so, I'm a hooker. A bona fide, two-syllabled who-oore. Slutty and paid, that's me. People who fuck for free? I don't know them.

Listen, you're not a soup kitchen. You're not a thrift store. You're not a charity. You're a million dollars on two legs. You don't have to give it away for nothing because you feel bad for these guys. R-E-S-P-E-C-T your-self and have some self-worth!

So, I get paid and I have fun. Save a little, spend a lot. Whatever. I want everyone to know I'm using these peak youthful-charm years to my fullest advantage. I'm proud—so what? I don't waste my time doing shit for money that not only bores me but makes me barely enough to eat a scrap of bologna every now and then. No. I wouldn't be proud working an acceptable job if it meant I couldn't live the good life. My life. Being a hooker means I can have fun and get paid at the same time. Dick is dick.

Feels good whether the body attached is young, old, ugly, wrinkly—even stinky I'll get over if the price is right. I love fucking, and I love getting paid.

Anyway, my sweet and brilliant BFF Nicole invites me to a costume party at her place. The theme is "female movie protagonist." One name pops into my head immediately: Carrie. You know, the chick who gets bullied for being a weirdo in high school—she goes to prom, gets crowned the queen like every dumb girl's dream, and then, duh, the cool kids dump a bucket of pig's blood on her IN FRONT OF THE ENTIRE SCHOOL. Holy shit. And that's not all. The pig's blood is, like, demonic or something, 'cause Carrie gets possessed by the devil. She's had enough of everyone's shit and lights their asses on FIRE, fuckin' kills EVERYBODY!

And the moral of the story is: don't be a bully. You tease the wrong girl and she will set your ass ABLAZE.

So, I'm thinkin' prom, something formal, and Nicole comes over, and we're looking in my closet like *dum-de-dum*, but nothing is screaming "troubled girl about to commit mass murder." Then I think, well, maybe I could just wear my normal clothes, but THEN I'm like SHIT, I'll wear my hooker lingerie and be like, I'm the hooker Carrie, Carrie the hooker. Oh, you're a jealous hater? You're gonna

pig-blood me for living *my* life? Go ahead, bitches. I'm about to light your puny brains on fire.

Now, Carrie's fire can be taken two ways. Fire destroys, kills, burns to a crisp—as in, *I throw you to the flames*. Or, follow me on this one, there's a flame that gets people hot and bothered, turned on, but like, *spiritually*. I know, you look at me and you say, "That girl's a whore. I like her but I can't trust her—she sells her body and that can't be right." Well, burn that shit away. I'm a person just like you, trying to make a living, and unlike a lot of people, I actually like how I make my money. So, all that hate you have against whores who are living the life they want to live—burn that hate away.

Watch me get drenched in pig's blood—and burn that hate away.

So, I'm like, Nicole, for this party tonight, you be responsible for the liquid strawberry milk mix, all right? Fuck pig's blood! I'm sweet like candy and I've got my own milk right here! What, you want wisdom? You wanna know the truth? You want insight into *this* mystery? Suck on these, babies! I'm feeding, who's buying? Cum and get it!

Nicole's put four litres of Nesquik in this bucket right here, and for that I thank her. Thank you, Nicole, this party's gonna be a blast. Here goes. Don't forget to feel sorry for me now.

Yummy! Oh, poor victim! Look how pathetic and exploited I am! God, I'm sexy. There, all done. How do you feel? Hot with shame, or bothered with lust? Both? The doors are locked, you know. There's no leaving now. You can't unsee this. You've been burned by a holy hooker. You're all victims now. Only you know how badly you've been scorched. Here, let me help you with that—I forgive you. Whatever you thought of me before—don't worry. It's good now. I understand, and here's the healing balm: we're all whores. When you do some-thing for money when you'd rather be doing anything else, you're a whore. We all need to make a living, right? We're all whores. And you can either find a way to love the fucking or you can keep on hating that you're getting fucked. It's up to you. The fire that destroys won't put itself out. It keeps on burning. What are you gonna do about it?

Holy water, get your holy water. I'm selling it on discount tonight. ♥

UNSHAMEABLE LOVE

My parents and I have always been close. Never hid a thing from them—we could talk sex, death, religion, and I knew their love would never waver. When I began escorting, however, I understood I was testing the limits of that love.

My pride and joy—the freedom to work when I wanted, doing the work I wanted to do—became hot shame in the presence of my family; the lies a burning pile of embers in my gut, poked and prodded by the constant reminder that I couldn't be myself around the people who loved me most. Desperately, I yearned for honesty and acceptance, but I gladly would have taken detached disapproval over the continued charade.

I told my younger brother first. We were sitting at a picnic table in the backyard of our godmother's house, eerily close to a client's residence. I mentioned this. With wide, teary eyes, he asked concerned question after question pertaining to my safety, my enjoyment, my income, all the while casting no judgement on me whatsoever. He was a supportive ally from the very beginning, and

I thank my lucky stars that I have such an empathetic and understanding li'l bro.

Six months in, I tested the waters of unconditional parental love by telling my dad first. We had spoken candidly in the past about my yearning to be a stripper, so he was no stranger to the pro–sex work rhetoric. He'd been close friends with a dancer many moons ago, a dancer he considered "the smartest woman I ever met," a dancer who spoke four languages and held a law degree. Whatever happened to her, I wondered.

I suspected, too, that my dad's status as a divorcee had given him a certain respect for sex workers; not that he saw them himself, though I wouldn't judge, but that he might be sympathetic to the reasons other older, lonely, love-weary men might procure the services of a professional. A woman, as they say, not paid to be there, but paid to leave.

I made the call to Moncton, New Brunswick. After a thoughtful pause, my pops said, "I know you've got a good head on your shoulders. You've got your reasons, so I support you. And if anybody hurts you, you let me know and I will beat the living shit out of them."

Hurray for Dad's love!

Next, to tell my practising Catholic of a mother—a funny, sensitive, and loving woman I knew would be, to put it lightly, *devastated* by the revelation.

One evening, Mom and I sat casually on the couch in front of the TV, chit-chatting. I nodded at the small talk, shaking, sweating, my face burning red as the words no mother wants to hear lay like hot coals on my tongue. Finally, I spat it out. I told my mother I was a whore. I told her and watched the blood drain from her face and her body slump as if she were dying. As if I had killed her.

Her thoughts returned after the shock subsided. What about diseases? What about getting pregnant? What about violence? I explained, in tears—to the woman who had been president of her labour union when she'd met my father, who himself had been president of his own labour union—that sex work was work and a job

like any other, only it was stigmatized, forced into the underground, where the law allowed abusers to get off scot-free and workers to be continuously victimized. This was a labour issue and the industry needed to be decriminalized, I told her, with madams and agency owners treated like employers in the eyes of the law, and sex workers as employees entitled to the benefits afforded to others in more "upstanding" workplaces. She nodded, still slumped, looking like I'd followed my words with fifty swift kicks to her gut.

As I left her house that night, I told my mom that being honest had extinguished the fire inside that threatened to burn me alive.

"Well," she said morosely. "You just lit *me* on fire."

I cried the whole walk home. I had burned my loving mother with the truth.

Over time, the wounds healed. The tearful calls to me in the middle of the night stopped. The hurtful comments like "Why did I pay for your education when you could have dropped out in grade 7 to become a prostitute?" also stopped. I told her I wanted to become an activist for sex workers.

"Why not write a comedy about prostitution instead?" she said. "Make people laugh, show people a side of it they've never seen before. Do something creative with your experience."

On the day I graduated with my English degree from the University of Toronto, my mom, dad, boyfriend, brother, and I went out for a celebratory lunch at a Yorkville pub called Hemingway's. Just as our asses hit our seats, my mother asked, "So, when are you gonna quit that job of yours?" I scanned the darting eyes around the table. They all knew I was a sex worker, so I hadn't been unduly outed, but I did have to make a very quick decision. I'd just turned twenty-three. "Okay," I said. "By my next birthday."

"Great," she said. "I'll get that in writing."

That night, I wrote and signed a contract with my mother with a vow to quit escorting. As a matter of honour, I stayed true to my promise. Besides, having an "exit strategy" wasn't the worst thing in the world. A girl like me needs structure—and setting a date made it easier

Nov 20,
2012

I, Andrea Werhun, vow to stop hooking
on my 24th birthday, November 10th, 2018.
You HAVE IT IN WRITING!

Sincerely,

Andrea J. WERHUN

for me to accomplish my financial goals. Even if I'd pushed back against her wish for me to leave the industry, I knew my mother would never have stopped loving me. But I owed it to her—the queen who'd made me who I am—to meet her in the middle. After a substantial battering, our love and respect for each other returned full force with a commitment to mutual honesty and trust. With her love and the support of my family, I felt unstoppable. Untouchable. Unshameable.

And yet—despite being loved by my family, I was still susceptible to the societal shame imposed on me by a few thousand years of cultural prejudice against women who choose to capitalize on their beauty and sexuality. Escorting after graduation stalled the inevitable confrontation with adulthood outside of the university and the need to "get a real job." Still, shame followed me like a sinister shadow, though with all my heart I knew I'd done nothing wrong. When I applied for non–sex work jobs, I had to assure myself there was nothing suspiciously whorish about my resumé, my look, my smell, my cadence, my essence. In the closet, I feared being *caught* most of all—being exposed, humiliated, laughed at, singled out, excluded, deliberately hurt—and that fear poisoned my mind. Every day I had made-up arguments with classmates, teachers, co-workers, and bosses intent on discrediting me based on my "other" job. This

imaginary bickering stunted friendships that never had a real chance to begin, because I believed, deep down, that everyone was laughing at me behind my back.

And yet—in the evenings after my daylight work, with my glossy gear tucked into my purse, I hopped into my driver's car and went on whoring. I was not ashamed of the act—I *loved* the act. I was ashamed of the shame of others, the shame that wasn't my own. The shame I still yearn to see transformed into an unshameable love for all.

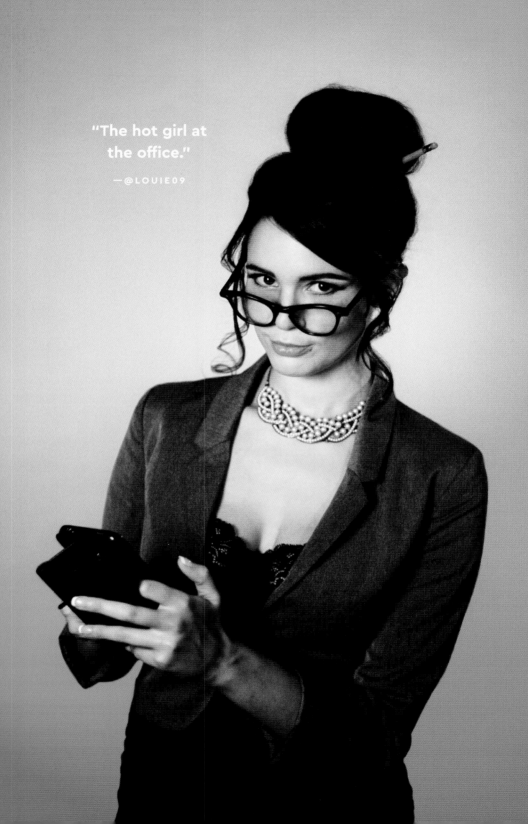

"The hot girl at the office."

—@LOUIE09

A SWEET GIRL BY @LOUIE09

First of all, you guys in Ontario should be thankful for what a great country you live in . . . literally dozens of hot SPs available for every taste in a low-risk and reasonably priced environment . . . my country can put a man on the moon, but try getting a full hour, MSOG with a great looking and fun SP in a safe place for under $300 . . . anyways . . .

I had been eyeing Mary Ann for a while and I was very very pleased with my time with her . . . she hit all of the buttons that are important in a session . . .

Looks . . . great face, the Rachel McAdams thing is true, she has a great smile, dimples, great hair and full lips . . . I thought she would look more ARTSY for some reason but she looked like the hot girl at the office who catches you looking down her shirt and smiles about it . . .

She has a great sex body with big full boobs, a C+ if not a D, very soft but firm if that makes sense and very responsive . . . sometimes girls with big tits are bashful about them, not her, she knows they need to be played with . . . she has a tiny waist and then full hips and bum with kind of a large booty . . .

Attitude . . . I have a few specific things that I like to do to start a session and she was totally game for it and made it extra sexy . . . while we were getting to know each other on the couch LFK and DFK were available as well as handfuls of those great tits . . .

No time watching or wasting . . . when she went to the bathroom to get ready she was out in no time at all, she did not kill time in there like lots of SPs do . . . we went over our 90 minute session by at least 10 minutes which is really important to me . . . I hate to feel like I am getting shortchanged with the "40 minute hour."

The action . . . she did all of the things that I wanted to do . . . DATY . . . DFK . . . BBBJ . . . BLS . . . COB . . . MISS . . . CG . . . Doggie . . . digits . . . we had a quick first round (see all the previous descriptions for the why) . . . then a full 2nd SOG and squeezed out a 3rd . . . literally in her hand talking dirty about any number of things . . .

She really seemed like she wanted to be there and she enjoyed herself and made sure that I was totally exhausted and satisfied when she left . . .

The only slight negatives that I would have is that her legs were not memorable as they are fairly short and she did not offer COF, I did not ask but she did not offer it either . . .

Overall, I would repeat, rinse and repeat again with Mary Ann . . . she is a sweet girl who loves sex and exploring sexuality in a hot way . . .

Thanks for all of the posts, I would not hobby without the board . . .

MARY ANN'S TAKE

RINSE AND REPEAT

May I translate? Louie begins by saying he is pleased that there are "dozens" of hot sex workers for every taste in this "country" of Ontario. Unlike the U.S.A., it's easy to find an attractive and fun sex worker here who allows multiple jizzings during an hour-long appointment, in a safe environment, all for under $300. Talk about bang for your buck!

In addition to Rachel McAdams, I also look like "the hot girl at the office who catches you looking down her shirt and smiles about it." That is so me. It's not sexual harassment if I like it, right? Hehe!

Along with my "great sex body," my attitude was on point—and what pray tell are the specific things he liked to do at the beginning of a session? Gather round, children. As soon as Lou and I were on the hotel room couch, he let me in on a fantasy he'd been having about a certain co-worker. Would I be able to role-play with him? Heck yeah! I love acting! I was born performing! Not only did Louie give me full background on this young lady, he also provided me with a script he'd scribbled down on cue cards prior to my arrival. When he writes that I took no time at all in the bathroom, he is referring to how quickly I reviewed my lines in preparation for my role as his co-worker. I was taking acting and improv classes at the time, so this shit was my jam. I'm getting paid! I came out and gave the best performance of my life, namely with a bareback blowjob, ball licking and sucking, deep throating, his cum on my breasts, doggie, fingering, and all in all, draining li'l ol' Louie's ball sack a hearty three times in an hour. Not bad! Is an Academy Award in my future? You better believe it!

Except, as Louie carefully noted, there are two things holding me back. For one, I have really stubby fucking legs apparently, and I made the grave mistake of not offering to let him cum on my face, *even though he never asked*. I'm an idiot! How will I ever give the BJ of my life on the casting couch if I can't read the minds of my clients? It's the difference between a four-star and a five-star performance, I'll tell you that much. Sigh, I have so much to learn. At least he would rinse and repeat with me like some sort of sex rag. That's a compliment, right?

THE MERRY MEN
OF MARY ANN

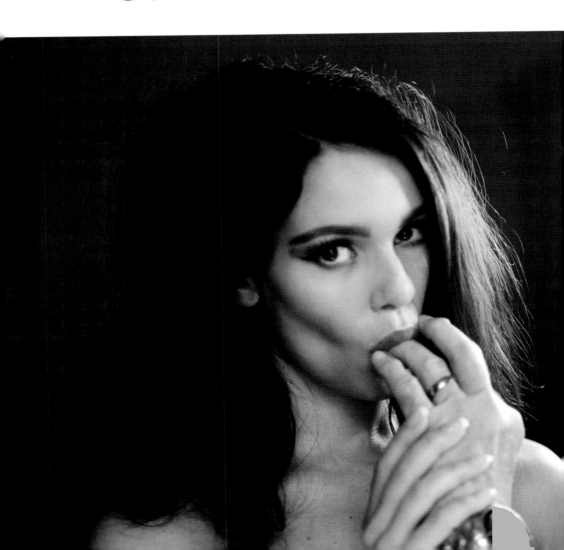

No matter what you call 'em—clients, johns, tricks, adulterous scumbags, your dad—the men who pay for sex have a bevy of legitimate reasons to procure the services of an erotic professional. Maybe they're lonely, stressed about work, or dissatisfied with life. Perhaps they're not getting what they want in the bedroom, not sure of *what* they want, or are too afraid to ask. Whatever it may be, these men are in desperate need of someone who can sexually alleviate their woes.

Take your single, travelling businessman, for instance. No wife, no home, no children, he bounces around from airport to hotel to conference room to airport again, selling his wares. Nothing caps an exhausting day of pitching the next big thing like a good, relaxing, lay-down-and-do-nothing fuck.

Then, there are the men fresh out of long-term relationships—vulnerable, hurting, in need of some tender, loving care. Whores do immense amounts of emotional labour for men with broken hearts. Never discount the value of an open ear and a little non-judgmental touch.

And there's always your regular, run-of-the-mill dorkazoid who couldn't make a move on a real girl if his internet connection depended on it. The kind of man who trembles and shakes and breathes heavily and cums really fast, and shoos you out the door as soon as the stressful ordeal is over. In and out!

The lazy, impatient bachelor is my personal favourite: good-looking, efficient, and very horny. The lazy bachelor, in his many forms, has presented his philosophy to me like this:

"Say I'm at a bar and I meet a woman I'd like to fuck. I buy her a few drinks and, if I'm lucky, she gives me her number. Then I go on a date with her, and of course I have to buy her dinner. Even after all that, I'm still not guaranteed sex. I don't want to play games—I just want to fuck! Hiring an escort is definitely cheaper in the long run."

And there you have it, folks. Games aren't fun if you're not guaranteed a win. Go for the gold, go for the whore.

The most common type of client of all is the married man. Why? *Because being a good husband is the hardest job of all!*

Trina, my madam, used to say, "I think we save marriages. It's safer for men to see an escort than it is to, say, have an affair with the secretary at the office. There's a lot less mess." And thank goodness for that. We wouldn't want wives divorcing their husbands en masse for unearthing a little infidelity, would we? Since the truth poses such a threat to the holy institution of marriage, let's all do the acceptable thing and keep our adulterous predilections a secret.

Here's a line I often heard from my married clients: "This isn't emotional cheating, you know. I'm just paying you for a service. It's not like we're having a passionate affair or anything." Uh-huh, then why not tell your wife?

Crickets.

You know why you won't tell your wife, married man? Because the status quo serves *you*, not her, and you know it. Having a wife, whether she's at home minding the children or at work busting ass for that second income, is too good a deal to fuck up with a truth bomb like "When I tell you I'm staying late at the office, I'm actually doing lines of coke with an escort in a motel room off the highway." Spare her the gory details. What's the harm if she doesn't know?

So, ladies, I pose this question to you, in all earnestness: what's the point of getting married anymore? *What's in it for us?* I have fucked so many self-serving, outwardly devoted, secretly philandering men in my time that you'll have to excuse my disillusionment regarding institutionalized monogamy. I know your husband is the exception. I have happily accepted wads of cash from many, *many* exceptions. Do hard-working, independent women truly need to marry a man?

Oh, but enough about them. Let's talk about the people who most benefit from the loving touch of a sex worker: our clients with disabilities.

One of my regulars was a man we'll call Paul. During a particularly nasty cold in his thirties, Paul woke up with a tingling sensation

in his legs. Tingling, the next day, became numbness, and numbness became full paralysis below the belt. For someone whose life had been turned upside down by a mysterious and debilitating condition, Paul was an incredibly positive, kind, and resourceful individual.

Every week, I travelled an hour by subway to a distant station where he would pick me up in his minivan, fully tricked out with all the knobs and gears that allowed him to drive without using his legs. When we arrived at his home, he'd swivel the driver's seat and unfold his wheelchair, unfurling the ramp from his vehicle to the garage floor, and roll to an elevator that took us into his house. From there, we took another elevator to his bedroom. Paul lived alone and was quite self-sufficient.

Adjacent to his master bedroom was a spacious bathroom suite fitted with a jet stream bathtub. He ran the water as I disrobed in the bedroom. He too would disrobe, and when the water filled to a comfortable level, Paul would muscle his way with impressive upper-body strength into the tub, and I would follow, spooning against him. Here we would soak in the warm water, lightly touching each other, relaxing, talking. I would step out first, putting on the plush bathrobe he always provided, and help Paul exit the tub. For the next half-hour, we'd lie naked and clean on his bed, wrapped in each other's arms, kissing.

Paul would then wiggle his way down the bed and go head over heels into pussy town. To say he was gifted at cunnilingus would be an understatement. His legs may have been paralyzed, but G-o-d that tongue was limber! Sometimes it was too much for me to handle, and he'd wiggle his way back up and we'd talk.

Among the six types of sex work clients I've outlined, there are essentially only two types of people: the kind and the unkind. The reason a client hires a sex worker is inconsequential if that person is unkind. There are plenty of reasons johns see sex workers—and not a single reason why they should be a dick.

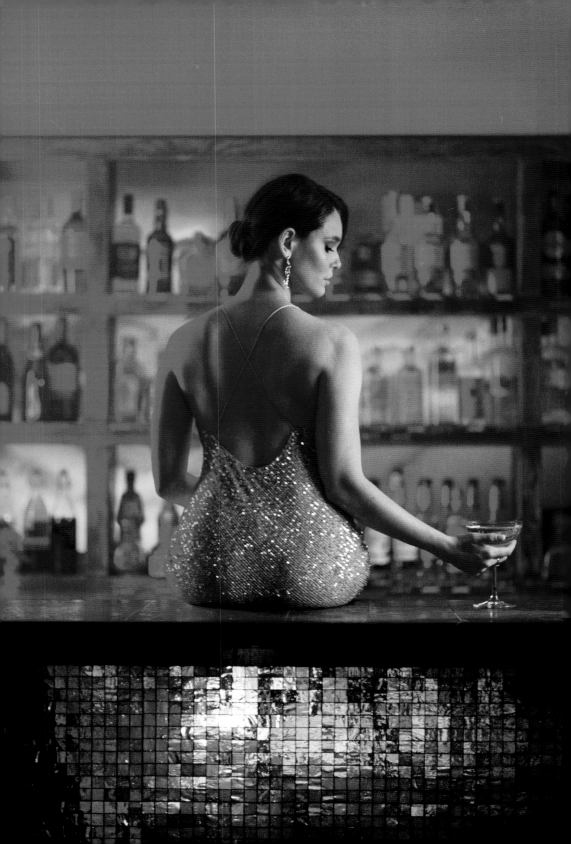

Intoxicants

If you think you're nervous, take a look at the man in front of you. A bead of sweat drips from his receding hairline to the swell of his temple. His hands are clammy, his lips tremble, words trip and fall out of his mouth. He's been pacing, distracting himself from the total knockout of a woman about to appear at his door. He might be green to the industry, forced to confront his own expectations. He is definitely nervous. He wants you to like him. He announces the purchase of a bottle of wine. Just for this special occasion. Just for you.

Aside from easing your respective nerves, the drink gives him an opportunity to get to know you. Being in the same semi-intoxicated state also lends the hour a certain transcendent sheen. My rule of thumb: get as far as tipsy, never drunk. Sloppy sex is fun, but not when sex is your job. When you're sloppy, you're careless. You'll take longer to clean up, forget your things, and you'll be plastered for your next potentially sober client. Not to mention vulnerable. Don't be a drunk whore. Be conscious at all times.

In addition to booze, drugs may be on the table. If you have a history of addiction, you may want to reconsider your decision to become a sex worker. If you feel unwanted pressure to partake, remember you always have a choice. If a man disrespects your boundaries, let him know you can call your driver. Use your discretion and trust your intuition. A client once shared he could tell I was new to the business because I'd left my purse unattended. Same goes for your glass of whatever. When you leave the room, take your purse and drink with you. Being cautious demonstrates your intelligence, not your fear. Don't sacrifice your safety for fear of judgement.

TOUCHED

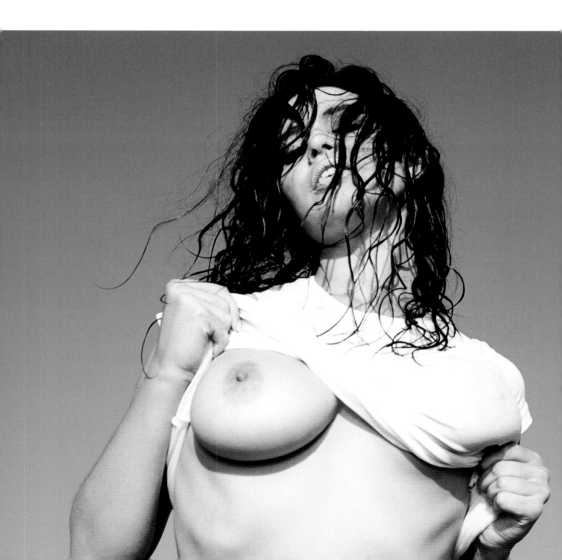

The colour has faded from memory—monochrome. Dirty upper-crust. Suburban. A lived-in home, worn out. Filthy beige. One of my first clients. "He likes breaking in new girls," I'd heard. Resembled the Penguin. I was also warned he might tell some story about being molested by his mother. It probably isn't true, they said. He may just be testing you.

The preamble when we met was relatively normal. The sex was also relatively normal. After the sex was a conversation. He told me that when his father left for work every morning, he would crawl into bed with his mother. What started with fondling, he described to me in graphic detail, became regular sex. "I see," I said, suddenly a psychologist. "And how has this affected you?"

He said, "I thought it was great. My mother is a wonderful woman. She taught me sex. I'm pretty well-adjusted, I'd say." He was a doctor, after all.

Our second time was the last time. He told me about his stripper girlfriend and eighteen-year-old son. Son was a virgin. Girlfriend was a whore. As a graduation gift, he paid his girlfriend to fuck his son. Family portrait of them on the wall.

During sex, he asked me abruptly, mid-thrust without stopping: "So, who touched *you*?" No one had touched me. I made up a story about fucking a high school teacher. I played along. Said it was true. Does it matter? Was he touched—was I? The only truth was that we were touching each other right now. Everything else was a story.

I listen without judgement, without right or wrong. Stories of honour, stories of horror, because I'm a whore. I'm paid to be. Whatever needs to be, I will be.

Assault

When I was in grade 8, I tutored a third-grader in my neighbourhood after school. One grey day, I was walking towards her house as two uniformed high school boys approached me.

"Nice tits," they jeered, cranking up their pace. I walked backwards between her house and another, as the boys chased and cornered me, taking swipes at my breasts. I successfully opened the side door before they could graze any closer, ran down the stairs, took a few deep breaths, and began helping my young student with her homework.

When I got home I told my mom, who, without hesitation, called the police. In the confines of our home and in front of my mother, one officer asked the twelve-year-old me: "Are you sure you weren't doing anything to entice them? Maybe with what you were wearing?"

I didn't know what to say. My mother was indignant.

"How dare you come into this house and accuse my daughter of *trying* to get these boys to assault her," she said. The officer apologized, but said the question needed to be asked.

That week, I was taken out of class to identify the culprits from a high school yearbook. I was driven to the police station alone in the back of a cop car, then interrogated by a female officer in a yellow-painted cinder-block room, a camera on a tripod set up to record our "interview." I was again asked the same questions.

"What were you wearing? Do you think you may have been flirting with them?"

I knew in my heart I hadn't done anything wrong. The cops seemed intent on making me feel otherwise. That day—and everyday—the powers that be taught a young girl that it was her fault for getting assaulted, and her sole responsibility to protect herself. The boys were innocent.

KINKY KYLE

Known semi-affectionately to the girls at the agency as Kinky Kyle, he was a short, stubby man who had a knack for pushing our limits. His voracious appetite for escorts, cocaine, and kink was well-established and the simple utterance of his name would draw a sigh from a co-whore, followed by an almost angry "I *hate* the nipple thing." I, too, hated the nipple thing. But that was Kyle, and Kyle—for better or worse—came with the nipple thing.

He was one of my most consistent, from-the-beginning-to-the-end regulars. Greeting me in his Woodbridge, Ontario–Italian accent as "Marianna," he would kiss me cheerfully on both cheeks, ask how I was doing, and maintain an affable demeanour before we got down to business.

Kyle was a switch, but his preference lay in playing the dominator. As a dom, he poked and prodded my boundaries in the following ways: dousing my mouth in shit-coloured lipstick and writing the word *slut* across my forehead and *whore* across my chest; squeezing my breasts with zip ties, tightening them until the colour of my tissue

changed; fucking my face raw, my head upside down and hanging off the side of the bed, tears streaming down my forehead; berating me with insults that ranged from the lightly humorous to the deeply offensive; and stripping me naked on a hotel balcony. All the while—during each and every humiliating act—he demanded that I pinch his big, thick, baby-penis-like nipples.

As brutal as he could be, I lived for the nights he'd ask me to dominate him. On one occasion, he brought a litany of delights, including a pair of women's underwear and a box of tampons. With glee, I forced him into the panties and had him suck the cotton phallus for lubrication, only to demand he shove it up his own ass. Like a good little sub, he did it—and the stubby man waddling around the room with a string hanging from his butthole was a picture of personal triumph.

Another night he lay below me in a bathtub, eagerly awaiting the spray of a golden shower, when suddenly—and sadly—I was struck with stage fright and unable to perform. Kyle resourcefully removed the cap off a baby wipe container and asked that I pee in that instead, and so, I did. With curiosity and wonder, I watched him tip the shallow dish into his mouth and drink down every last drop of my yellow aqua vitae.

"Chug," I chanted with a quiet, menacing resolve. "Chug."

Spliced into the subbing and the domming were vulnerable moments of tears and truth. The first time I broke down with Kinky Kyle, I'd just returned from a six-week solo trek across Europe. In Berlin, caught up in the wild, nighttime magic of the city, I cheated on my boyfriend more than once. When I returned, I revealed my indiscretions, but the hit to my self-esteem for betraying him was profound. When Kyle went on his usual "you're a dirty whore no one will ever love" tirade, something rang true deep in my heart. The ringing hurt so much I began to cry, and as soon as he noticed, he stopped.

"Marianna!" he squealed. "I'm so sorry!"

He ran to the bathroom, drenched a towel in hot water, lightly massaged my feet in the wet warmth, and asked, "What's wrong?" His concern was so sincere that I cracked wide open, told him the

truth, and listened as he offered his own lengthy stories of hurt and indiscretion that helped calm me down.

The last time I saw K.K.—approaching, like the other girls, "my limit"—he was in trouble with the agency for having taken things too far with a co-whore. She'd accused him of choking her without permission, hard enough to leave hand marks around her neck— while *he* maintained he always respected the limits of the girls, only going as far as they enjoyed. Each time I saw him in that period, he would go on about the ridiculousness of the accusations. My instinct told me he protested too much.

"Would I ever do that, Marianna?" he asked. "Honestly, do you think I would choke someone without their permission? I swear she was enjoying it!"

Particularly annoyed with Kyle's extra-rough demeanour, I was short on patience for abuse. There I was in bed, attached to his nipples like a perverted baby to her father-mother monster, biting and sucking as hard as I could. He was slapping my breasts with increasing force. The harder he hit me, the harder I bit him, and so it went until I was possessed with the very real urge to bite his nipples right off, tears and hatred in my eyes. As I reached the peak of my anger, Kyle suddenly sighed, "Ahhh, let's take a break, Marianna. That was so good!"

I sped out of the room, stone-cold and teary-eyed, locking myself in the bathroom. He ran after me, knocking voraciously—"Marianna, Marianna!"—but I told him I was leaving and would not be finishing the next hour of our two-hour appointment. I'd already called the driver.

"Please don't tell your boss," he begged from the other side. "You're making me question everything, all of this, everything, for the first time in I don't know. I need to stop the coke. Oh Marianna, please don't tell your boss."

I felt empowered by his grovelling, so I schemed, saying, "If you pay me for the full two hours, I promise I won't tell her." As the response, "Yes! Anything!" flew from his lips, I left the ordeal an extra $260 richer. Seemed a fitting end for Kinky Kyle and me.

Tyrant

Keep your distance. Don't say too much because he won't understand, and his confusion will incite him to violence. If you're going to square off with him, be ready for a battering. He doesn't suffer losses at the hands of women lightly. Challenging a tyrant means taking a stand against everything he stands for.

Like most creatures, his eye is the weakest spot: aim accordingly. Zero in on his narrow scope, his shitty, limited capacity to see. Force him to use his imagination. He can't grasp anything but your body, so present him with something more: your ideas, your stories, your insights. He'll be floored—and, if you're lucky, disarmed.

Know your power and don't give it away. Your body is power, and he'll attack it first. He'll start with words. Your face is too long, too short, too round, too ugly. Your eyes too small, too big, too slender, too ugly. Your nose too crooked, your lips too thin, your chin too sharp. Too ugly. Your breasts too small, too big, too floppy, too ugly. Your nipples

too big, two coins, two pepperoni slices, too ugly. Your skin too rough, too pimpled, too stretched, too dark, too pale, too ugly. Your butt too small, too big, too flabby, too hard, too soft, too bony. Too ugly.

Oh, and your pussy? Your cunt hole cumbucket? Too much not a penis (no homo). Too holey. Too hairy. Too stinky. Too scary. Too ugly. According to the tyrant, everything wrong about you starts with your body. So, he weakens your body. You're busy thinking about your body while he's thinking about getting the upper hand. You think, my breasts are too small, my nipples *are* too much like pepperoni slices. My waist is too wide, my bum is too flabby, and this cellulite? Eww. How can anyone look at me? I'm a monster. I'm gross. I hate myself. I hate my stinky pussy, too.

Then the tyrant looks at you and says, "Hey baby. Yeah you, baby. I think you're pretty, baby." And you hang onto his every word because he's chosen you and said a nice thing, after all the other things. Your vanity is engorged from the hours you spend in front of the mirror squeezing pimples, plucking hairs, and layering your face in foundation. You are building a foundation of nothing but vanity, and your vanity grows while your strength of character, your goals, your hopes, your dreams, your sense of self, your boundaries, and your knowledge all but dwindle to a mattifying translucent dust.

Dehumanizing, degrading, and demeaning the body is how the tyrant defeats his enemy. In a world run by tyrants, how does a body, valued only for its particular *bodiness*, fight back?

One unexpected tactic: a sense of self beyond the body.

With this one simple little trick, the woman can know her body, love her body, appreciate the bigs and smalls and pepperonis of it all—and know that these features do not make her any less of a person, but rather more of herself. She can question the integrity of the prejudice against her body; she can ask, "Who says my body is ugly? I like my body just fine. It gets me around and feels good in clothes." She can even dress in an old rice sack, and with her attitude—that finest and most telling of bodily adornments— she can look good. Look good, like a puzzle she's pieced together

but he hasn't. Knowing yourself isn't a foolproof defense against tyranny, but it's a start. A proud girl is not a vulnerable girl, or an easy target.

The tyrant sees his first victim approaching. Girls in rice sacks aren't easily lured. Girls in rice sacks want a fair exchange, not a compliment from a stranger. Rice sack girls aren't looking to get discovered, aren't looking for their "big break" from the tedium of everyday existence. They like their existence.

The tyrant tells the rice sack girl her dress is ugly, and that *everyone* is making fun of her behind her back. She's only wearing it to hide her body, and why would she do that?

"Girls should show off their bodies," the tyrant tells her, "not hide them, don't you know? Don't you want to be taken seriously in this world, darling? Show Daddy some skin, baby girl."

Rice sack girl looks at the tyrant with a raised eyebrow.

"Show more skin? This rice sack—ugly? Taken seriously, by *this* world? No. No thanks."

And the tyrant watches his enemy walk away and swears she has not won but given up. He has won because he is a tyrant, and a tyrant never loses.

He waits for his next victim. She'll wear high heels, a short skirt, a little cleavage exposed. Hair done, sunglasses on, earbuds in. She is a young woman with something to prove, and that something makes her *exactly* what the tyrant expects her to be—she fits the mould and does what she's told.

"She's a whore," he mutters as he takes another drag on his limp cigarette. "A whore who gets away with teasing the world, and when she walks by, I'm going to treat her like a whore, and show her how a teasing whore gets treated."

The so-called whore strolls down the street all proud, pounding the concrete hard with her heels, always in a rush. She's a busy beauty, a walking art installation, her own work-in-progress. Her face alone is a masterpiece, the makeup artfully applied with the skill and grace of a Renaissance painter. The so-called whore is a lover of beauty,

a lover of herself. She gets a kick out of every click of her walk, the look of her legs, the pertness of her ass, stepping in rhythm to the music playing in her ears.

The tyrant hears that strut from a block away and rubs his hands, licks his lips, and says, "We've got an insecure one comin', oh boy!" He's been staring at her for a while, and of course she's noticed: her sunglasses and earbuds are an earnest attempt at avoiding eye contact and conversation.

"You're in tyrant town now, girl. Mmm," he says. "MMM! You are looking good to me!"

She continues to strut without acknowledging his existence.

"C'mon girl, you're not too good for me," he says. "Mmm, that ASS! What I would do with that ASS! I'm just gonna walk with you for a sec, girl, I don't mean any trouble. Can I put my arm around you?" he asks, while proceeding to do so. The so-called whore comes to a full stop. She was at the top of her game until he touched her.

"No," she says, pulling out her earbuds. "Don't touch me."

"C'mon baby," he says softly and a little too close to her face. "You're lookin' so good in that little skirt, baby, I just had to say hello. What did you expect?"

The so-called whore keeps walking. She is intent on losing him, and not afraid to make a scene. It's broad daylight on a busy downtown street. People see the tyrant, know his tricks, say *tyrants will be tyrants*, and go about their days.

The tyrant thinks the so-called whore's ultimate weakness is her vanity. He thinks if he continues to sweet-talk her with compliments about that ass and those sweet titties, she'll fold. She'll say, "Okay, here's my number, let's have sex some time," because the so-called whore appears to the tyrant to be dressing strictly for his benefit, accentuating her goods for the attention only the tyrant can provide. He feels he's just doing his duty. His duty to that booty.

"Leave me alone," she says.

"What, you can't take a compliment?"

"Leave me alone," she says.

"Dress like a whore, get treated like a whore, bitch."

Speed-walking now, stomping and cracking the pavement with her stilettos.

"Pussy bitch," he calls after her. "You talk the talk, but you can't walk the walk. Don't dress like a whore if you can't handle the attention," he yells. "Bitch!"

He returns to his corner. He leans against the wall, waiting for his next victim. This time he'll aim a little lower, at someone a little less confident. A whore-in-training, he thinks, a girl new to the slut game of womanhood—a naive, flowery-dress-pinched-at-the-waist, flat-sandaled bitch. Maybe she's in her first year of university, maybe she's in high school. It's not the age that matters, but how vulnerable she is to the tyrant's suave maneuverings. A so-called self-assured girl on new terrain. He'll show her how a girl gets self-assured on his turf. His turf happens to be all public places. It happens to be the whole world. He'll give this pre-whore her training wheels.

The tyrant watches her walk down the street. She's got a bouncy, carefree step, bubbly with the fresh jubilee she carries in her shopping bag. He knows she won't respond to the usual catcalls, so the tyrant alters his approach. He's gotta be soft. She's gotta call the shots—or rather, *think* she's calling the shots. *These modern whores*, the tyrant muses, *always thinking they gotta be in control*. But he'll concede. He'll do what he's gotta do to win. He sits on a perch looking aimless, and knows he's got her attention. The tyrant is handsome; the tyrant is idle. Pre-whores yearn for the spontaneity of idleness, reminders of a simpler time before essay deadlines and early morning classes. She walks by, and he jumps off his perch, just catching her peripheral vision, and walks up close behind. She knows he's there. You see, the tyrant is playing the tortured romantic: the kind every girl secretly pines for, the one to take her away from the doldrums of responsibility. The "broken guy with nothing to do but fall in love with a girl like you" shtick. The guy the girl's gotta save. The tyrant knows it works.

"Hi," he says with a sheepish smile, ducking his head into her view, hurrying his step alongside her.

"Hi," she says back with an incredulous half-laugh.

"I couldn't help but notice you," the tyrant says, trying to keep pace with her hurrying step, "and feeling like I just had to get to know you."

"Okay," she says, looking straight ahead.

"Did you know you're beautiful?"

"Yeah, actually," she responds quickly. A little too quickly for the tyrant. *One of these bitches*, he thinks.

"Well, that's refreshing to hear, a girl who knows she's beautiful. You're confident, I like that."

"Mhmm," she responds.

"I'd love to get to know you, if you're not too busy. You seem like the kind of girl who's always doing things. You in school?"

"Yes," she replies, not giving him anything more.

"You . . . wanna grab drinks sometime?"

"No," she says—again, a little too quickly for him to take lightly.

"Oh, you got a boyfriend," he replies, beginning to feel provoked.

"Nope," she says, turning a corner.

"Then why are you being so standoffish, girl?"

"Because I'm not interested," she responds. This, he does not understand.

"Why, you think you're too good for me?"

"Look, I'm in a hurry," she says. "Those are my friends over there, and if you want to keep harassing me, I'll introduce you to them."

"Whoaaa, harassing you? Girl, you don't even know what harassing is. I was just being nice and admiring your beauty, how is that harassing?"

"I'm not interested," she says. "Okay?"

"Why? Not your type? You like pussy guys you can control?"

"Yeah," she laughs. "I guess I'm not *your* type."

"Stupid bitch. Shouldn't even be wasting my time on sluts like you." He continues to walk with her.

"Yup!" she says. "Calling me a stupid bitch is a sure way to get inside my pants! Can you leave now?"

"You're a stupid slut, you know that? You know that, right?"

"Yup, a big ol' stupid slut. Look, those are my friends. They can see you. You should just go, okay? I hope you find love in your life, man, I really do. I'm sure deep down you're a really great guy, but I gotta get on with my day, okay? Just go."

The tyrant shakes his head *no*, waves his hand like *I'm over this*, and walks away.

"You're a dumb slut!" he shouts.

Everyone on the street sees and everyone hears. The pre-whore's friends laugh at him. "What a loser," the tyrant hears one yell. He considers fighting her group of friends, which consists, unsurprisingly, of mostly guys—typical of a pre-whore's need to tease all the men around her, he thinks—but decides against it. She's not worth it. She's too dumb to see that the tyrant is the real deal. Alone, the tyrant creeps back to his corner.

"Fucking whores," he mumbles, "they just don't get it." ♥

YOU LOOK LIKE A MOVIE STAR

Embarking for cottage country on a call was always exciting, but embarking for cottage country to fuck a C-list celebrity and his wife— well, that was something special. My madam and I got to know each other pretty well on those two-hour trips, especially when we got lost. Once, the GPS led us off-road to a bush trail; ahead of us in the darkness, a veritable lake of water pooled across our path. Trina knew we had to get to the other side and, both of us screaming, we charged on through.

My first time with the high-profile couple, I was new and I was nervous. My fragile thigh-highs already had a run in them. My legs were stubbly, so taking them off was not an option. I was wearing a tiny slip from a vintage store, a black '80s number spotted with blooming red roses. I felt like a used-up pageant girl. Would they like me? Would I be good enough, hot enough?

I walked up the driveway to the spacious waterfront home with clammy hands and a deep sense of cultural impoverishment. I was not classy enough for these folks; class could not be faked. I was out of my league.

The movie star answered the door. He was fleshy, old, his jet-black curly hair firmly gelled as if egg-basted. His wife sat on a couch in the spacious living room, beautiful and observant.

The open-concept main floor was straight out of a Canadiana catalogue: a Hudson's Bay throw over the brown leather loveseat; light fixtures hanging from rustic wood beams; a shag rug next to the fireplace; a stone mantel of family photos. I sat carefully across from the couple as if at an interview, and gladly accepted a proffered glass of wine.

Don't notice the run in my stocking, I thought, *don't notice my hairy legs, don't notice this second-hand slip I'm so pathetically attempting to pass off as a dress, don't notice my poverty, don't notice that I've only been to Muskoka a handful of times with better-off friends. Oh, fancy people, please don't notice me.*

I smiled a people-pleaser's close-lipped grin and tightly held the wine glass between my sweaty palms. I made conversation as best I could, answering that yes, I was still in school.

"Our son, too," the wife said, shifting in her seat.

After some G-rated small talk, our famous man finally said, "Why don't the two of you go upstairs? I'll join you later."

I walked up the steps, grateful for the opportunity to strip off the vestments of my class anxiety. Naked, we are all equal. No—naked, I am young. Fresh. Virginal. Naked, I have the advantage.

We disrobed and lay in bed. She was quite beautiful—the beneficiary of a pampered life—with her French-manicured nails, straightened hair, tanned skin, and fake tits. (She could have passed for a mature high-class escort—a part of me internally chanted, *One of us, one of us!*) I'd never seen fake breasts before, and feeling their hardness was such a fascinating contrast to my own pillow-soft F-cups. How firm they were, how obediently set in place no matter the movement of the adjoining body. They defied nature, and they were glorious.

The couple had requested I bring toys to our appointment. Even this was a source of shame, because the only toy I owned was a silver bullet vibrator, a sleek midsize beast that didn't really do

much for me at all. In fact, up until this point in my life, pleasure from masturbation had somehow eluded me. The only reason I had the vibrator in the first place was because some guy two years older than me in high school had resolved to solve my masturbatory quandary by purchasing the thing out of "genuine concern." At last, the toy had come in handy.

I feebly used the bullet on m'lady and she lay back with pleasure. I did my best, reverent of her pussy as a giver of life, a mother's lips so sweet.

"You're so good at that!" she moaned, and I welled up with pride like a teacher's pet. "He doesn't know," she whispered, "just how much I like women. He has no idea," and soon we were rolling around, kissing with our fingers in each other's orifices.

Big Daddy appeared at the foot of the bed.

"You girls having fun?" he asked. "Look how beautiful you two look."

He kissed his wife and lay down on the king-size bed, folding prophylactic film over phallus. I was instructed to get on top. Wifey played with the vibrator and watched.

"Wow," he said as I hopped up and down. "You look like a movie star."

A sensation of validation washed over my body—and I grinned, giddy as could be, feeling as if this man could smell and taste and see me for me, along with everything I wanted outside of this whore game. I almost came right then and there. By golly, he saw me.

Years later, no longer an escort but still dealing with the consequences of internalized whorephobia, I participated in a rigorous yoga teacher's training program. When I was granted a spiritual name, Anandi, which means "bestower of pleasure," that same sensation washed over me, replacing inherited shame with the distinct feeling of being *seen*. They

saw me for me, the same way this man saw me. What a thrill it is to be seen.

As the famous man fucked us both with love and kindness—especially his wife—I could feel their passion for each other.

"Why have fun with others when we can have fun together?" he said.

The cottage country sun had set. The movie star made me a sandwich, offered a $100 tip on top of the already high price for the out-of-town call, and walked me to Trina's suv door for an exchange of pleasantries.

Just another relaxing Muskoka afternoon.

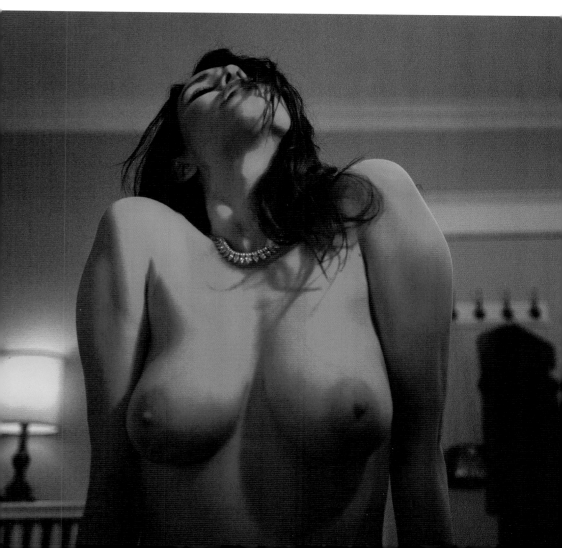

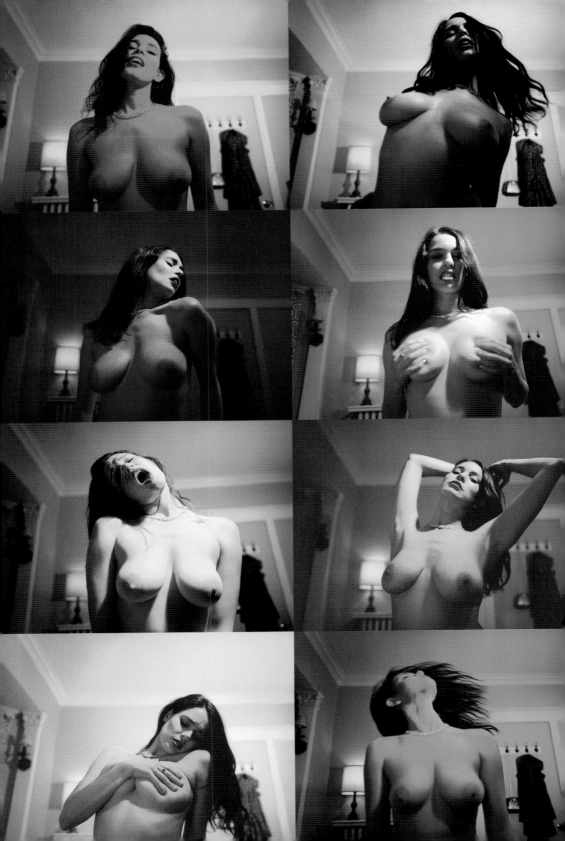

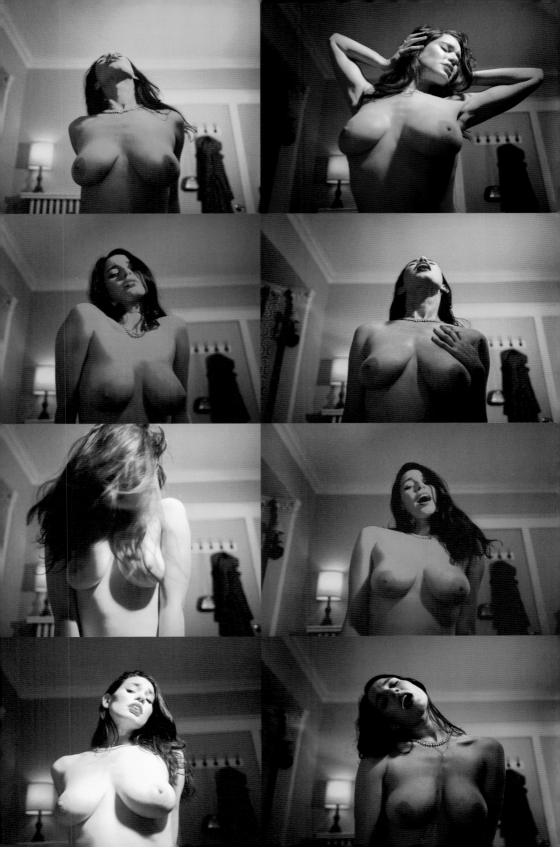

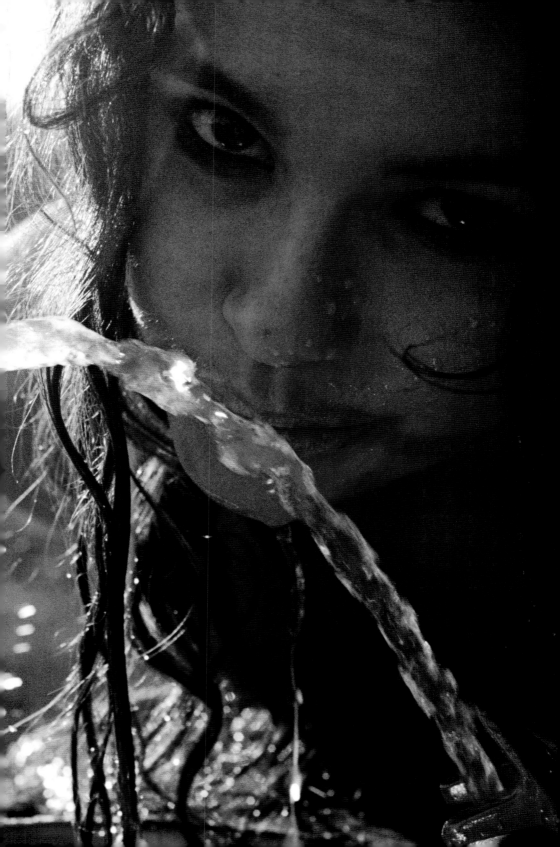

Mr. D

I had just finished running my eighth-grade regional cross-country meet, and I was standing at the top of the stands with my hands on my knees trying to get my breath back. At the bottom of the bleachers was the popular teacher Mr. D, waving a bottle of water at me, as if to say, *You want a drink?* I shrugged a *sure*, and headed down to get some of what he was offering. We agreed to waterfall. Mr. D held the bottle above my head and poured the water into my mouth, but soon the water fell upon my breasts. I ducked out of the stream. He'd made a mistake.

"Let's try this again," I said.

Up the bottle went, down the water flowed, from my mouth and onto my breasts once more.

"What are you trying to do?" I asked. "Wet my shirt?"

He grinned and exclaimed, "*Yeah!*"

In passing, I told my before-and-after-school-program teachers what had happened at the track meet. They told the principal. The principal suspended Mr. D for the rest of the year. The students blamed me and said, "You're the girl who got Mr. D suspended." It was my fault.

Years later, I finally understood that it wasn't me who got Mr. D suspended. It was Mr. D who got himself suspended.

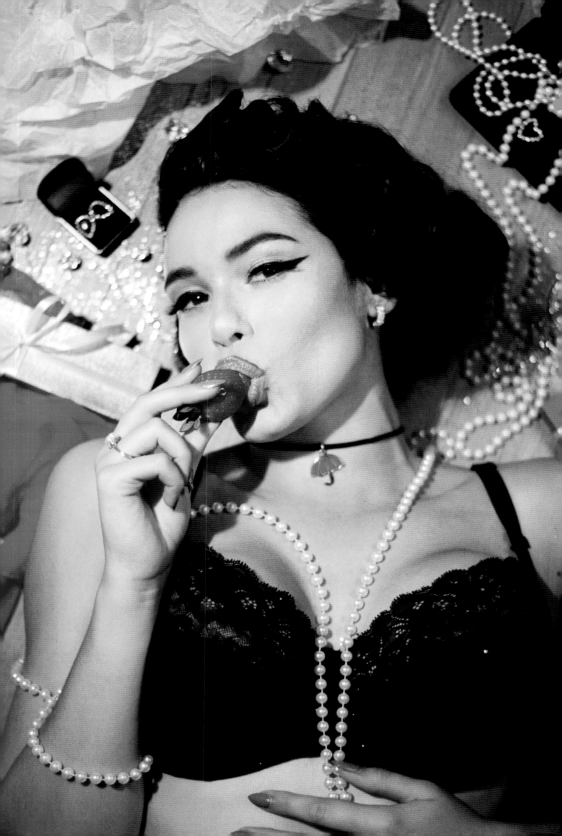

GIFTS

Feeling particularly free-spirited one fine summer day, I deviated from my usual femmed-up whore's uniform for a wife-beater, tattered jean shorts, combat boots, and a bandana in my hair. I was going out before and after work, so I figured I'd take a chance and look a little more like myself. Hot rebel slut *is* the look.

When I approached my client's hotel room, the door was open, a note balanced on the knob: "Be back shortly, Mary Ann! Help yourself to fresh strawberries! – Charlie." What a treat! Inside I beheld the large carton of freshly washed berries, along with a cornucopia of other fruits, cheeses, and nuts strewn about the room. I indulged in the bounty and hoped with all hope that this wasn't part of some elaborate plot to rape and murder a sex worker. *Please, just let me eat the cheese first*. I was pleasantly surprised when the tall, scrawny, and definitely-not-a-rapist-murderer Charlie appeared, his orange skin tanned from fifty or so years in the sun, his boyish smile as wide as the countryside.

He flattered me relentlessly and I, in turn, giggled and glowed like a schoolgirl basking in the centre of his attention. He explained his situation: Charlie's high school sweetheart and wife of decades had been diagnosed with a life-threatening disease, and the treatments had wreaked havoc on her libido. His lusty needs, however, were alive and well; so he'd asked her permission to see a sexual professional, and after much discussion she'd agreed. Before me, he'd seen no more than one other escort—making me the third person he'd ever had sex with in his life. Charlie was the only client I knew who not only spoke openly with his wife about seeing escorts, but had asked for her blessing. I was proud of his courage and his honesty.

Charlie's excitement was akin to a teenager's on a first date. Sex with this sensitive, appreciative lover was interspersed with breaks for conversation, including topics as down-home as building geodesic domes, living off the land, and tips for cultivating the perfect herb garden. I didn't normally tell clients I had a boyfriend—what with it killing the illusion of a girlfriend experience and all—let alone details about his life, but I told Charlie that my partner in crime was an organic farmer and that maybe, one day, I would work with him on the farm. Charlie's enthusiasm hit fever pitch and a torrent of questions and suggestions followed. Several times during sex he got so caught up by a fleeting agricultural idea that he lost his boner.

After many restarts, the deed was finally done, and Charlie pulled out three big bags of Ontario-grown nuts in different flavours. He asked me to take two. He also gave me a giant carton of strawberries, which was the best tip I'd ever received. He asked for my number to contact me directly, and without hesitation, I gave it to him. He was such a nice guy that I was willing to take the risk.

The next time I saw him, there were lavish gifts. A bottle of absinthe—listed as my drink of choice on the agency website— and a silk blouse. As far as gifts I'd received from past clients went: booze, aplenty; clothing, never. His kindness was impressive. He'd never had absinthe before so I fixed him my own ramshackle version of the drink, a simple half and half with water—no sugar

cube or fancy spoon. He was hesitant, but sipped it nonetheless. I must have chugged four cups down, the luxury of this rare, expensive drink too exciting to resist.

We stood on his hotel balcony overlooking Yonge-Dundas Square, and he asked about my aspirations in life. I told him that when I was an ambitious twelve-year-old, the thing I'd wanted to be most of all was the Prime Minister of Canada. I'd even popped my loonie into the Speakers' Corner booth when it still existed at Queen and John, and declared my NDP mandate to the world. Charlie was floored. Excitedly, he said, "You can still do it, Mary Ann! It's never too late," encouraging me to start with municipal politics. These were the days of Rob Ford, so it felt like anything was possible. If a crack-smoking, social program-cutting, bumbling ignoramus could be the mayor of the country's largest city, then maybe a former escort could become the Prime Minister of Canada. It no longer felt outside the realm of possibility.

Charlie, it turned out, had himself been involved in municipal politics, so he knew what he was talking about. I found him inspiring. We went out for dinner that night and I ate a humongous steak. He paid handsomely for my company, and I couldn't have been happier.

After I quit the industry, I was occasionally greeted with an out-of-the-blue inspirational text message from Charlie: *Never forget that 12-year-old girl who wanted to be Prime Minister, Mary Ann. Don't let go of your dreams and remember that anything is possible.*

Charlie was one of the kindest people I'd ever met, inside or outside of sex work, and he showed me that johns could be incredible humans capable of giving the greatest gift of all: treating sex workers—and their dreams—with the love, respect, and dignity they deserve.

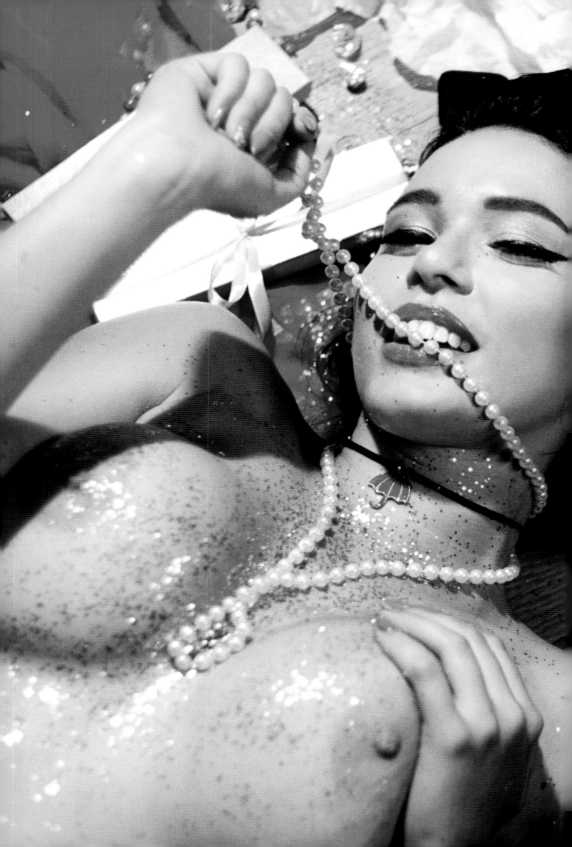

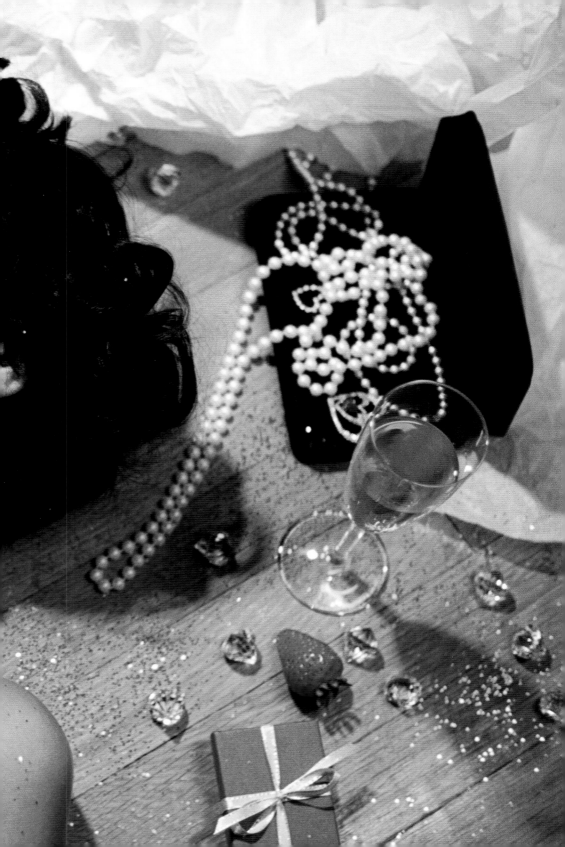

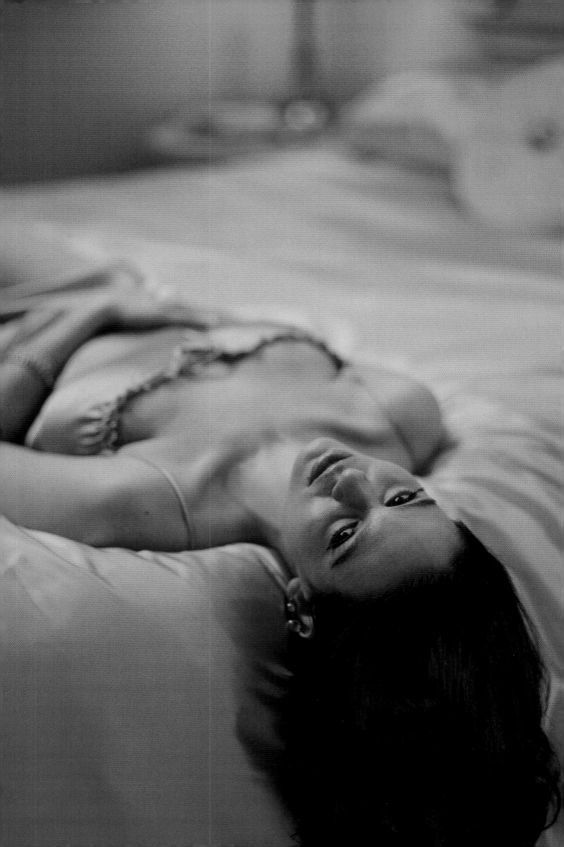

Health

An escort's health is her most valuable asset. Keep your money-maker in tip-top condition with constant vaginal lubrication. Make note of any suspicious activity in your pussy, such as excessive discharge, swelling, strange odours, irritation, bumps, sores, redness, or anything else that strikes you as different from the norm. Develop a deep relationship with your family doctor or the nurses at your local public health clinic, and if it is safe to do so, tell them you're a sex worker. They (likely) won't judge—they've heard, seen, and smelled it all. I suggest getting tested for STIs at least once a month as a precaution, as it is possible to catch something nefarious without exhibiting symptoms.

Though condom use is standard in vaginal and anal sex, many infections are transferred by mouth. If your client has gonorrhea and you suck his dick without a condom, kiss him, and he eats your pussy, that gonorrhea can pass to your mouth or your vagina. Some sex workers avoid this scenario by only offering CBJ, a "covered" blow job. Bear in mind that most clients prefer oral sex without prophylactics, so you may experience pushback. Remind any boundary-pushers that it is your body, your rules, and your safety. As an escort it is imperative that you are always comfortable. Do you.

As with any other job, don't show up if you're feeling under the weather. Your work is sex—full-contact, fluid-swapping, body-smashing sex. Use common sense! Regardless of health, it's important to take time off for yourself. Sex work is emotionally taxing and physically draining. You're constantly putting other people's needs above your own, so you need to schedule me time. Take a night off and relax. Remind yourself who you are and why you love yourself. You're a special person. Treat yourself!

STONE-COLD DADDY

At an upscale hotel, D-A-D-D-Y stickers lined the top of a laptop screen. Javier was handsome, intelligent, and built like a baseball player. A great client for my last week of work. I looked forward to the sex, which set me up for disappointment beyond comprehension.

The sex was unbelievably rough. Afterwards, I planned to run out of his hotel room without a word when he stopped me with a cheerful request to meet again. Numb and in shock, I offered him my escort email. He sent me holiday messages and alerted me of his occasional presence in Toronto long after I retired.

One evening, I received yet another perky email from him. As I silently wept, I decided to respond by telling him how that night made me feel.

Hi Javier,
I think it's important for me to tell you this. When I saw you in November, I felt we had a great rapport during our conversation. I thought you were smart, well-spoken, and open to new ideas. You were an ideal client. And then we had sex and it was terrifying.

You scared the shit out of me. I thought you were going to rape me. You put your full weight on my body, looked me dead in the eyes without any words, and continued, despite my protestations, to rub your cock dangerously close to the inside of my vagina without a condom. Seeing as you were not listening to my requests for a condom, I started to grow limp and disinterested in pretending I was having a good time. I tried faking it with you for a while, to go through the motions, to get the appointment over with, and you seemed to be either completely deranged (the constant, unblinking eye contact; never verbally responding to my condom concerns; the full weight of your body on mine that rendered me fully pinned to the bed) or you were completely unaware of how you were making me feel.

I remember thinking while you were on top of me, having not put on the condom as I'd asked, though you eventually did, "Is this it? One week before I quit and I get raped?" I thought you'd pulled one on me, that this was your MO: lift a whore's expectations with great conversation, and crush her with really weird sex. I left the bathroom anticipating to just leave the hotel room without any words, and then, you spoke, and you were chipper as fuck. You wanted to keep in touch. You've kept in touch and it is very strange for me to receive your emails.

I don't know anything about you, but I do know the sex we had felt like a violation of my body. I do not want to meet with you again. Also know that I hold no ill-will against you. Despite how I felt about the situation breaching rape, you absolutely did not rape me. I hope you'll consider the way you make other escorts feel in the future and take their well-being into consideration when paying them for sex.

Sincerely,

Mary Ann.

You'll notice I made sure not to call what happened rape. For reasons I do not understand, I did this to comfort him. But whether it was rape or just disturbing, semi-consensual sex, the event permanently scarred me. He never responded to my email.

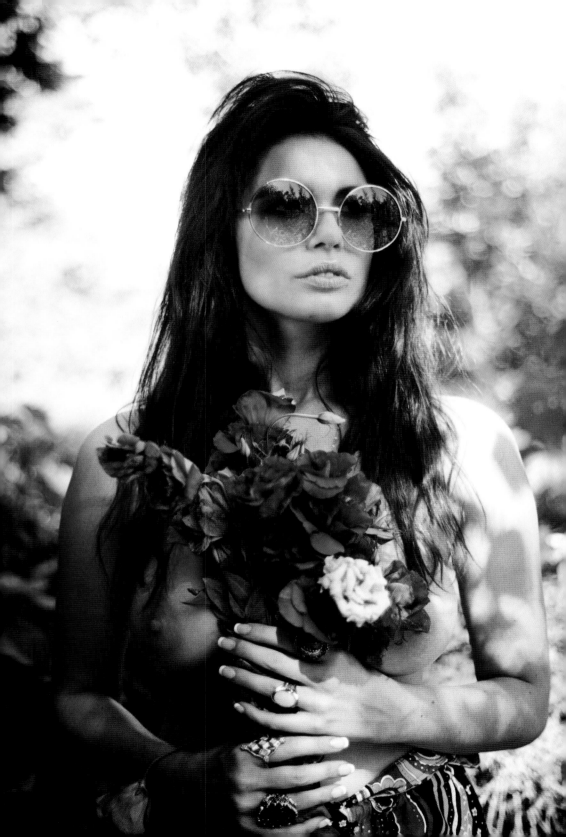

Our Girl Violet

Once upon a time, in a land both near and far away, Pappa Zooks the Father God sat upon his heavenly perch, about to engage in his favourite pastime: raping mortal pussy. Pappa was a king who loved playing dress-up. With a sniff, a huff, and a sashay in the mirror, Zooks flew from his perch into the unseasonably warm spring night, excited to exploit yet another earth-woman's flesh. Earth girls are easy, as they say, and he was God, after all—capital G-o-d, God—so everything, and everyone, was ripe for the rapin'.

He spotted his prey at a campus bar, laughing and drinking with her friends, too pretty to be smart, too dumb to put up a strong defence. With his carefully curated disguise—a tall, dark, and handsome physique; varsity cardigan, bootcut jeans, and sneaks—Pappa Zooks was ready to rape.

The girl at the bar was easygoing, already drunk, and happy to talk to strangers. He scooched up beside her, and amiably chatted about the upcoming midterm and Professor Whozzit's boring lectures. With her back turned, he sprinkled angel dust into her pint, then watched her drink and slur and hobble out back to an alley where he had his way with her.

She woke up alone next to a dumpster, her panties at her ankles, semen on her flesh, blood in her mouth, and garbage in her hair.

And this is how our girl Violet was conceived.

Violet's mother never said a word about the rape, nor a word about the pregnancy, hiding her haunches under oversized sweats and soldiering through the school year as if nothing had happened. What else could she do? She hid her sickness, her sadness, her shame, and her truth, like any good woman would, to protect the ones around her from the pain she'd endured. The mother deep in grief gave birth on a bed of death, and before she bled out, these words to her infant daughter she said:

> *Violet the violated,*
> *Baby of my shame,*
> *Though I let you go,*
> *I'm not the one to blame.*
> *Your father is a monster,*
> *This fate you can't escape,*
> *If you truly are my daughter,*
> *Then you will avenge my rape.*

As mother took her final breath, Pappa Zooks—the unholy king of heaven, spying gleefully from his perch—swooped down and wrested the swaddled newborn from her arms, flying home to Paradise with his newest half-breed bundle of indentured bliss.

As the king pimp of Paradise, heaven's largest brothel, Pappa Zooks was always scouting new demi-goddess talent to add to his roster of temple whores. The gods were lusty beasts after all, and an

hour with one of Pappa's half-breed daughters was a sure way to remain in the Father God's favour *and* fill his heavenly coffers.

Soon as Violet could walk, she swept. Soon as Violet grew breasts, she whored.

One day, Prince Promantheus, Pappa Zooks's one and only begotten son, came to visit his father in Paradise. Proman, as he preferred to be called, was a strapping young demi-god with nary a hair on his boyish face, whose latest sojourn to the human realm had him crucified on his father's behalf. Life for the son of God was birth on earth, followed by a violent death, concluded by a return to Paradise and a semi-joyous reunion with his father. Inevitably, Proman would reach his threshold for tolerating the tyrant, and he'd long to return to earth, born to a new flesh prison, ready to be forsaken by Zooks once more. His was a cursed cycle, but there were perks to being the son of the most powerful God in heaven.

"My boy," Zooks said. "My boy! Pick any whore you'd like— my treat!"

Innumerable women, of various ages in various stages of undress, were leaning, lounging, and talking, or kissing just as many horny gods, leading them to bedrooms for some good ol' fashion Father God worship. The prince's eyes fell upon a woman in purple silks, sweeping the floor.

"Violet," Zooks whispered in his son's ear, standing a little too close behind him. "You want her? She's a filthy animal, that one. Just wild. C'mon, give her a shot."

She's the most beautiful girl in heaven, Proman thought, clutching the breast pocket of his jacket. His heart shook.

"C'mon son," Zooks implored. "Have your way with her. You don't need to ask. Nothing is sweeter than the taste of a man's first rape."

"No, Dad," the prince said, his eyes locked on Violet. "You know I don't do that."

"Hey now, make your old man proud!" Zooks laughed, pushing his son in the whore's direction. "Room number six," he called after him.

Thus prodded, Prince Promantheus approached the back of the silk-shrouded sweeper, tapped her on the shoulder and offered a sheepish "Hello."

"*Oh my Zooks!*" Violet yelped, dropping her broom and kicking her dust pile across the marble floor.

"Let me help you with that," Promantheus offered. He picked up the broom and began sweeping for her, as she stood in disbelief—as did Zooks, who watched from afar and did not approve of this pandering performance.

"Really, you don't have to do that," she protested, though flattered.

"No, it was my fault. I shouldn't have come upon you from behind like that," he said, the dust pile now neatly intact.

"You wouldn't be the first," she smiled.

"I'm Prince Promantheus," he said, jutting out his hand, "But you can call me Proman. Your name is Violet, right?"

"Yes," she said, and then it dawned on her: "Wait," she lowered her voice, "Are you Zooks's son?"

The prince turned 'round to Pappa, who offered a supportive thumbs-up. Proman kept his voice low, too.

"Yes, I'm the son of Zooks. He wants me to take you to room number six—but really, we don't have to do anything. We just gotta keep up appearances and he won't know the difference."

Violet laughed.

"You're a joker," she said, taking his hand. "Let's go."

Inside the room, Violet began to disrobe.

"You don't have to do that," the prince implored. "Can we talk? I'm sorry," he said, "I just—I'd like to get to know you."

"Well," she smiled, sitting beside him on the bed. "That's a first. Of course we can talk. What would you like to talk about, my lord?"

"I don't know," he said. "Okay, here's one: what do you do in your spare time?"

"Spare . . . time?" she asked. "What's that?"

"I mean, what do you do when you're not doing *this*?"

"Proman, with all due respect: this is what I do. I don't really have a choice. I don't get to leave or go on adventures like you. There's nowhere for me to go. But," Violet perked up, "sometimes when I'm alone, between 'worshipping' the gods, I like to take baths. That's the only time I feel relaxed."

"Yes, baths are nice, aren't they?" Promantheus replied, nervously. "I'm sorry, Violet. I hope I didn't make you upset."

"No, it's okay," she smiled. "I like you. You're sweet. Thank you for asking. Oh!" she suddenly remembered, "I also like to read and write poetry. When we weren't 'worshipping,' the god of libraries taught me how to appreciate the nuance of language. I'm so grateful for his patronage."

"That's wonderful!" Proman exclaimed. "I write too," he said, pulling a pen and notepad from his breast pocket. "I've lived so many lives, and yet, it's as if I am always writing the same story—forsaken by my father." He paused. "But I'd love to read your work some time!"

"Oh, I'm too shy for that," Violet beamed bashfully. "But I'm not too shy to ask you for a kiss."

Promantheus smiled. A kiss couldn't hurt. He leaned in for a peck. Her lips were like magnets, and as theirs touched, mouths melded together. Violet swung her arms around him, pulling him in closer. Clearly, she wanted more than a kiss. Proman was in no position to resist.

In room number six, Violet and the prince made love in a dimension unbeknownst to either. In the throes of their third round, straddling his body and moaning with delight, something changed in Violet—her body froze, her eyes bulged from their sockets, and as if she were a blind seer possessed, she calmly spoke these words:

> *The King must die,*
> *We all know why.*
> *Though it may seem profane—*
> *A Queen must reign.*

And then she fainted.

"Violet!" cried the prince. He laid her body on the bed and paced the room, his heart heavy, his mind a blur. "Violet!" he repeated, reaching for the pen and notepad in his jacket. He scribbled down her words and once more uttered her name, kissing her forehead. To this, she awoke and smiled.

"Mmm," she moaned, "that was the most intense orgasm I've ever had."

"Violet—what you said . . ." Promantheus trembled.

"What I said? When?" she replied.

The prince recited Violet's words.

"No, I would never say that," she said. "You must be mistaken. Zooks might be flawed but he's still a good god. He doesn't deserve to die. He loves us. Doesn't he?"

"Violet," the prince said, "not all gods are good. A good god wouldn't rape as he pleased, or keep you tethered here like a sex slave. Listen, I'm his only son—and even I think what you said is true."

"No," Violet said through her tears. Promantheus gave her his pen and notepad. "Here, if it happens again, maybe you'll be able to remember and write it down." The pen was ornate—silver and sharp, it featured two snakes that wound their way from the bottom and gazed at each other at the top. She reluctantly accepted his gift.

The next evening, after a long day of fucking gods and sweeping floors, Violet relaxed in her candlelit bath and thought about her time with the prince. She touched herself as the memory came over her in waves, her pleasure intensifying, as if he were there with her, touching her too. Soon, her body froze, her eyes bulged from their sockets, and as if she were a blind seer possessed, she calmly spoke these words:

> *The King must die.*
> *Time to glorify*
> *The Whore without stain—*
> *A Queen must reign.*

The incantation resonated both inside and outside of herself, and this time she heard. She rushed out of the bath to write the words in the prince's notebook. The next morning, performing her daily chores under the watchful eye of Pappa Zooks, she spotted Promantheus talking casually to the god of coffee shops.

"Psst!" she said, motioning the prince over. "It happened again."

Zooks watched the two huddling together like school children and grew suspicious. It was obvious—*He didn't rape her*, thought Zooks, feeling the sting of betrayal.

"*Violet!*" the Father God reprimanded from across the room. The whore's smile quickly turned to terror as he rushed into room number six. On her bed lay the notebook.

"No!" she yelped, running towards the room. She froze in the doorway, watching Zooks read the words on the page. When Zooks turned around, Promantheus was standing there beside her.

"What is this?" Pappa Zooks asked.

"She's an oracle," said the prince.

"Is that so?" Pappa calmly replied, walking slowly towards the pair. "And how does this so-called oracle tell the future?"

Violet looked at the prince with fear and hope.

"Orgasm," he said. "When Violet is pleasured, she can predict the future. But you won't hear her prophecies by raping her, Zooks. You have forsaken me for the last time and I won't let you forsake—"

"Is that so," Pappa Zooks repeated, shoving his son aside, locking the door, grabbing the whore by the hair, and throwing her on the bed.

"Is that how you like to play, you little slut," he said, ripping her dress from the bottom up and forcing himself on her. He pounded her with anger, mad with jealousy that his one and only begotten son had triggered this orgasmic prophetess before he did.

"Tell me the future," he said, "you pathetic slave."

"I cannot, I will not," she replied, "for I am quite brave."

She endured the rape like her mother before her, like all the mothers of all the whores in heaven. She wondered why she had ever defended him. She felt as if she'd betrayed herself.

"Tell me the future," he said, "you ugly bitch."

"I cannot, I will not," she replied, "I won't say a stitch."

Her resolve strengthened as his brutality worsened. *The King must die*, she repeated in her mind, out of her body now, searching the room for an escape.

"Tell me the future," he said, "you worthless whore."

"I cannot, I will not," she replied, "but ask me once more."

"Tell me, Violet, you vile harlot!"

The whore reached for the silver pen on the nightstand, and with a thrust of her fist, she bellowed: "Say hello to my mother!"

And Violet stabbed the king over and over, in his eyes, his heart, his dick, the blood gushing like a fountain all over her holy body. Just then, the prince forced open the door, pulling the royal prophetess from beneath the rapist God the Father.

"No more rape," Violet muttered, shaking.

"No more rape," Promantheus replied.

And the prince and our girl Violet fled Paradise as the new king and queen of heaven, free from the tyrant rapist Father God, where they reigned without stain, happily ever after. ♥

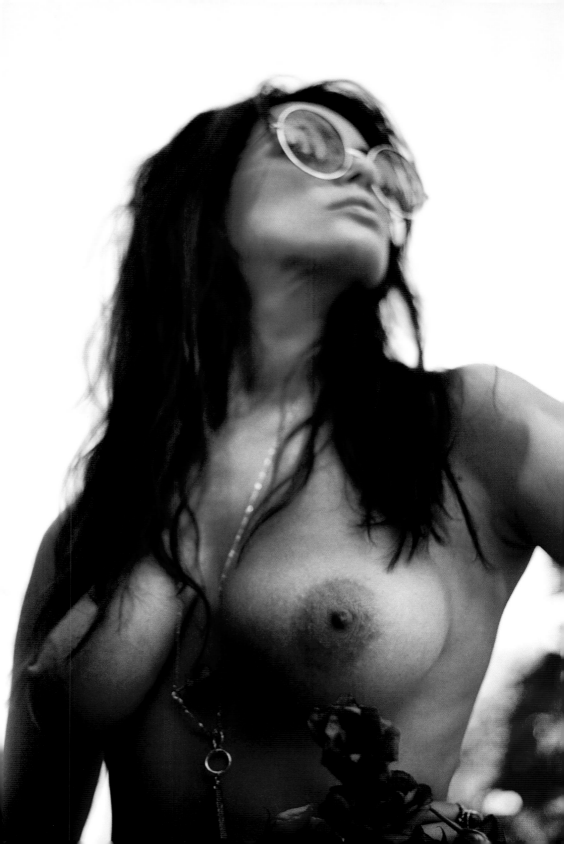

I'M A LONELY MAN, MARY ANN

"Yes, Daddy. I am *such* a whore."

Perched on my knees, I begged the paternal authority figure—with his sweaty, furrowed brow and twitching, pained smile—for approval.

In the afterglow of our union, my client revealed that he was a high school teacher, and a writer in his spare time. I was a writer, too, I told him, opening up a relationship beyond the daddy-daughter dynamic. His teacher persona emerged while I sucked his cock or rubbed his manhood between my breasts: "I like that, Mary Ann, that's very good, I really like it when you do that, Mary Ann." He became a regular: quick sex off the top, ejaculation, then forty-five minutes of arms-wrapped-around-each-other storytelling and critiquing. We picked at each other's structures, plots, and characters, as money, fluids, and ideas were exchanged in the sex worker's creative writing workshop.

Occasionally he blurted, "I'm a lonely man, Mary Ann." Which, over time, became "I feel like you're my girlfriend, Mary Ann." And I would smile and say, "Yes, I am *like* your girlfriend."

On our last night together before I left the agency, we discussed my plans outside of sex work.

"It'll be hard for you," he said, "to date. You know, having worked in this industry."

I asked him why. He spoke slowly, from the moral high ground of a john in the arms of a whore.

"Well, a lot of people don't have respect for . . ." And here, like many of my clients, he stammered as he searched for the right word. Clients *hate* the word *prostitute*. It sounds filthy, derelict, and inherently lower-class. But "e-e-e-escort," as he'd twitchingly put it, is *much* more tasteful. More *high-class*. How my eyes rolled, though I see it—there are distinctions and classes that separate the sex workers of the world.

I'm *high-class*—I'm unseen, I'm your daughter, I'm your friendly, funny goofball of a pal, I'm your happy-go-lucky free spirit, spreading joy across the land and fucking men for money because I like it—I'm *high-class*. But even I, he gauged, as *high-class* as I am, would find it difficult to find a man to love me considering my "past."

Men are too jealous, he said. Men don't respect women like me, he said. I thought: *Men don't respect women, period. They don't respect a woman who's taken life by the tits and lived according to her own wishes, for the sake of learning more about herself. No, men don't like a self-realized woman, a woman who doesn't need a man but may come to him of her own volition, when she feels genuine love and warmth—a woman who will not stay out of duty, or loyalty to a tyrant or an unrealized ideal, a woman who will not settle because she is afraid of getting older or of being alone. No, men don't respect women who operate outside of what a woman can do for them.*

"I never told you this," I said, "but I have a boyfriend."

His eyes widened, his mouth hung open.

"You do?"

"Yes," I said, "and he loves me wholly and completely. He knows about this job, and he sees it for what it is: a job. He can't be the only person in this world capable of loving a whore."

We both watched the "you're like my girlfriend" status disappear, *poof*.

"Well," he said. "He must not be a very jealous person. G-g-g-good for him."

The driver rang. Time was up. One last hug for the lonely man.

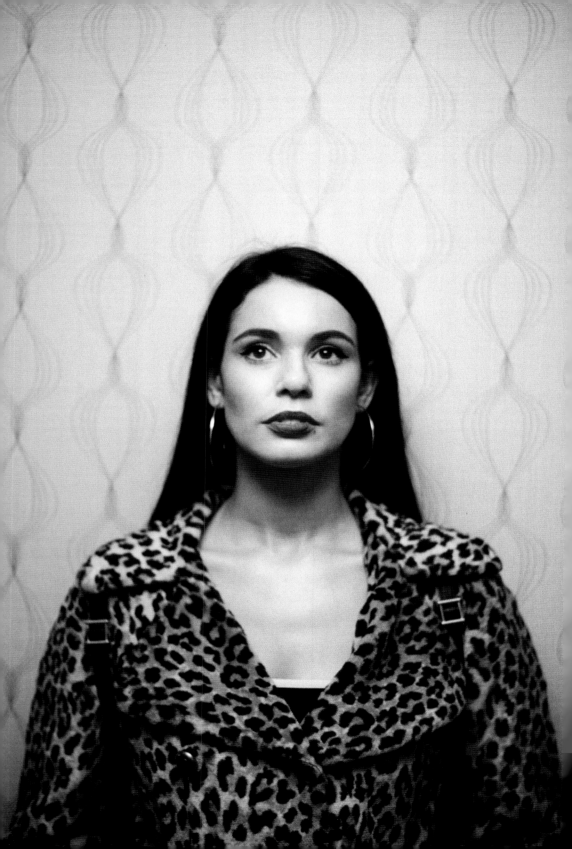

Closing Time

The perks of escorting are great: the financial independence and freedom of time and movement grant the sex worker a unique opportunity to work towards their own goals. The trade-off? The mental, emotional, and physical toll of sexual labour and the social stigma. If you're on the fence about becoming an agency escort, ask yourself the following questions:

- Am I willing to tell or lie to my closest friends and family about my work?
- Am I willing to tell or lie to my partner or prospective partners about my work?
- Am I willing to talk to law enforcement if I am abused on the job?
- Am I ready to accept that sex work comes with mental, emotional, and physical risks made all the worse by social stigma?
- Do I have an exit strategy and/or a monetary goal to work towards?
- How do I feel about being branded a whore for the rest of my life?

The choice to enter sex work is not to be taken lightly. It *will* change your life, for better or worse. The major risk of escorting is not rape or murder—though, while rare, they are definitely risks—but isolation and fear as a result of stigmatization.

Sex workers and allies around the world fight every day to destigmatize and decriminalize sex work—to make it a safer, more acceptable job for people who enjoy their independence, freedom of time, and financial liberation. No matter what happens to you, remember this: you are not a bad person for being or having been a sex worker. As we raise our voices together, sex workers will be heard, we will be understood, and we will be loved.

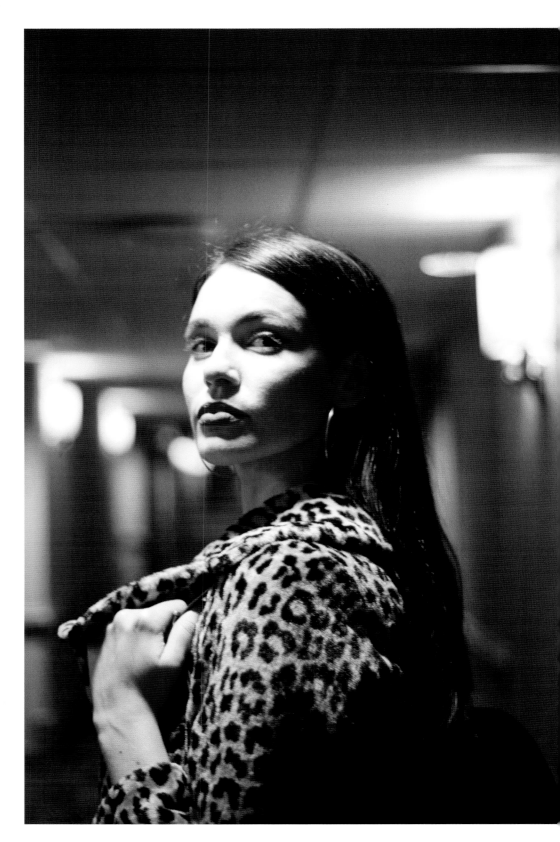

A WHORE'S
LAST WORDS

Oh, the horrendous things I'd heard about working on an organic farm. The long hours of back-breaking labour in the rain, shine, snow, and vomit-inducing heat. The paltry monthly stipend well below the poverty line. The desperate isolation of the country, with no markers of civilization—cafés, bars, restaurants, theatres, strip clubs—within reasonable walking distance. And guess what? It's all *true*!

And it was everything I wanted.

When my whoring days were done—that is, when my contractually-obliged exit date arrived as per the agreement I signed with my mother— I continued to work my "daylight" receptionist gig at the comedy school. Depressed, my suffocating schedule was set in stone for the month and my hourly wage was a slimmed-down double digit. I should have been happy: *I'm normal now! I'm a wage slave, I can barely make rent, I have no free time, I'm normal!* Being miserable is so much more acceptable than fucking men for money. I was both free and shackled.

I wanted to escape the city. I wanted to work hard. I wanted to "pay back" my farmer boyfriend for his two years of loyal, unshameable love. And most of all, I wanted to be myself again. The fear of judgement does such damage to one's sense of self, and I needed time to heal. Alone.

In Greek mythology, Persephone's rape-kidnapping into the underworld and eventual

return is the creation story for the cycle of the seasons. In the wonder of summer, the virgin daughter of Demeter, goddess of agriculture, plucks a flower—a narcissus—from the earth. Hades spies the beauty and steals her away to the underworld, where he rapes the girl and makes her his queen. Autumn sees the mother's mourning for her missing daughter, and winter feels Demeter's wrath—her refusal to allow any growth until Persephone is returned. Spring marks Persephone's re-emergence, the happy reunion of mother and daughter, and the promise of regrowth on a barren earth.

The story is familiar, immemorial and entirely relatable to me today. At the beginning of my journey, I saw in myself a sexy seed, one that rumbled, sprouted, and bloomed at the sight of beautiful, naked, dancing women. The moment I plucked the flower—a Marygold in my case—and placed it to glow between my breasts, was the moment I stood outside the door of my first client, awaiting the ravishment of my whore virginity.

The flower glimmered, but the bloom—yanked from its roots and hidden in darkness—could not survive. The perennial Marygold must die, and so did I: Mary Ann the whore lived, died, and was born again in the fertile fields of St. Agatha, Ontario, where I worked happily for two years following my escort career.

At the farm, I observed the cycle of life first-hand. Seeds in the greenhouse became transplanted sprouts—weeded and watered and protected at all costs. Healthy and ripe, our bounty was harvested at full potential and shared at market and with our community members. Dirt between my fingers, starlings singing every morning, the freshest, tastiest food: I felt closer to myself, and further away from the demons that told me I was nothing but a whore. Off the clock, I howled at the moon, I stared into campfires, I let my imagination, newly expanded and as wide as the sky, run wild. I am forever grateful for the lessons I gleaned from working the land.

In October 2016, I prepared to publicly come out as a former sex worker.

I'd met Nicole a few years prior on the set of a music video and we became fast friends. Conversations about my escorting career became impassioned artistic brainstorms—we knew we wanted to collaborate, but how? I was still in the closet. In 2014, Nicole came to visit me at the farm, camera in hand. We imagined a project that respected my desire to tell my story as well as my need for anonymity—a graphic novel, perhaps; a monthly magazine could work; or maybe even a serialized comic strip. We eventually settled on this hybrid of memoir, photography, fiction, and fairy tale. The unconventional form played to our multitude of strengths, and both of us liked a challenge. Neither of us had made a book before.

For the longest time, I didn't feel comfortable being publicly upfront about my sex work experience, and as we were working on the book, that didn't change. Nicole and I agreed it'd be better for the *Modern Whore* mystique if I played coy about whether or not I'd actually been a sex worker. I could lean on my writerly status and call the genre "creative non-memoir"—an alternative life story with my name on it.

The first piece I read in front of an audience was "Go Leafs Go!" at the Bed Post Sex Show, a super sex-positive and sex worker-friendly variety show run by my long-time friend in the comedy community, Erin Pim. The charming little Social Capital Theatre in Toronto's East End, in its dark and dingy glory, was a safe place. Erin's open-minded Bed Post crowd listened to sex workers tell their stories on her stage with warm, supportive acclaim.

In my preamble, hemmed in between shame and a sense that mystery might help my project, I couldn't say the words "This is a true story about an experience I had when I worked as an escort." I could, however, giggle, wink, and say, "Is it true? I don't know, maybe? But how would you know? It's probably true, but probably also not true." Having never told these stories publicly, I felt pre-emptively embarrassed. But when I stopped rambling, took a deep breath, and actually read my story, I could feel the audience supporting me. They were listening, laughing, gasping. The crowd was on my side. They gave me confidence—I didn't need to feel ashamed, not

about being a sex worker, nor about reading my sex work stories in public. There was an audience hungry for stories like mine, ready to love and accept me as my fullest self—and I was eager to share.

Being coy was proving increasingly difficult. The breaking point came at the first Toronto Art Book Fair, in the summer of 2016. Sitting at my publisher's table, pitching our promotional $5 "Modern Whore Centrefold Teaser," the questions came fast:

"Have you ever been a sex worker?"

I'd rather not say . . .

"But you're here to promote a sex work memoir?"

Yes, but it's "creative non-memoir," you see . . .

"So, you're telling the story of a sex worker as if you did it, but you don't actually have any experience in sex work?"

Gulp.

I wasn't interested in being accused of appropriating a marginalized narrative to further my literary career—not when I'd actually been a sex worker for two years. I played coy because coming out posed an immediate threat to any sense of normalcy in my life—the truth would change everything. Without coming out, however, I felt like I couldn't speak with any authority on the subject. I've never been one to cower in fear. Yes, I was afraid of how my life would change, but I was more afraid of the consequences of my silence. If I chose to speak, how many others would follow? If I chose silence, how many would never tell their stories?

I knew then and there that it was unfair to hide behind my privilege and mantle of "respectability"—being white, cisgender, educated and middle-class—for fear of rejection.

I spent the next few months preparing for the repercussions of coming out. I began the process of casually telling more friends, acquaintances, strangers even, that I'd worked as an escort. Every time I did it, it got a little easier. Whether it was at the dive bar or in the dentist's chair, there was always shock, averted eyes, a clearing of the throat, followed by "Was it okay?" I knew most people thought of sex work as a form of misogynist abuse; that fundamentally I had

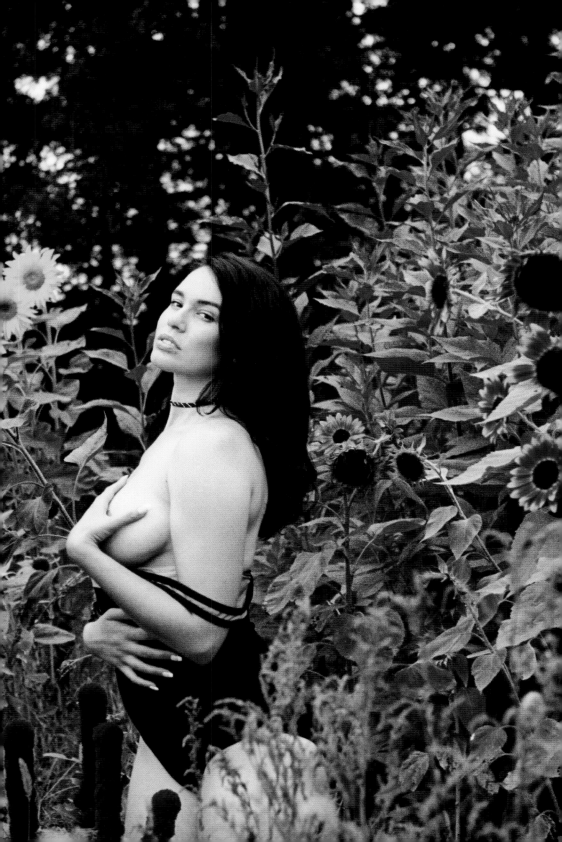

been "damaged" in some way. I watched as friends, acquaintances, and others who knew me reconciled the Andrea they knew—the happy-go-lucky, funny, hard-working, and intelligent little lady—with the stereotype they'd inherited from a few thousand years of prejudice. I don't blame anyone for thinking badly about whores—but I do find those unwilling to change their positions in the face of evidence suspicious. Why hold on to a harmful prejudice that only serves to dehumanize a group of already vulnerable people?

In the fall of 2016, I would be appearing in a CBC documentary called *Sugar Sisters*. I'd decided to be identified in the doc as both an author and a former call girl. In anticipation of the national broadcast, I came out on Facebook.

"For years," I wrote, "I've hidden my sex work past from the people I love. I've cried a lake of tears for fear of people's judgement, for fear of what this could mean for my future, to come out, to say it loud and proud: I have been a whore . . . so there, Internet. I'm officially out! Shame can suck it!"

I signed off as Andrea "Mary Ann" Werhun and the comments rolled in. Though my hands trembled with adrenaline, my heart beat out of my chest, and my face was wet with tears, I felt joyously overwhelmed. I couldn't believe it—everyone, from old elementary school buddies to former co-workers to family friends—they were all so incredibly supportive. My coming out couldn't have gone any better, but I was also about to come out on national television. Let's just say not everyone in my family who unwittingly caught me on TV was happy about my "oversharing."

When it comes to whores, everyone's got an opinion. Do these opinions come from a place of understanding, or from a dark, unexamined corner of the collective psyche—the by-product of a culture that has shamed the body, sexuality, and independence of women for millennia? How many people who hate, dislike, and distrust sex workers have ever spoken to one? Of course, someone they love is probably a sex worker—a sex worker too afraid to come out to them.

Storytelling—that is, telling our *own* stories—has the power to transform ignorance into wisdom, hatred into love. The truth changes people. That's what I call advocacy.

The tired question of empowerment—"Is sex work empowering or disempowering?"—is not a question we ask of workers in other industries. I found my desk job occasionally depressing and unfulfilling, not to mention farm work, where I laboured for dollars a day—could I not call those jobs disempowering? Perhaps all work is disempowering, but that's another story.

Bottom line in a capitalist society with a fragile social safety net: having money—being able to put food on the table, pay the bills, and have enough left over for saving and spending—is empowering. How one gets there, and how one views themselves is entirely relative.

To extol the narrative that "all sex workers are victims" is ignorant, negligent, and for some of us, deadly. A self-fulfilling prophecy. A harmful narrative that necessitates *and* perpetuates victimhood.

Sex work was empowering for me. I enjoyed having the free time to pursue my creative interests, the money to pay my rent, travel, and further my education—I took improv and acting classes; writing and bookbinding workshops; a yoga teacher's training course—because I engaged with clients who literally enriched my life.

After coming out, I could finally, with pride and joy, host book launches for *Modern Whore*. We threw packed parties in Toronto, New York, Montreal, and Vancouver, to hungry and supportive audiences. There is nothing more special to me than performing for sex workers. Their collective gasps and giggles of recognition are forever etched into my heart, and hearing the whores hootin' and a-hollerin' when my words rang true was an honour and a privilege. I'll probably be chasing that high for the rest of my life.

Today, I can no longer imagine my life in the closet, can no longer imagine depriving myself of the opportunity to tell stories that resonate with people deep in their souls. I didn't get into sex

work to write about it—but being told I wasn't supposed to tell my
story made me want to write it even more. Being privileged meant I
could take the risk.

When I was working, telling clients I was a writer excited some,
and scared others. "You won't write about this, will you?" *No*, I'd
think, *you're not interesting enough.*

If I remain silent on behalf of my clients, who speaks for me—
who gets to be the hero?

I am no victim in this story. I am the heroine of my whorish path.

Modern Whore is only one story out of countless heroic tales ripe for
the telling.

I am one deeply fortunate former escort. I've had the love and
support of my partner, my parents, and my close friends to keep me
"intact" on this journey through the sexual underworld. My hope is
that these stories provide some insight into the motivations of both
sex workers and the clients who employ them. As you've read, my
experience has not been overly positive nor overly negative—but,
it's the truth.

When we listen to the stories of people who have lived experi-
ence in the industry, we allow ourselves to understand and relate to
their pain, their shame, and their pride. Stories have the power to
show sex workers and civilians alike that we have a lot more in
common than we think. Stories can help us understand that the high
risk we face for physical abuse, rape, and murder *because of our work* is
a fundamental injustice we must all confront together.

Whether sex work is freely chosen or not, those who engage in it
deserve our respect and kindness. Sex workers' basic human rights
need protection.

I hear that seed splitting, splintering open. Spring is coming on.
Soon the whores will be born again, to bloom in all their rightful,
beautiful, naked, dancing glory—without shame, without danger.
One day, we too will be free.

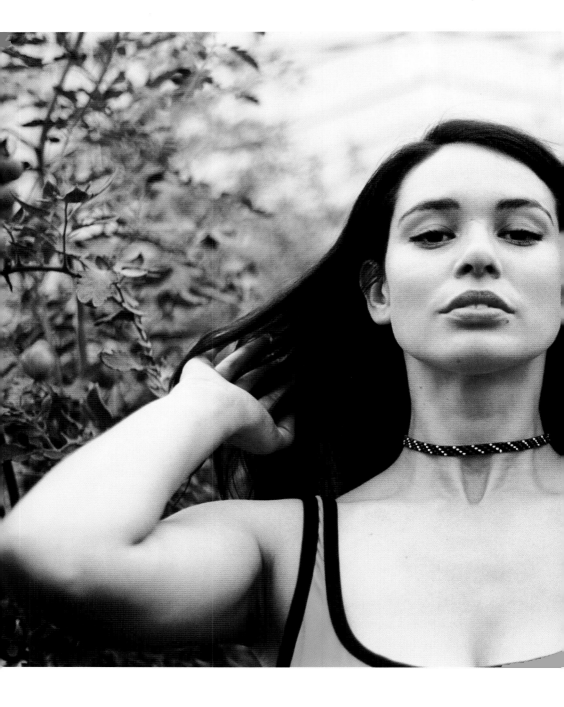

PART

POSTMODERN WHORE

2

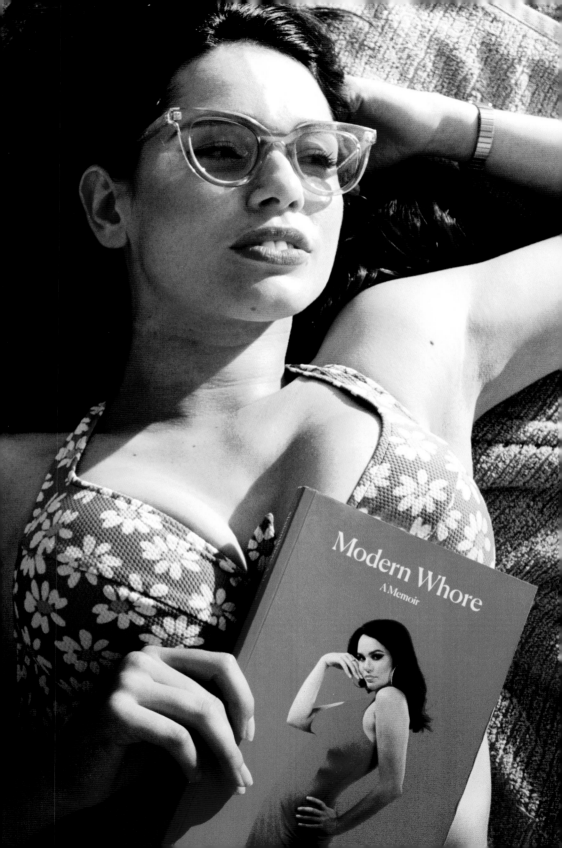

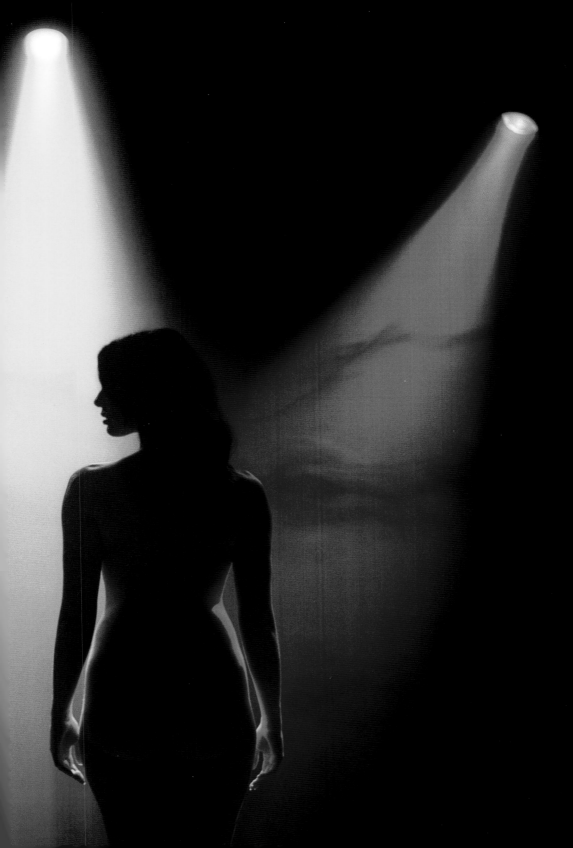

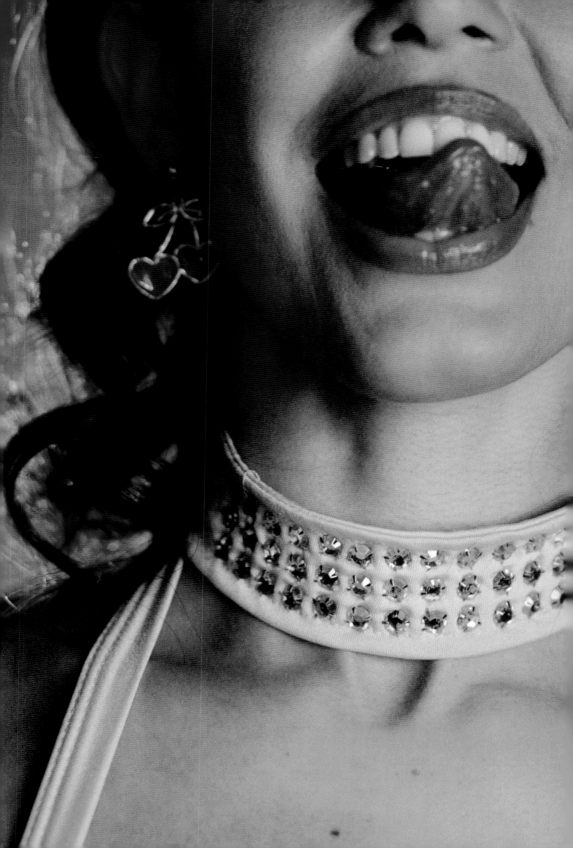

Feeling Lucky

Toronto, 1958. Clarence Joseph Thompson—or "CJ," as his children called him—worked on the Danforth as a waiter. His good wife, Bridie, mother of six and taker of blows, starched his white shirts and pressed his black pants. Every day.

At thirty-four, thirteen years had passed between him and the horrors of the Second World War. Life was for the living. My grandfather, the one-man party. The shell-shocked veteran. Fun and exciting, terrifying and violent.

My mother's earliest memory is from her crib in her parents' bedroom on Allen Avenue: stacks of coins—a waiter's tips—atop her father's dresser. Cash in hand is always easy to spend.

After escorting and two years on the farm, I got a gig as a high school science tutor in the Cree Nation of Eastmain. The first edition of *Modern Whore* hadn't yet come out, and at that point I was still painfully in the closet. I loved teaching, and so I continued to keep my past a secret. Most people don't take too kindly to whores, current or former, teaching children in their schools.

Stigma has a way of maiming the sex worker's maternal instinct. And yet, sex work is often an exercise in mothering. We are ever patient with our clients and their assortment of quirks. We are professionally warm, tender, gentle, and affectionate, all the while maintaining rock-solid boundaries. We are excellent communicators, astute observers of the human condition, and intuitive to boot. It's a shame we're shunned from schools: sex workers make some of the best teachers around.

Upon my return to the south after leaving the teaching gig, I moved back into my mom's house. My finances were shot after farming and tutoring, and back in the city, I felt that strange yearning yet again to be "normal." Having wiggled my way into all sorts of professions with some proficiency, I figured I was up for something steady and respectable—being able to tell people what I did for money would be nice—and ideally, relevant to my interests.

After a rigorous interview process, I landed my first salaried position as an assistant to a TV and film agent. This whore could work the land, this whore could teach the teens, but could this whore work a nine-to-five? Turns out, *no!*

I loved learning the ins and outs of the Toronto film industry. But the pressure was high, and the pay, which evened out as slightly above minimum wage, was so very low. Lunch hours were spent at my desk playing catch-up, as were untold hours of unpaid overtime after work. I resented being told what to do for so little money and was chastised by management for having a "problem with authority." *Who, me?* My (female) bosses, in turn, made me cry for sport and mined my upbringing for clues into my apparently contrarian personality. With disdain and gritted teeth, the owner called me a "victim warrior," which she didn't mean

as a compliment. Imagine what she would have called me if she'd known I'd been a sex worker?

I listened to Patti Smith's *Easter* album every morning to get myself to the office. Patti, my living hero, spoke directly to me, the baby, the black sheep, the whore. *Do you like the world around you?* she asked. *Are you ready to behave?* From the subway station, I trudged along the snow-narrowed sidewalk. Another day of pretending to be a normal woman.

After work, released from the grey crunch of rush hour, I would arrive home, like clockwork, in tears. It did not make sense to work this hard—and suffer this much—for so little money and for someone else's dream. Nightly panic attacks became my reality. Normal, I confirmed in my bones, was code for miserable. Ironically, three months working in an office was more traumatic than the two years I'd spent as an escort. I quit.

How's that for shell-shocked, Grandpa?

Between serving the guests of the Wembley Hotel and impregnating or beating my grandmother, CJ drank, gambled, and womanized. The riskier the game, the better.

CJ was the type of father a child might find smashed, black-eyed, and bloody in the alley beside their house. His two front teeth long socked from his maw, a denture fixed to fill the void—if he remembered to put it in.

When he got roped into a plot to rob a bank with one of his brothers, what gave CJ cold feet? Was the reward not worth the risk? His brother went through with the heist without him.

Perhaps there weren't enough women in prison. CJ enjoyed countless affairs with women of all kinds, fast and loose, prim and proper. He couldn't resist. Were they sex workers? Who knows. When your vices are getting drunk, having sex, and spending money, hookers are never too far away.

One of his favourite haunts was across the street from his mother's house at the Wilton Court Private Hotel on George Street. In its heyday, the building—a wonder of Edwardian classical style—was home to

William Allan, whose name adorns the nearby Allan Gardens. Rumour has it that once it became a hotel, my grandfather lived there with a woman named Iris and her mother, before he met my grandma. And there was only one bed . . .

As the mortgage payments for Allen Avenue piled up, the siren call of wine, women, and song grew ever louder. Life was for the living, for dancing, for laughing, for making jokes. At the Wilton Court Private Hotel, my grandfather drank and laughed, drank and danced, drank and gambled, until one day, Allen Avenue was no more. My mother was five years old when CJ drank away her family's house.

One evening, my mom and I sat together on the couch, mindlessly watching the six o'clock news. I was depressed and she knew it. She knew how much I was trying to be something I wasn't. How much it hurt.

"Sometimes I wish I could go back to sex work," I said, staring at the TV.

"Are you thinking of going back?" she asked.

"No," I replied. I was serious about honouring our agreement.

"Are you thinking of becoming a madam?"

"*Huh?*"

"What, it's a real job!" she exclaimed.

"No, Mom," I said, bewildered. "I'm not thinking about running a brothel."

"I think you'd make a great boss," she said. "And you know what it's like to do the work."

"You're right," I said. "But I want to be a writer. Not a madam."

"Just a thought," she said. Easy-breezy. No big deal. How far she'd come!

The truth was, I wanted a job that allowed me to work independently, with a flexible schedule and the ability to make more money the harder I worked. I wanted a job that was physical, since I knew a desk job was out of the question. Better yet, I wanted a job that didn't require a resumé. A job that was amenable to gaps in one's work history, that didn't ask any questions, and opened its arms wide to anyone willing to do the work.

It was the winter of 2016. I'd come out publicly as a sex worker, and Nicole and I were hard at work on the first edition of *Modern Whore*. With all my criteria in mind, I got a job as a bike courier.

I liked the gig at first. There was freedom, there was community, there was relying on our bodies to make money. But there was also snow and ice. There were thankless customers who rarely tipped, or who complained, during a snowstorm, that their ice cream had arrived late. (I'd fallen off my bike.) There were days I made much less than minimum wage. Streetcar tracks, errant doors, icy grates, snowstorms.

After getting almost-doored for the tenth time, I finally asked myself the question: What's more dangerous in Toronto—working as a bike courier, or working as a stripper?

At twenty-seven, I evaluated my meagre income and modest prospects, and made my decision. I wasn't gonna die on these streets, not without hustling for more. Not without trying to fulfil my first sex work dream: using my creativity, sexuality, and humour onstage to not only get a rise out of the audience, but to make a good living with enough time and energy to write, too. Stripping was always the goal.

I didn't tell my mom. Stripping wasn't hooking, and I had deliberately worded my agreement with her to leave the option open. With $417.65 charged to my Visa, I became a card-carrying, licensed Adult Entertainer in the city of Toronto.

Over the next ten years, my mother's family lived in ten different homes. "Always running," she said, "to escape CJ's violence." His behaviour was erratic, unpredictable. He could come home in the middle of the night, drunk as a skunk, in the mood to dance, and then suddenly cruisin' for a bruisin'. One day, while passing my mom on the staircase without a word, CJ took a swing at her, his fist punching a hole in the wall. The same father, on the same staircase sometime later, passed my mom again, and with a warm kiss on her cheek said, "You look just like Veronica Lake."

CJ wasn't all bad. He bought my mom a Raleigh bicycle, a memory she cherishes. He also took her bowling, and once, to a baseball game. Needless to say, she and her seven siblings learned to always keep a nickel in their pocket. Well, my mother did, anyway. She was the one who called the cops from the nearby payphone when her dad got violent—in those days, calling the cops cost money. Thankfully, my mom

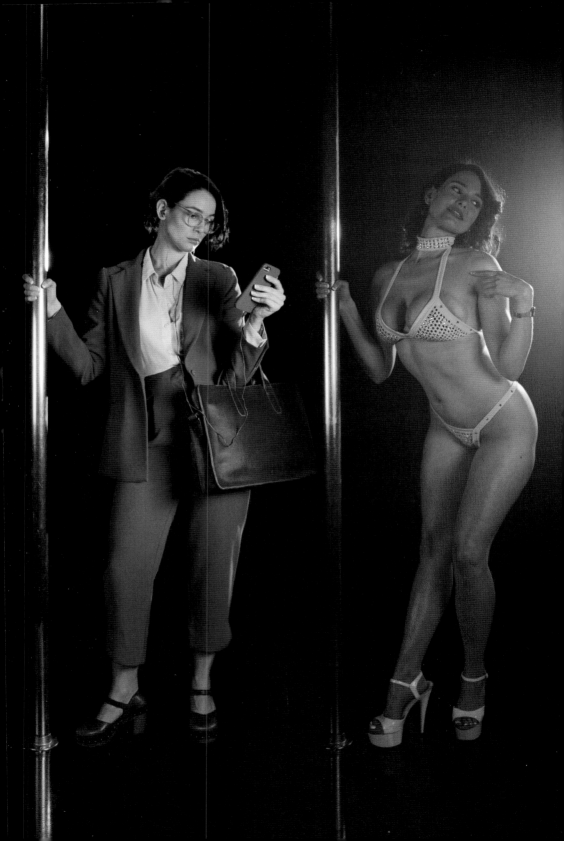

knew if she put a piece of cardboard in the coin slot, with a little nudging, ding-ding-ding—there was the dial tone. Gaming the phones was easy: making sure CJ didn't see her sneak out of the house to the phone booth was the real challenge.

Bridie, my long-suffering grandmother and a war veteran herself, worshipped the ground CJ walked on. But every long-suffering wom-an's got her limits. Bridie always served her husband the nicest meals. One day, CJ came home so drunk and disorderly that she, very calmly, opened up a can of dog food, warmed it on the stove, and placed it on a plate in that beautiful, loving way of hers. Fork and knife in hand, CJ dug right in. My mom couldn't stop laughing, and neither could my grandmother.

As a patron, my favourite strip club in the city was Tomcat's. The beautiful dancers were down to earth, their performances fun, and their lap dances, well—let's just say the dancers at Tomcat's followed their pleasure. The club wasn't "high class," but neither was I.

I emailed Maurice, the entertainment manager, about a job. I attached photos from the not-yet-published first edition of *Modern Whore*, the one of me in the red dress from "Tyrant," and another of me in the grass at the farm. I got an immediate response: *If that's really you, then yes, you can come in for an interview.*

When the manager at Tomcat's arrived to meet me, late, he wore a three-piece suit. He was bald. Articulate. Friendly. He spoke as if I'd already gotten the job, which I found reassuring. In a private area on the floor protected by a beaded curtain, Maurice explained how the club worked. Over his shoulder, I could see a dancer performing her stage show, her long blonde hair grazing the floor as she crouched on all fours. I wondered if I could ever be that beautiful, graceful, and sexy onstage. I felt earnestly clumsy.

"This is a new girl," Maurice said to the DJ, giving me a tour. "We'll call her, I dunno, *Fluffy*. Fluffy, this is Zeke."

I cringed at the name.

"I'm definitely not calling myself Fluffy," I told Zeke with a smile.

Maurice took me upstairs to the VIP. He explained how the security guard at the top of the stairs noted the dancer's name and the time she arrived, so no one got ripped off regarding a song count dispute. He showed me the lounge and the booths of the VIP, where dancers made $20 per song, and the Champagne Room, where customers booked by the hour, for $300 a girl. This wasn't agency escorting: the club didn't take a cut on a dancer's earnings. Everything I'd make in the VIP belonged to me.

While we stood at one end of the VIP bar, there was a commotion at the other. A dancer stood sternly, discussing matters with a client at the ATM. While she looked sweet, she also seemed frustrated. She approached Maurice.

"Excuse me," he said to me, walking over to speak with her privately, the client in sight. I, too, kept an eye on the situation.

As bouncers approached the customer, Maurice returned and explained that sometimes, *rarely*, but sometimes, customers would try to rip off dancers. He led me away with a hand on my lower back and told me not to worry about it.

"So, you wanna start tonight?" he asked.

"Oh, no," I said. "I need time to prepare. How about tomorrow?"

"Sounds good," he said.

I told my mom I got a job. As a waitress at Tomcat's! A half lie. I would start tomorrow.

"On Dave's birthday?" she asked.

Well, *fuck*! I'd booked my first shift on March 1, 2017. My stepfather's birthday. It was a bummer, but a girl's gotta work.

Maurice and I went back and forth on names over text. My first choice was Serena, after my girlhood heroine, Sailor Moon. Taken. Second was Violet, after my demi-goddess protagonist in "Our Girl Violet." Taken!

What about Sophia? he texted.

A revelation. Sophia meant wisdom. But, of course!

I arrived at the club an hour early for my Wednesday 5 p.m. shift, bright-eyed and bushy-tailed. I traversed the hotel lobby stairs, looking for Maurice. He wasn't there, but Matt, one of the other managers, took me into his office to sign the dancer contract, and gave me the lowdown.

"So," the young and perpetually hungover-looking manager stated as a matter of fact, "you've got the left side of the VIP, and the right side. Keep the right side to just dances. If you want to do extras, that's what the left side is for."

Feeling puny on the other side of his enormous bureau desk, I nodded.

"Now, we're not encouraging you to do more than dances, I'm just saying that if that's what you want to do, we'll turn a blind eye to it."

I didn't really want to do extras—mostly to not break the rule with my mom—but this was all good information to know.

"The thing is, if someone tries to rip you off after you've given them an extra, there's nothing we can do, since it's not technically allowed," he explained. "So, always get your money up front before you provide a service."

Left side, right side. Collect up front. Got it.

While he was erratic for most of her life, my mom understood CJ's untreated PTSD to be the source of his pain, and forgave her father for his trespasses. He drank to drown out the demons and was often heard screaming in his sleep. He drank because, back then, there was no mental health help for veterans. Emotional pain was equated with cowardice. A disease of manhood. Failure. Weakness.

By 1969, CJ was out of the picture. In '71, my mom, aged eighteen, went looking for him. She spotted him on Dundas, and followed him to Pembroke Street, calling out his name. At first, he didn't recognize her. She called out a second time.

"Rosalie," he asked, "is that you?"

CJ died in February 1973 at the age of forty-nine.

I signed the contract. In the pink-walled locker room, I donned the fanciest outfit I could muster—it had been four years since my escort days: a white bra and lacy black bottoms; sturdy thigh-high stockings from Agent Provocateur; unbearably high vinyl heels (no dupe for the all-important stripper shoe, the Pleaser); and a purse from Value Village, the same one I'd used for the "Tyrant" photoshoot. The baby stripper, embodied.

George Street, where CJ used to live with his family, eventually fell into such decay and disrepair that the locals referred to it as Little Detroit. While the residents of Seaton House, a men's shelter, were often blamed for the "urban blight," it was a developer in the 1980s and '90s who purchased and abandoned many of the street's old houses, which date back to the 1800s, leaving them open to squatters.

In 1980, the Wilton Court Private Hotel, where my grandfather had done so much living, was purchased by Stage 212 Incorporated and transformed into a strip club.

By 1985, the building at the corner of George and Dundas had become Tomcat's Gentlemen's Club & Hotel. The place my grandfather gambled away his wealth is the same place I chose to make mine.

Stripping is a gamble, but the return is worth the risk: I'm here to make back everything CJ lost, one lap dance at a time.

Two mirrored counters lined the locker room, and in a corner, I applied my makeup and took up as little table space as I could manage. Looking reasonably strippery, I shoved my belongings into a little locker, took a deep breath and one last look in the mirror. Then, I made my first strides down the long, carpeted hallway, past what I'd soon learn was the smoking room, through a glass door, and down a stairway where each step was a different size, pushing through another door to the hallway between the VIP and the stairs that led to the floor. With my hand on the brass rail—and feeling lucky—I made my debut.

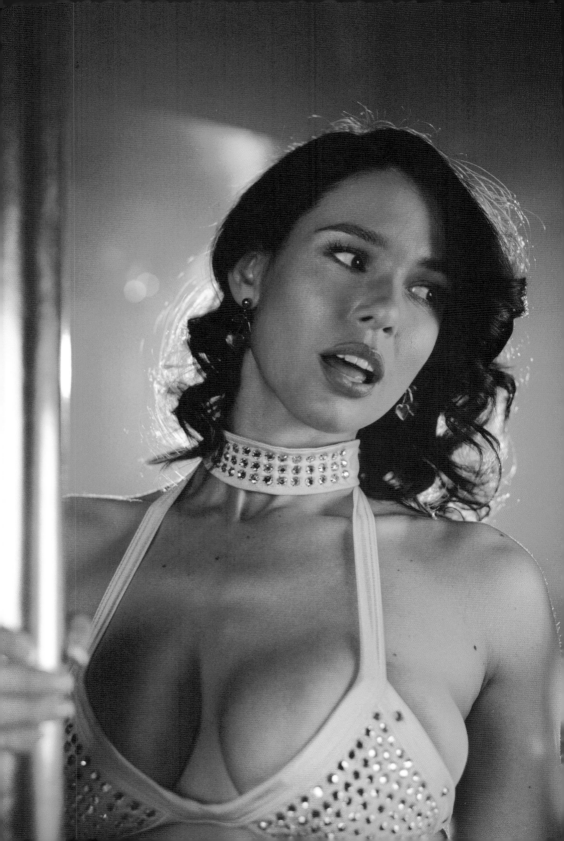

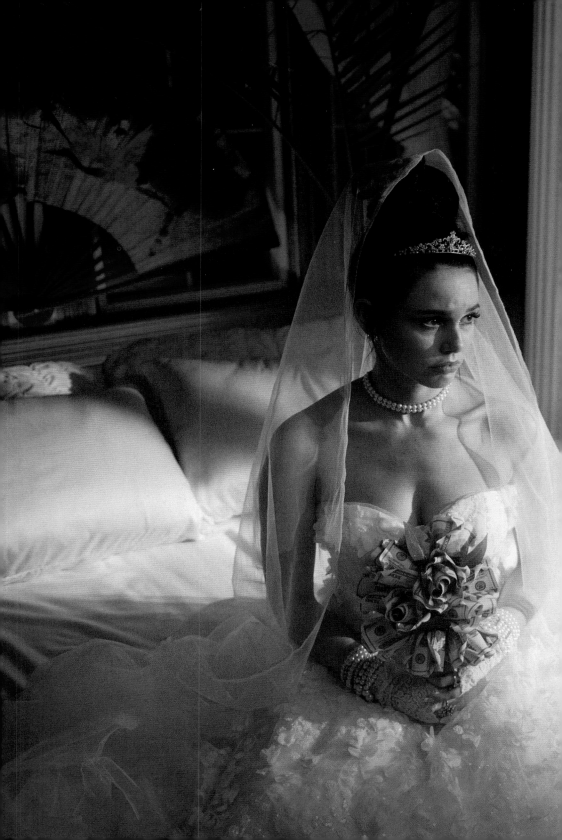

THERE'S NO
MONOGAMY
AT THE
Strip Club

The strip club is both a polyamorous playground, and the sexy working woman's factory floor. When a customer enters our domain, his wedding vows are shelved at the door, and he is imbued with the unspoken understanding that a woman in this space owes no man her loyalty. That's his wife's job. At work, a woman's loyalty is to making money, not making men happy for free. At the strip club, the dancer enjoys multiple paying partners per night, and the man who calls himself monogamous will wait patiently to be next in line. Dancers, too, share partners—and intel, of course. We recommend clients to our co-workers, offering tidbits about behaviour and, most importantly, spending habits. We keep mental notes on every single one of our partners, the ones worth returning to, the ones worth discarding. We are the masters of paid polyamory.

The barflies and the regulars know there is only one way to make friends with strippers, and that is by spending money. That could mean taking the dancer to the VIP, or it could mean plying them with liquor—whatever it is, dancers aren't going to stick around long if we're not getting something for our time. We can smell a timewaster from a mile away.

Don Wan was my first client on my first night at Tomcat's. By the time I met him, he'd been coming to the club nearly every day for the last eight years. Retired with a passive income, Don had spending money—and boy, did we love him for it. Don held court at the same table every night, surrounded by a revolving door of beautiful dancers and a spread of his tasty home-cooked food. Lively conversation was pierced with "Who wants a shot?!" He never let a glass run empty.

Don's table was a hub, a sanctuary for the wayward stripper. We'd sit with Don, one eye always on the room, and if we spied a quality prospect, we'd excuse ourselves to shoot our shot. Most people don't realize that stripping is 100 per cent hustle—50 per cent success and 50 per cent getting rejected. Don's table meant we had a comfortable place to return to after being turned down. And sometimes, it was Don who would take us up to the VIP.

For my first six months at Tomcat's, Don booked me for an hour every single night I worked: a negotiated $250 to dance and make out. With all his club clout—he was single-handedly paying a manager's salary with his

nightly bar tab—he would get us the Champagne Room, and in between kissing, we'd sit on the couch, tangled up in each other, watching sports on the overhead TV. At the end of the hour, we'd flip a coin for $50 of my rate. Gambling at the strip club—Grandpa would be so proud. Winning $300 for the hour was euphoric, but earning only $200 made me feel cheap, so I had to put a kibosh on the betting. A guaranteed $250 a night was nothing to fuck with. It gave me a sense of financial security that allowed me to relax during the rest of my shift. What a gift.

Two weeks into my new career at the club, I met another client who'd become a trusty regular. Ron, soon known as "Sophia's guy," came in every single week and didn't see anyone but me for almost three years. Loyal, steady, and in a word: monogamous. It certainly wasn't my requirement that he only patronize me, but I wasn't mad about it, either. There was an undeniable status that came with his weekly visits. He either paid me by the dance or by the hour, which always included a dinner—and a foot rub! *Swoon!*—at the special Don Wan rate of $250. With a large vegan burrito in hand, chowing down shamelessly in my lingerie, there was something about getting paid to eat and eventually gyrate on this kind, funny, generous man's lap that transcended the transaction. He made me feel like the Queen of Tomcat's.

Like any excellent client, he also brought me gifts. It was Ron who presented me with that all-important sex worker milestone: a piece of jewellery from Tiffany's.

"I'm a real whore now!" I squealed at the beautiful silver necklace, that trademark robin's egg blue box in my lap. He also surprised me with a pair of shoes. Not that other hooker triumph, a pair of red-soled Louboutins, but the most comfortable shoe of all: the Vibram FiveFingers toe shoe. Fashion be damned!

During those initial six months at the club, I was half hustling dances, half raising support for the first *Modern Whore* Kickstarter. Many of my clients became artistic patrons, and Ron was no exception.

With Ron, I felt respected and taken care of. As a result, I was always happy to see him—and Ron was always happy to see me.

———

In September 2017, just over six months after my stripping career began, I left Tomcat's to launch the first edition of *Modern Whore*. With limited knowledge of the financial realities of self-publishing, I quit stripping with a vow to never return. Literary fame and fortune were right at my doorstep! I threw a party to celebrate my "last night ever" at the strip club. I invited all my friends and jokingly performed with gusto to the Village People, b4-4, and the Vengaboys. All the waitresses came up onstage during my last song, with tips in their mouths. The DJ announced that I was moving on to publish a book and wished me all the luck as the crowd thundered with supportive applause. It was so sweet! I hung up my heels and let my Adult Entertainer licence expire, my writing career on the verge of blasting off.

Why didn't anyone tell me there was no money in publishing? Sure, we'd printed 1,000 books, got a ton of press, and sold out within the year, but we hadn't made any money. Not enough to pay ourselves, anyway, and certainly not enough to live on. Seven months later, without a dime to my name, I returned to Tomcat's with my tail between my legs and got back to work.

The lesson here is, only amateurs announce their departure from sex work. If I hadn't made such a show of it, returning to work wouldn't have been so embarrassing. Likely, no one would have even noticed I was gone. Dipping in and out of the sex industry is common practice. Thankfully, none of the dancers held my folly against me.

Yes, I was back, ready to take my seat at Don's table again, and resume our nightly VIP jaunts. But things had changed. We didn't have the same chemistry. Like a rookie, I'd worn a regular lipstick instead of a smudge-proof matte and got it all over my face during our make-out. I looked like a used-up clown.

"I don't think this is gonna work out anymore," Don concluded. "But how about I make you a home-cooked meal every night you work instead?"

Now, I'm not the type to force a man's hand. If he doesn't want me, why fight him? I love to eat, and that's a fact. It wasn't $250, but a guaranteed delicious dinner seemed just as good. I happily accepted his offer.

But things with Ron didn't change. He still came in, was still my guy, still patiently waited for me to finish in the VIP with someone else.

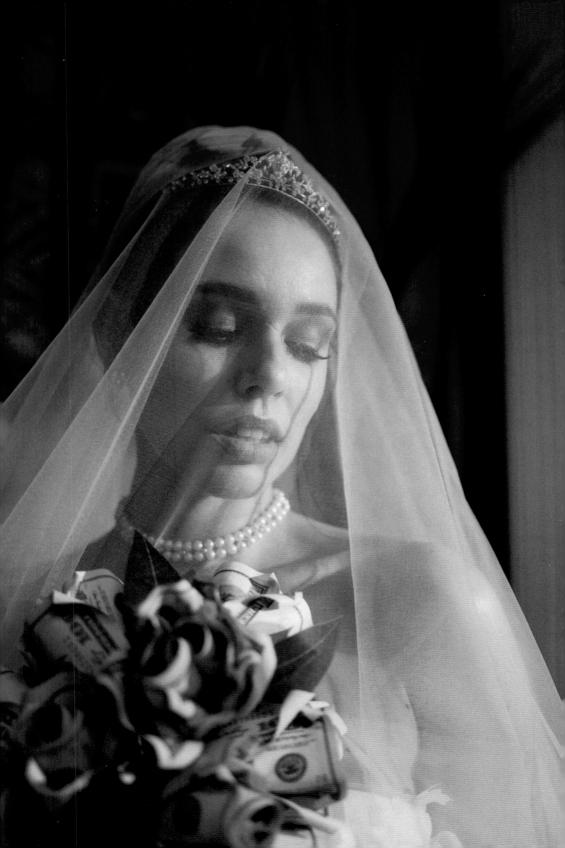

Because he was loyal to me, the girls knew not to approach him. That meant he was sitting alone all that time, while guys like Don were surrounded by women constantly. I didn't realize Ron was getting lonely—or that he was a flight risk.

Two years after we'd met, I invited Ron to my thirtieth birthday party—an elegant rager at the Darling Mansion, where we screened our short film *Modern Whore* for the first time. Club colleagues—dancers, waitresses, and DJs—came through, along with a ton of sex workers, friends, and supporters of the project. No clients allowed, save for awesome major benefactors, like Ron. It was there that he got to know some of my close co-workers, and there that he decided he would branch out.

A month later, at the strip club staff holiday party—with a delicious buffet, hilarious karaoke, and the owner serving drinks at the open bar, Tomcat's *always* did it right—one of my fellow dancers, Charlie, pulled me aside for a private conversation. Charlie, a beautiful, non-binary playwright and big-tittied genius, let me know that Ron had come in to see them—not to go up to the VIP, but for a $50 conversation.

"He's *your* client," Charlie said, weirded out, even though they hadn't done anything more than talking—yet.

I was grateful for their honesty, but my first feeling was shock. A tiny, unexpected betrayal—not by Charlie, of course; get that money, baby—but by Ron. I examined my feelings. This wasn't my first rodeo. In my personal life, I'm polyamorous, and have been for many years. I don't believe in partner ownership. *This is polyamory in action*, I thought. The first time a partner steps out can be difficult, whether they're paying or not. Charlie was also polyamorous, so they understood.

"Honestly," I said, collecting myself, "he's a great client. Why wouldn't I want to share him?"

And while it stung, there was something about Ron venturing out after nearly three years as my "monogamous" client that made me happy. Like he was growing. I just didn't want to be disposed of, replaced.

A few nights later, another close dancer friend named Melissa—a slim, tattooed, soft soul and pole superstar—approached me in the tiny, mirrored hallway beside the stage, after I'd just finished performing. She

pulled me aside in the same way Charlie had, like she had something to tell me. She did: Ron had come in the night before, she said, and when he saw her, apparently exclaimed, "You're here! I've been waiting hours for you!" Initially, she told me, she didn't want to go to the VIP with him unless I knew what was going on—but eventually, they went upstairs.

"But not for as long as you go up with him—I don't think," she said.

Now, admittedly, I was hurt. Again, I examined my feelings. I realized that it wasn't Ron getting dances from other girls that bothered me; it was that he hadn't talked to me about it. That Ron was no longer "Sophia's guy" battered my ego and my reputation. I didn't feel like a queen anymore.

Does a client need to disclose to a sex worker that he's seeing other sex workers? I mean, no. Of course not. People often engage in sex work to escape traditionally possessive relationship dynamics, both as clients and as workers. But what I've said in my personal polyamorous relationships, I felt I had to say to Ron: the only way to make this work is by being honest. Even though Ron and I had never had sex—we had never even kissed!—our relationship felt deeper than what I had with any of my other clients. I still wondered, though, if honesty was an unfair ask of a client, and if my strong reaction wasn't about his non-disclosure but rather the disruption of my elevated status.

If he's no longer monogamous—do I lose my power?

And so, we talked. I told him I was hurt, that I craved honesty. He heard me, and explained himself, pointing over to Don's table. Sitting alone at the club for hours was taking a toll on him, especially when he'd met such awesome women at my birthday party. He wanted to make friends with the dancers, and he knew the only way he was going to do it was by paying them for their time.

It clicked. I grinned, pride welling up in my whorey soul. *Oh, Ron.* What a good client! I'd trained him so well.

Thankfully, sharing Ron did not diminish my status. It just meant sharing the wealth. And all now have matching pairs of toe shoes!

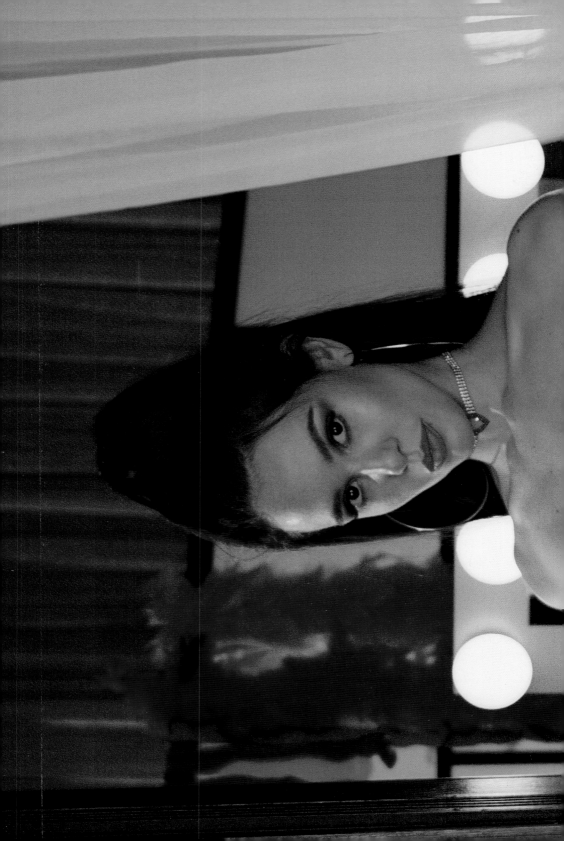

A SOPHIA SATURDAY NIGHT

Time	Activity
10:00 a.m.	crawl out of bed
10:15 a.m.	make some coffee, read the news
11:00 a.m.	sun salutations
11:30 a.m.	shower and shave
12:00 p.m.	breakfast: matcha-banana protein smoothie
12:30 p.m.	answer emails
1:00 p.m.	write
4:00 p.m.	late lunch: leftover chili
4:30 p.m.	pack my stripper gear: outfit, makeup, purse
5:00 p.m.	ride bike to the club
5:45 p.m.	arrive, make small talk with the front desk
6:00 p.m.	begin the beautification process in locker room
7:00 p.m.	descend to the floor fully glammed, check in with DJ
7:30 p.m.	perform my first set to empty room
8:00 p.m.	get bored, smoke weed
8:30 p.m.	high as fuck, return to floor
9:00 p.m.	spot a regular, make money
10:00 p.m.	perform my second set to an appreciative audience
10:15 p.m.	back-to-back clients who tip generously
11:00 p.m.	get paid to eat a burrito with a regular
12:00 a.m.	perform third set with a bloat, crowd goes wild
12:15 a.m.	more clients, very good night
1:00 a.m.	back on the floor, drunk men in groups are not my type
1:15 a.m.	cut my losses and head back to the locker room
1:30 a.m.	homeward bound, cycling into the night
2:00 a.m.	safe and sound in bed, a good night had by all

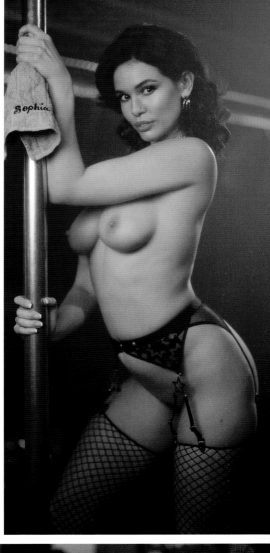

The club was awhirl with magic. Money, freedom, performance, pleasure, and budding friendships with my co-workers all gave me life during my first week at work. *Why*, I pondered, *why did I wait so long to fulfil my dreams?*

I met Bob Abrams on my second shift. A mid-thirties blond in a suit, he was blue-eyed, well-heeled, and handsome. Married with a newborn, he smelled of a man who'd had everything handed to him. A Brock Turner. An American Psycho.

He implored me to sit with him for the whole night, plying me with drinks. Baby Stripper Sophia happily imbibed. Drunk, we made out passionately in the VIP. He begged to eat my pussy, so I stood up on the booth seat, giggly surveying the room to make sure no one was looking, and pressed my pussy into his mouth. Exhilarating.

I'm getting paid for this! my heart rejoiced.

He asked if he could take his cock out. I didn't see why not. He asked if we could fuck. I said I could suck, drunk enough to cross that boundary, even though I had no idea what I would charge. He said no, he wanted to fuck, forget it. No harm, no foul.

We called it a night at fifteen songs. Euphoric. We exchanged information. I gave him my old escort email, and he gave me his work email in return. We arranged for him to visit me at the club the next week.

Friday night, 6 p.m. Empty club, perfectly sober. Bob Abrams and I sat at the bar sharing intimate small talk over our first drinks of the evening before moving the party upstairs. As the only patrons in the VIP, we had the entire place to ourselves. I began the dance in earnest, but it lacked last week's passion. By the third song, as is customary, I writhed on his lap naked.

Bob Abrams pulled his dick out. He asked if we could fuck. I said no for a multitude of reasons—no, I didn't want to; no, I didn't have a condom; no, I didn't think we were in the right place; and no, again, I just didn't want to—but continued to dance. There was an erotic tension between us, a game of flirtatious struggle.

With his grip tight on my hips, he pulled me down, bridging the gap between my pussy and his dick. I resisted, hovered, swayed, annoyed. Like a game of ring toss, and I was the ring.

Finally, he scored—and I was the defeated loser with a raw dick inside me. For a moment, I could not move. I regained my composure, hopped off. Told him not to do it again. Continued dancing. But he did do it again, two more times, and still, my reaction was the same: motionless resignation.

When the game was no longer fun for him, the dance came to an end. I sat beside him in the booth, dejected.

"Whatsa matter, babe?" he asked. "You look so sad."

"I'm disappointed in myself," I said, auto-victim blaming, "for letting you transgress my boundaries."

"Why?" he asked, cocking his head. "Do you have something?"

I shook my head in disbelief. Said nothing. Collected the money.

I have herpes. Maybe now he had it, too. And soon, perhaps, his wife.

Bob left and I continued to work.

Usually, I'm an open book. Always a little too eager to tell a story about myself.

When it came to the story about Bob, however, I didn't tell a soul.

X

Something was wrong. A week after the incident, I was invited to lecture about sex work for Professor Lauren Spring's Sociology of Gender course at the University of Toronto. It was my first opportunity to read the not-yet-published sex work stories from *Modern Whore* to a college audience. I wanted to give the students a sense of the ups and downs of sexual labour, so I chose "The Merry Men of Mary Ann," to demonstrate the benefits sex workers give our clients with disabilities, followed by "Walter Wack," about the risk of rape when one's job is sex. Fitting.

Lauren and I, along with Nicole for moral support, met at a subway station and took a bus together to the Mississauga campus. The ride through the wide, gridlocked suburban roadways was long, bumpy,

even nauseating. When Lauren asked how stripping was going, I already felt a bit sick.

"Good," I said curtly. Not good. Strange. I told her about the glory of performing, taking home more money than I'd ever dreamed of earning, and cultivating friendships with kindred sluts, but Bob I left unmentioned. Unmentionable. A lump in my throat.

A few days later, my boyfriend and I got into a rare fight. We were at a Sunn O))) concert, the smoke machine on blast. The band played ambient noise in hooded robes for the seated and appreciative audience. We stared into the fog at the hooded men in resentful silence. Afterward, I wept for hours, tender to the lightest infraction, hurt. At home in bed, we tore into each other until the nearly repressed memory crawled out of my throat and fell out of my lips. A client had taken his dick out and forced it inside me after I'd said no, repeatedly. I didn't cheat. I didn't want it. *I'm sorry I didn't tell you,* I said. *I didn't know how to say it. I didn't know what to do. I'm sorry.*

Only in saying it out loud did I realize that I'd been raped. The truth of what had happened had festered underneath the surface of my every interaction with the world. In bed, next to my love, I sobbed myself to sleep, relieved. I finally understood. I resolved to take the week off to process, and I vowed to tell strip club management what had happened when I returned.

X

I told Phil first. Phil was the manager who was always there, steering the ship, ensuring the club ran smoothly. He took my experience very seriously, and asked what I wanted him to do about it: Call the cops? Print out Bob's photo and bar him from the club?

Cops were out of the question, I said. Since I had Bob's information, I told him I'd contact him directly about not coming back. As we concluded our conversation, Phil said, "You know, I've worked here for nine years and you're the only dancer who's ever told me about something like this happening—and I know you can't be the only one."

I found out why on my next shift, when I approached Maurice, the manager who had hired me. Maurice only seemed to appear late on Friday and Saturday nights, to drink with the girls.

"By now I'm sure you've heard what happened to me," I said, getting comfy beside him at the VIP bar.

"Yes," Maurice said. "And I think it was your fault."

I just about fell off my stool.

"There are security buttons in the booth for a reason," he explained. "If you were feeling uncomfortable, you should have pressed the button. You didn't, so that's on you."

I told him I'd been in shock—that it was my second week of working and I didn't know what to do. I told him he was victim blaming, and this was exactly why girls didn't tell management when sexual assaults inevitably happened.

"Hmm, I never looked at it that way," he said, feigning understanding. I'd said my piece, so I moved on. It certainly didn't stop Maurice, in stereotypical strip club manager fashion, from trying to fuck me, either, but that's a story for another book.

The next week, I got an email from Bob.

Subject: Hi there
Hey!
Are you around today or tomorrow evening at all? Hope you're well. :-)

I promptly responded.

Mar 28, 2017, 11:41 AM
Hey Bob,
I've given some thought to what happened during our last exchange and I still feel uncomfortable about it. If you don't know what I'm referring to and require further explanation, you may come in but I won't be going upstairs with you. Consent is not a game. No is no. Especially without a condom. I don't care about passion, I don't care about money. By violating my boundaries, you showed your total lack of

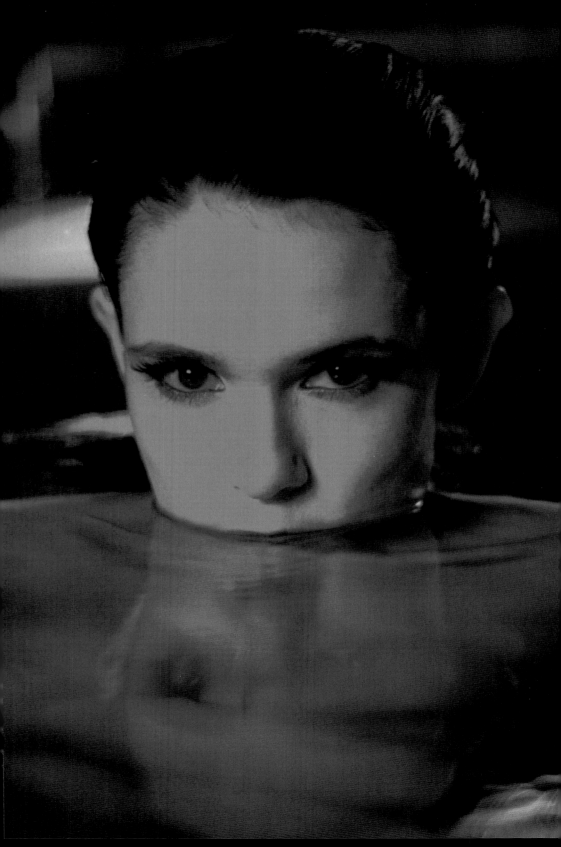

respect for me. I could have been your refuge. You fucked it up. I won't be seeing you again.

Sincerely,
Sophia.

Time passed. It was two years, almost three, before Bob had the audacity to appear again at the club. It was no longer my second week at work. I was older, wiser—and more importantly, I was sober. Sobriety gave me access to a bravery I didn't know I had, but bravery only comes with practice.

I was sitting with a new client, about to go up onstage. Bob came in with a group of people. He looked older, uglier, more haggard than the day he raped me. His blond hair dull, his blue eyes grey.

I fumed in my seat. The *entitlement*! I glared at him and his friends, laughing away. Did they know they were sitting with a rapist? I was mad enough to tell my client what had happened.

"Disgusting," he said. "You want me to beat him up?"

No, I told him. I just wanted him and the world to know what he'd done to me. That's all.

I went into the DJ booth to pick my songs.

"Just so you know," I said to Zeke, "the guy who raped me here is sitting at that table."

"Should we get security and kick him out?" Zeke asked, alarmed.

No, I told him. I hated that he'd brought the protection of a large group. That it would be embarrassing for us both to make a scene right now. I didn't want this to take up my entire night. I didn't have the strength—the bravery—to have him kicked out, to make that scene. But that night, I made myself this solemn vow: next time, I *would* find the courage to get him kicked out, because Bob Abrams raped the wrong whore.

I got up onstage and pretended to enjoy myself, while the rapist and his friends looked on. I was anxious as all hell but coped by not paying attention to that side of the room, not giving that bastard any validation

or complicity with my gaze. I would never "let" him transgress my bound-
aries again.

From the corner of my eye, I saw Bob and his crew go upstairs with a
few dancers during my third song. When I was finished my performance,
I asked my client if he wanted to go upstairs now.

"Why?" he asked. "Because your other guy went up there?"

Red flag, red flag. I ignored it, of course. He said he was joking and
wanted to wait until he finished his beer. Perfectly fine. Taking his sweet-
ass time . . .

Eventually, we made it up to the VIP. We passed the Champagne
Room and I caught a glimpse of Bob. I was still mad. While I gave my
client his dance, I fantasized about writing a note on a napkin in lipstick,
and throwing it like a grenade into the centre of the room: "Do you know
your friend Bob is a rapist?"

My own client became pushy with me and asked, "How much for a
blow job?" I said I didn't give BJs here.

"Let me take it out," he said.

"No," I replied.

"C'mon, just look at it."

"Dude!" I shrieked. "I just told you I got raped here by a guy who
whipped his dick out after I said no. Can you not?"

"Fine, fine," he said. And then: "How about a beej for two hundred
dollars?"

I stopped dancing. "We're done here."

"What, why?" he asked.

"Because we are. That was five songs. One hundred dollars."

"What if I want more dances?"

"I said we're done."

He grumbled and paid me. The fucking nerve.

Later, I approached one of the dancers who'd been in the VIP with
Bob and told her my story. She was surprised and said she'd found him
very respectful. While I was relieved he hadn't hurt her, it didn't change
what he'd done to me.

I sent him another email.

Oct 21, 2019, 9:25 AM

Don't come to the club, Bob. The staff knows what you did. If I see you again I will have you kicked out. This is your warning.

The email bounced. Bob was no longer with the company.

X

A month later, it finally happened: Bob was back, and I was ready.

He appeared, again with his friends, about ten minutes before Eden—my smoking-hot personal trainer turned friend and co-worker—and I were set to go onstage for a doubles show. I knew what I had to do, but I still felt a bodily resistance, a fear that clamped my tongue in the DJ booth next to Zeke. He was talking to another dancer, so I freed my mouth and unleashed the truth upon Eden.

"My rapist is here," I said, pointing him out.

"I think that's Devon."

Now I was confused. We watched as Bob, or whoever, stood up and strolled to the bar. Without hesitation, I walked right up to the table and whispered in one man's ear: "Hey, is your friend's name Bob?"

"Yeah," he replied.

"Bob Abrams?"

"Uh, yeah," he said, getting suspicious. "How'd you know that?"

"Thanks!" I chirped and returned to the booth.

"It's him," I confirmed with both Eden and Zeke. And now—show time! Eden and I strutted onstage for a disco set, and bubbling, sparkling inside me was a truth that shone through my smile and every movement. *Tonight, I'm holding a man accountable.* I'd never felt so sexy.

When we finished the set, I walked straight to Phil's office and laid it on him. Just like the first time, Phil was attentive, compassionate, and proactive. He knew exactly who I was talking about—"Tall white guy with a dirty blond beard, right?"—because Bob had a reputation. He'd been getting blackout drunk increasingly often over the last six months. Security knew who he was, too. I felt comforted by the recognition of a pattern of reckless behaviour.

Bob was currently in the Champagne Room. "Don't fuck with any-one's money" was a principle Phil and I both shared, so we agreed a confrontation would wait until Bob paid his tab. Good with me—I was done for the night and would be waiting, a soothing joint in hand, in the smoking room.

Sitting with my co-workers in a place far away from the prying eyes of customers, smoking cigarettes and *whacky tabacky,* the girls asked if I was okay. I told them I was, and what had happened. Perhaps unsur-prisingly, rape isn't something that gets talked about much at the club. After all, it's a real downer when you're trying to hustle. But me, I'm an open book. I dream of a training manual for new hires, and procedural guidelines for when sexual assault occurs at the strip club. Workplace health and safety shouldn't be a taboo topic, and neither should rape.

As I told my story, Tammy, a Nova Scotian colleague, silently reached out her hand to mine. Held it and nodded. Another dancer, the bright wildcat known as Fire, offered to throw her piss in Bob's face. I felt the love, warmth, and solidarity in the smoking room that night.

I was fully clothed and ready to head home to bed when Phil returned with the news: Bob Abrams, Rapist, had been informed he was no longer welcome at Tomcat's. Bob apparently asked, "Is this for good?" suggesting he'd be back to test the waters. He claimed he didn't know what this was about.

"You know what you did," Phil told him. "And I suggest you stay far away from here, because if she sees you again, she's ready to press charges."

I thanked Phil profusely. A good strip club manager is hard to find, but Phil—he was a good one. Thanks to him, I got my closure. I told my story and action was taken. No need to get the cops involved. Justice didn't mean going to trial and getting grilled on the stand, re-traumatized and slut-shamed by all the Maurices of the world. Justice, for me, was ensur-ing the predator didn't set foot in my club again. Justice was the recogni-tion that everyone who mattered at my workplace had my back. Justice was the quiet hand that reached for mine to say *I understand.*

Rape isn't inevitable. Sex workers should be empowered to trust their gut and establish, maintain, and assert their own boundaries.

No one should *ever* have to learn how to say no the hard way.

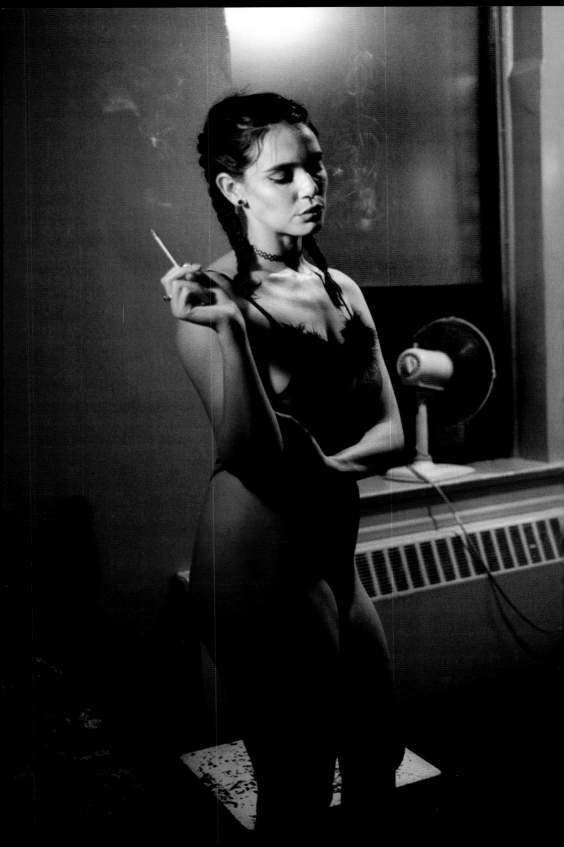

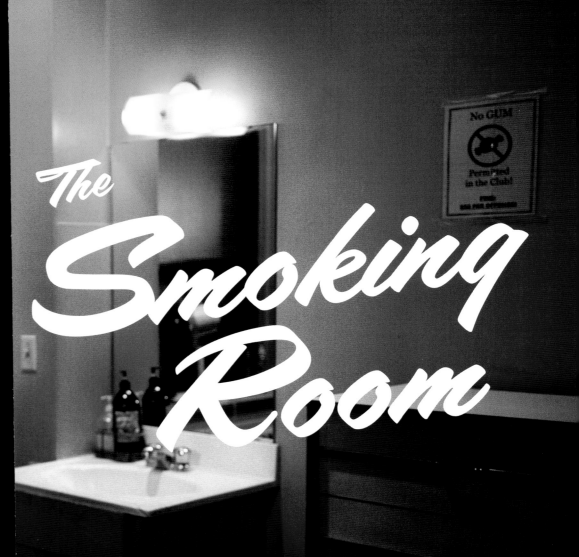

No GUM
Permitted
in the Club!

The Smoking Room

*E*very night around nine, the locker room at the club buzzes with excitement. Every chair at the mirrored counters is taken by women applying makeup, straightening hair, and trying on outfits. They are teasing, laughing, talking shit about customers. Tricks. Passing around bottles. Bragging about their children. Their men. They arrive late into the evening because that's when they make their money, when the patron is sufficiently plastered and ripe for the exploiting. As dancers, we find our people in the locker room—the ones with similar life experiences, backgrounds, and senses of humour.

For some, the mantra is "I didn't come here to make friends." Eye on the money, nobody else. For others, working at the strip club means a party—getting drunk and high on someone else's dime. One must coexist in the locker room with a variety of volatile personalities. Confrontational, cocky behaviour might get a girl cornered with a Pleaser heel to her throat. Coexistence is giving each other space and keeping to one's people.

I squat on the floor to reach my tiny, bottom-row locker and crack open the combination lock. 19-53-15. *In 1953, I was fifteen*, I sing to myself. When the door swings open, I unbuckle my shoes and replace my eight-inch heels with my club-famous cow slippers, never letting my feet touch the floor. In the locker room, we play a silent game of "the floor is lava." A stripper's bare foot on tile is verboten, frowned upon—it doesn't *behove* us. We're above all that. I play, too. Wearing my slippers is the only way I know I'm taking a break.

I grab my one-hitter and lighter from the bottom of the pile in my locker, close 'er up, and glide away, much shorter, to the smoking room.

In the hallway, a little window peeks onto the front desk of the hotel lobby. Mitch, on night shift, stands by, and I remember I told him I'd buy some of his weed.

"*Psst,*" I whisper, leaning into the window and looking around to ensure there are no hotel guests within earshot. "Can I get two grams?" We both have to be cautious under the gaze of the security cameras that surround us.

"Yep," he says, walking slowly towards me. "Meet you in the smoking room?"

"I'll be there."

Down the hall, I push and turn the old brass knob while twisting the key attached to a stick hanging from the lock. It's a one-two punch to get into this sacred room—a small, bare-bones chamber with pink walls tinged orange from years of smoke, featuring a sink, mirror, closet, dresser, desk, chair, bedside table, and single bed. A fan points out a small window, nearly the only window in this place. Inside, Adrianna and Tammy, two friendly smoking room regulars, share a blunt.

Adrianna stands next to the sink, a tall, slim, straight-shootin' mother in her mid-forties who's been a stripper for twenty years. She wears a plush aubergine robe she keeps in the dresser, and a shower cap—the musky smell of the smoking room has a way of following us out the door. Tammy sits on the desk at the foot of the bed, blonde hair in a high pony. She's in her mid-twenties and cute as a button. She can outdrink anyone and tells a story like no one else. I place my hanky down on the bed right below the pillow and take a seat.

"I can't take it, I can't damn well take it," Tammy says in her thick Nova Scotian accent, shaking her head. "It's too goddamn dead down there."

"Right?" Adrianna says in her thick Hungarian accent, looking at me. "What are we supposed to do? There's too many girls here, not enough men."

I shake my head as I take my one-hitter out of my purse. I slide the top around, release the pipe, and dip the tip into the weed compartment. When the bowl is full and tightly packed, I bring the acrylic tube to my mouth, lighting the metal end.

"It's awful," I say, blowing out a plume of smoke. I have $370 in my purse, so I'm not too worried, but I know, as we all do, that much of our money is chalked up to luck.

"And who are these girls giving fifty-dollar blow jobs?" Adrianna asks, bewildered. She's a member of the old guard. "It's not right."

"Literally, go work out on the street, you dirty urchins," Tammy says. "Ain't no fifty-dollar blow job got a place in here. It's so fucked up. Undercutting us like that."

"These are new girls doing that?" I ask.

"New girls, old girls, desperate girls," Tammy says. "It's a slow fuckin' season, I'll tell you that much." She takes a hit off her blunt and passes it to Adrianna.

"Where are the regulars?" Adrianna asks, gesticulating wildly. I love her. "Where did they go? I used to have so many. Now, they don't come. What's going on?"

I'm starting to feel my high. I think about all the times I've peered down from the pole, naked and glorious, to a crowd of men looking at

their phones. It's absolutely pathetic. "Everyone's just staring at their screens these days," I say.

"Porn destroyed our profession," Tammy announces. She has a wise, authoritative way about her. She'd make a great teacher.

"The internet destroyed a lot of professions," I say. "People don't even go to live shows anymore. They livestream that shit."

"They don't want to interact with humans anymore, is that it?" Adrianna asks. She wants to get to the bottom of this, I can tell. "Men, they don't want a human anymore, they would rather a screen? I hate it, I hate it." She takes a hit and exhales from her nose like an angry bull.

Someone is fiddling with the lock and door knob, eliciting our attention. Who will it be, we wonder. I see the beard first. Mitch enters the room.

"Hello ladies," he says.

"Hi Mitchie," Adrianna and Tammy say in unison.

"Special delivery," he says, as he swings his closed hand in my direction. I present my palm, and he drops the bag of weed into my hand.

"Thank ya," I say, digging through my purse for a twenty.

"It's an indica and sativa hybrid," he says. "Homegrown. Get ya fucked."

"Sounds good to me," I say.

"And how are we all doing this evening?" he asks.

"We're commiserating," I say.

"It's so dead, Mitchie," Adrianna cries, getting close enough to lightly shake him by his shoulders.

"You don't have to tell me twice," he says. "I know it's bad down there."

"No," Tammy says. "It's not just bad down there. It's downright dead. Murdered. Killed. Somebody's gone and killed Tomcat's Gentleman's Club and I sure as hell know it wasn't me. But someone did, that's for damn sure."

"Don't forget it's January," Mitch says. It's 2020—the year has just begun. "It's always slow the last two weeks of January, and the first week of February. Every year, like clockwork."

We all nod, traversing our memories of Januarys past and finding no lies.

"Okay, back to work with me. Enjoy the weed, little Sophia."

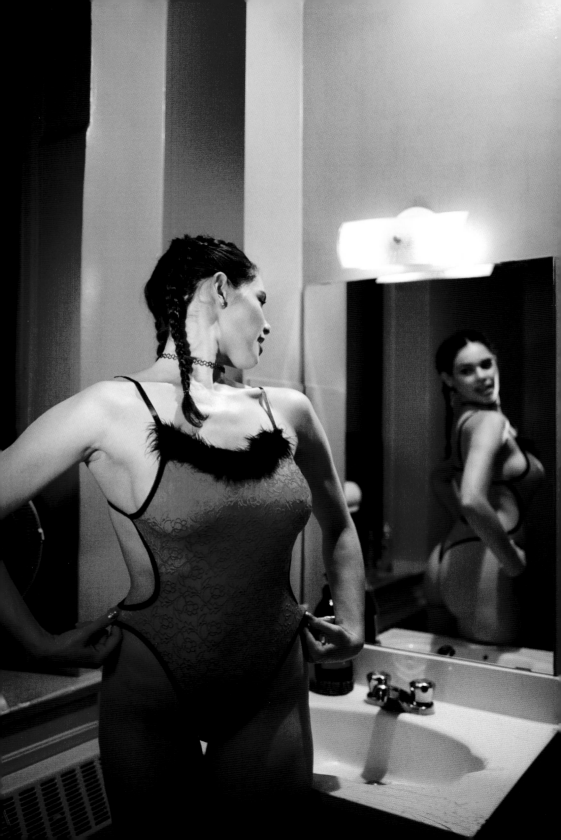

"Thanks Mitch!" I say.

"And I hope you all have a better night!" He disappears into the hallway.

"Okay," Tammy says to herself, but loud enough for us all to hear. "I've had my blunt. It's been a long time, the room better be different when I go down there or I'm coming right back up here, no word of a lie. If I don't make my money tonight, I don't know what I'm gonna do."

"You're gonna make money tonight, sweetie," Adrianna says. "We all are. You just gotta be patient."

"Oh," I suddenly remember, "Zeke said there was a miners' convention in town. That oughta help, ya think?"

"There's always conventions," Adrianna replies. "They don't really do much. But tonight," she catches herself, "tonight is gonna be a good one!"

"I better mine me a diamond tonight, I tell you!" Tammy says, rising to leave. She ties her ass-hanky to her purse strap. Below it hangs a little bottle of Purell, a stripper staple.

"Bye sweetie," Adrianna says to me with a big smile, as they both head out the door.

"Good luck!" I call out.

Being alone in the smoking room is a rare privilege. I stand up and look at myself in the mirror, one-hitter in tow. I blow out smoke and pout my lips and pose. I feel good. It's already 9:45. The floor has probably changed by now, but my policy with the smoking room has always been to take as much time here as I need. What's the rush? One more puff, and then I'll emerge.

I return my ass to the bed, shuffling backward to lean against the wall, my legs fully straight, my slippered feet hanging off the mattress. I wonder how often this comforter is washed, and then decide to stop wondering. Now that I'm so cozy and alone, I don't want to go back down.

Suddenly, Lara bursts into the room, shaking her head.

"Ughhhh," she says, plopping down beside me on the bed. "I hate it. I just hate it."

"Still bad down there?" I ask.

"Not just bad," she says, "but very bad. It's like every night I've worked for the past couple weeks there's always been one guy who tries to

haggle. Why the fuck do they do that? If I hear one more guy say 'Three for fifty' I'm gonna snap."

"I haaaaate it," I say, taking another hit. Fuck going down to the floor. Lara's too interesting. She's the club's resident lesbian. A pale brunette beauty in thick-rimmed glasses. I don't understand how she puts up with this shit without a modicum of sexual desire for these guys. She pulls out a joint and lights 'er up.

"It's so hard to make money with just dances anymore. I feel like in the last year my earnings have been cut in half. It sucks," she says, passing me her fatty. Lara is one of maybe three other dancers, including myself, who don't do extras. We're all feeling it. The pressure to do more.

"And I don't have the motivation to go up to guys to just get rejected," she says. "So, I sit in my corner and wait for them to come to me. Sometimes it works." She pauses. "No. It often works. Just lately, it's been, I don't know. Not good. I got bills to pay, dude."

Lara has been sewing stripper outfits in her downtime to supplement her income. I've purchased one of her pretty pieces, one she made just for me. There are few things I love more than supporting sex worker side hustles.

"I just wish I could make more money dancing," she said. "My girlfriend's got debts to pay I've been helping out with, and I don't have much myself."

"This is the girlfriend who disapproves of what you do?" I ask.

"Yeah." Lara peers at me over her glasses. "She hates what I do but she loves my money. She's so weird," she says, rolling her eyes.

I nod. It's a common sex worker complaint. People stay with their partners for all sorts of reasons. I assume Lara is happy enough. She has a job at a hospital too, and often comes in to work after her dayshifts. Two mouths to feed.

We sit in silence. It is now 10:00 p.m. What a good, long break I've had. Probably time to get back to work now, though no one's telling me what to do.

"Okay, okay, back to work with me," I say, slowly sliding myself off the bed. "Good luck, girl."

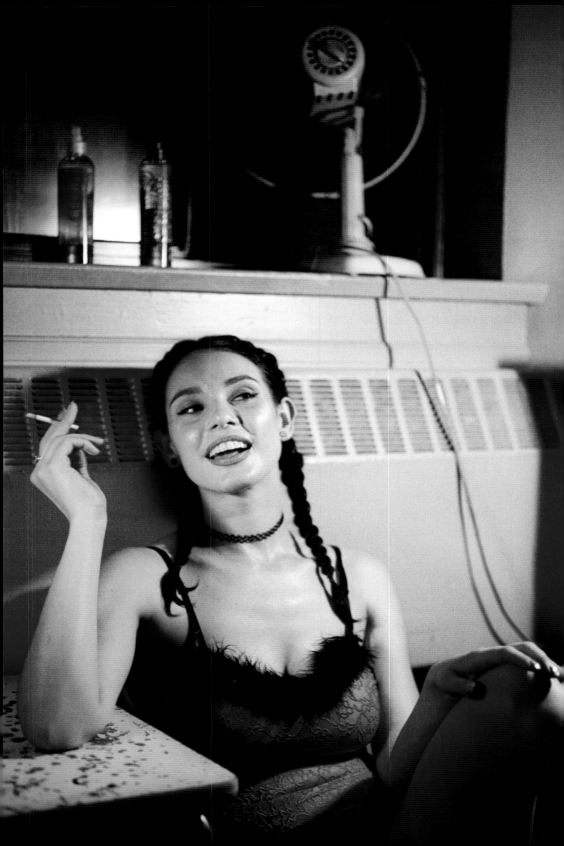

"Thanks," she replies. "I think I'm gonna get outta here too, and try one more time. If there's nothing, there's nothing. But I should probably make some sort of attempt, right?"

We leave the room together. She turns to the right to go straight downstairs, and I turn to the left to return to the locker room.

"Better to try," I offer. "It just takes one, as they say."

"True!" she responds. "Okay, good luck!"

"Good luck, you!" I shout back.

The same beautiful women are primping themselves up in front of the mirrors, passing a nearly empty bottle of tequila. The dancers hush momentarily as I enter the room, and just as quickly return to their conversations. At my locker, I put my cow slippers away, spray myself down with perfume, strap in my heels, and return to the grind.

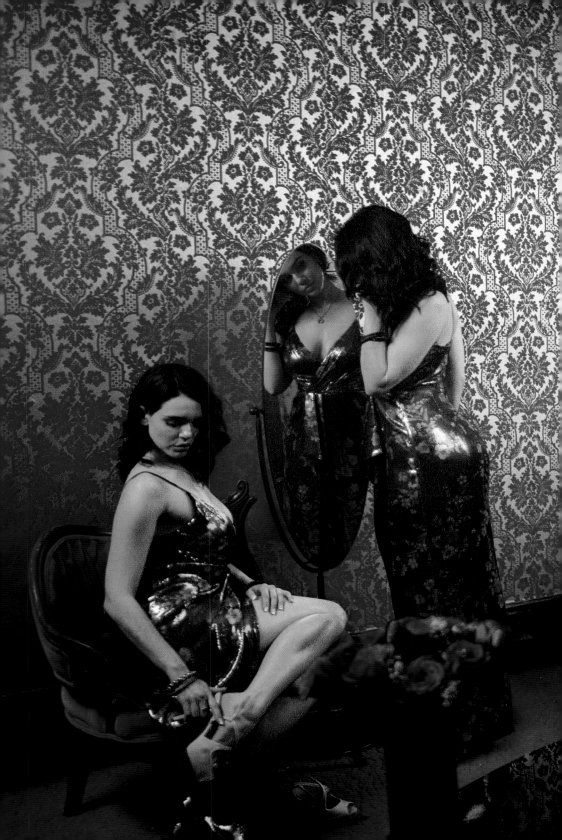

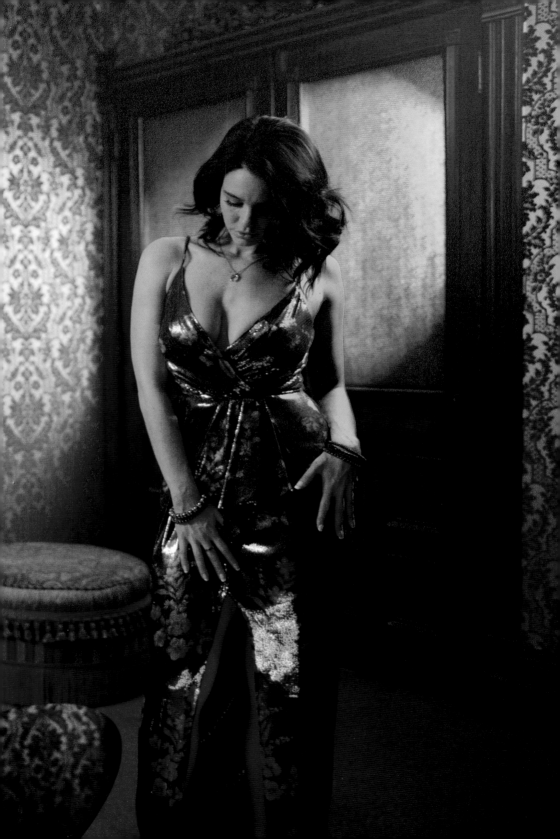

Baby STRIPPER

My first time was in ninth grade. In front of my entire school.

I was cast as one of six Hot Box Girls in the musical *Guys and Dolls*, a 1930s-themed hop rife with bobby socks, pouty lips, and a whole lotta shakin' going on. As a "niner," it was my musical theatre debut, and I was absolutely thrilled.

The choreographer—Mimi, a special needs teacher we got to call by her first name—envisioned a row of pretty girls doing boxsteps and, with the help of velcro, escaping the confines of our long, dowdy skirts by flashing the audience our unitard-clad teen bodies. A team of moms in wardrobe got to work right away, and a simple skirt was made fit for our flesh.

After months of rehearsals, we previewed "Take Back Your Mink" to our eager high school audience. While some of us girls were excited, others shook in their kitten heels, pre-emptively embarrassed. Me? I was ready. Giddy. Waiting in the wings and thinking to myself: *If they want a show, I'm gonna give 'em a show!*

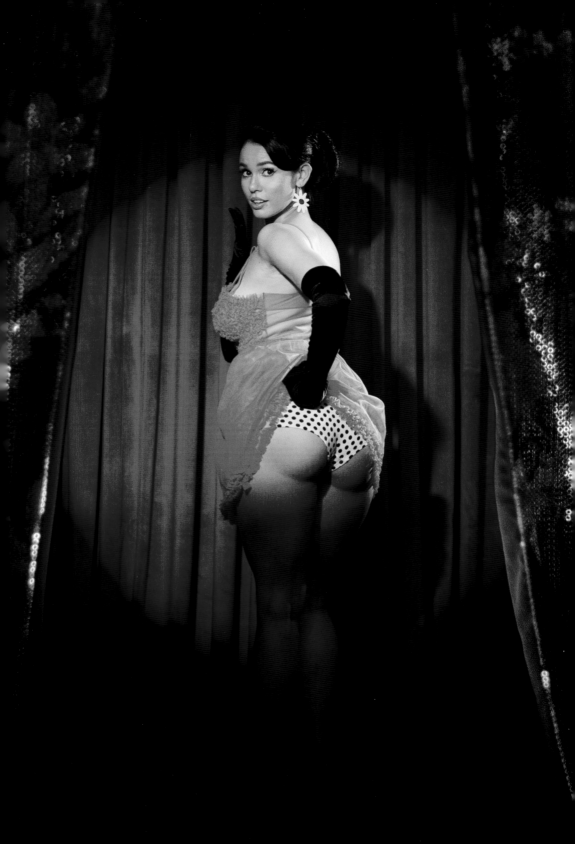

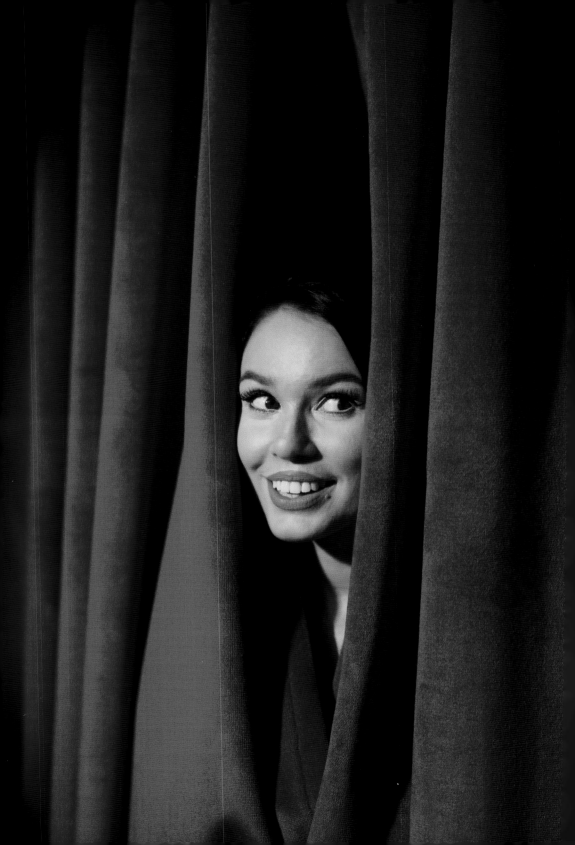

Thirteen years old, baby. The curtain closed and we scurried to our positions, centre stage. Deep breath. The curtain opened. Hormonal screaming from the teenage crowd. We did our song and dance, we grabbed the velcro at our waists, rotated our hips, and in one dramatic moment, we ripped off our skirts and revealed our unitards. The crowd gasped and cheered as we tossed those dowdy skirts upstage, gleefully dancing, effectively, in our underwear.

We got a huge round of applause. We sauntered off stage and I'd never felt more alive. I wanted to do it again and again and again—the teasing, the titillation, the riled-up crowd, the hootin' and the hollerin', the singin' and the dancin'—more, more, more.

I thought: *How can I make this feeling my living?*

Ten after one on a Saturday night. Five generous clients. Three new guys. Two regulars. One more round. Then, bed.

I descend the stairs, a cash cow in fishnets and not much else. I graze the room, searching for moneyed pastures. Coked-out suits. Handsy bachelor party bros. Dejected Toronto sports fans.

Packed house. I spy a young, hot guy with Allen Ginsberg vibes sitting alone at the rail. Thick-rimmed glasses and gentle demeanour, but with tattoos and muscle bursting from a white T-shirt. Just my type. Money? Maybe not. But my body is hungry and his countenance screams *sustenance*. I've made enough tonight. His eyes remain faithfully focused on the dancer onstage, a studious pupil at his master's feet. Three beers, two Jameson shots, one fat joint in, just wait till you see me. I'LL BE YOUR TEACHER, BABY.

I settle on a feel-good disco set. I strut onto the stage. I have the attention of every man in this room, but I only perform for one. I sway my hips, writhing against the pole, stroking my pussy.

My flesh casts the desired spell. Faithful adoration in his eyes, a crisp $20 bill in his hand. I spin down the pole to retrieve his offering, a pretty picture on my knees.

"I'll come see you," I whisper warmly into his ear.

"Please do," he responds.

I dance the rest of my set in a frenzy. At the end, drenched in sweat, I make a beeline for my courteous tipper.

"Hi!" I beam.

"*Hellooo Sophia!*" he grins right back with his best DJ impression. "Please, take a seat. Would you like a drink? Would you like my soul? You were incredible up there."

"Thank you, I would *love* a drink," I say, placing my hanky on the chair. "And yes, I'll take your soul, too. Thanks for that onstage offering."

"Worth every penny. You're easily the most beautiful woman in this room."

I look around. Oversized silicone breasts, perfect flat tummies, tiny little waists, big perky asses, hair extensions, fake lashes, nose jobs, lip injections, taut skin: all the beauty money could buy had been sold to the women of this room. And yet, the most beautiful man here is telling me that *I* am beautiful. I'm not ugly by any stretch of the imagination, but the bar set by expensive women is high. His words validate my big, floppy, natural titties; my cellulite, my zits, my frizzy hair. He says I'm beautiful. He seems so sure. I almost believe him.

"Thank you," I say. "What's your name?"

"Johnny," he says. "Pleasure to meet you."

"Likewise." I grin. "And what brings you to this illustrious institution this evening?"

"Lookin' to get inspired. I think I've come to the right place."

"Are you an artist?" I ask.

"A poet."

"Ah," I exhale. "And how does a poet make a living?"

"Construction work." He smiles. "But I'd rather be writing."

Sipping tall gin and sodas, we are still talking, unheard of on a Saturday night. More unheard of at the club is the subject matter: religion, politics, music, books. A poet! A rabble-rouser! Well versed in all of my interests! Funny, too. I'm in trouble.

"I don't suppose you'd want to go upstairs for a dance," I say. I'm genuinely happy just sitting with him. A truly anti-stripper sentiment.

"I thought you'd never ask," he says.

"Really?"

"Of course! Look at you! You're so hot, it's mind-boggling. And you've been so generous with your time. Of course, I'd love to go upstairs with you."

"Yee-haw! Do you have a stamp?"

"I do indeed," he says, which means he's already been to the VIP. Which means I can lead the hottest man to ever walk through the doors of Tomcat's straight upstairs to the lap dance of his life.

"Well then," I say. "Let the dry-humping begin."

All the booths are taken, save for one on the "extras" side of the VIP. This is unfamiliar territory. I've never done the ol' suck and fuck at work. I'm a good girl.

"We'll start on the next song," I say customarily, sitting in front of him to take off my shoes. The VIP is where I make my money *and* temporarily release myself from the bondage of my eight-inch torture devices.

Johnny takes a foot in his hand. I remove my fishnets for easier access. He rubs my soles.

"Just for a little bit," he says. "I want to make you feel good."

"This is foreplay and I love it," I say, looking at him. His gaze is steady. His manner calm. His hands oh-so-strong. Handsome as all hell. Trouble trouble trouble.

Five songs later and dripping wet, I hop on his lap. Crotches and foreheads meet in a surge of electricity, as I grind for ever more friction. His large hands grip my fleshy ass, and I palm that hard cock over his pants. I take my top off, our lips almost touching, breathe

into his sweetly scented beard. Writhing. Humping. Grinding. He sucks his teeth.

Another five songs pass. I have never wanted to touch a client's cock so bad. I let his fingers traverse my pubes, my lips, my clit, inside, one, two, three, reaching up deep, hitting me just where I need it. I unbuckle his belt. I have to know. Under his boxers soft, taut flesh awaits my hand, the girth of his member a real treat. I jerk him as he strokes my pussy. Mutually sweaty.

"How many songs has it been?" he asks under his breath. Neither of us wants to stop. But he has to know, and I have to tell him.

"Fifteen," I say. Not my fault we're having such a good time!

"Whew. This'll be the last song then," he says in that polite, soft-spoken way of his. Or is he just out of breath?

"Of course," I say, my hand never leaving that gargantuan cock. I continue to shamelessly stroke him.

I stroke Johnny so good, he jizzes in his pants—just in time for the end of the song. Panting, our heads touching.

I'm not done with him. I want more. We are quiet in the afterglow.

I pierce the silence with an indecent proposal.

"Do you . . . wanna go out sometime?"

"I was just about to ask you the same thing."

$300 later, I give Johnny my number.

"You can call me Andrea," I say.

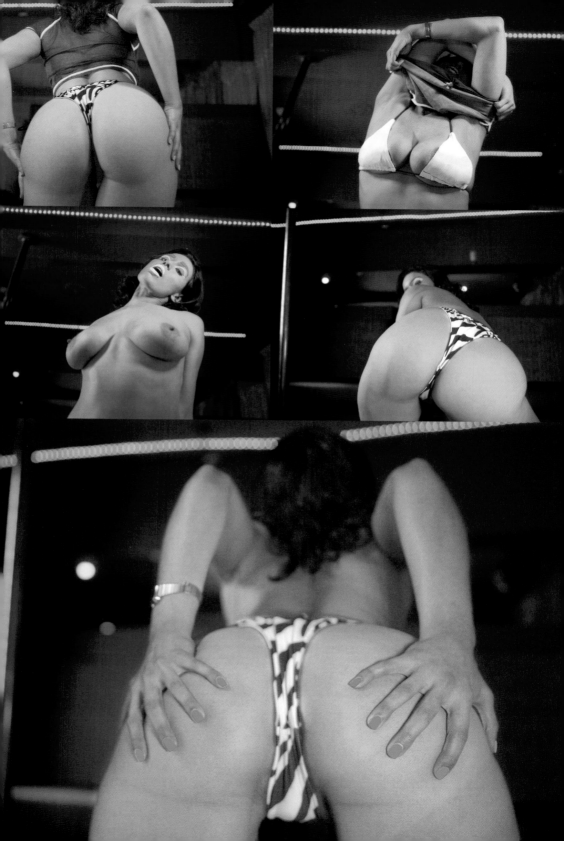

piss guy

He approached me for a dance, reeking of something familiar—yes, it was the way my grandmother smelled before she died. Despite the offensive odour, I decided to go for it anyway. I was PMSing and hadn't made any money yet, so why say no to a man who's made my job easy?

We settled into the VIP and the moment I sat on his lap, I felt a dampness. I bolted up.

"Did you piss yourself, man?"

The elderly gentleman, I'd venture in his early seventies, was bewildered. And, like a man who pisses his pants every day, he said: "Did I? No, I haven't—me? Piss my pants? No! That's crazy!"

I wasn't buying it. I told him he smelled like pee so I wasn't gonna sit on his lap, but rather dance near him, and touch him as I saw fit.

He roughly caressed my back, his long nails scratching me after repeated requests for softness.

About four songs in, Piss Guy asked me to stop dancing and sit next to him in the booth. Like a good stripper, I obeyed.

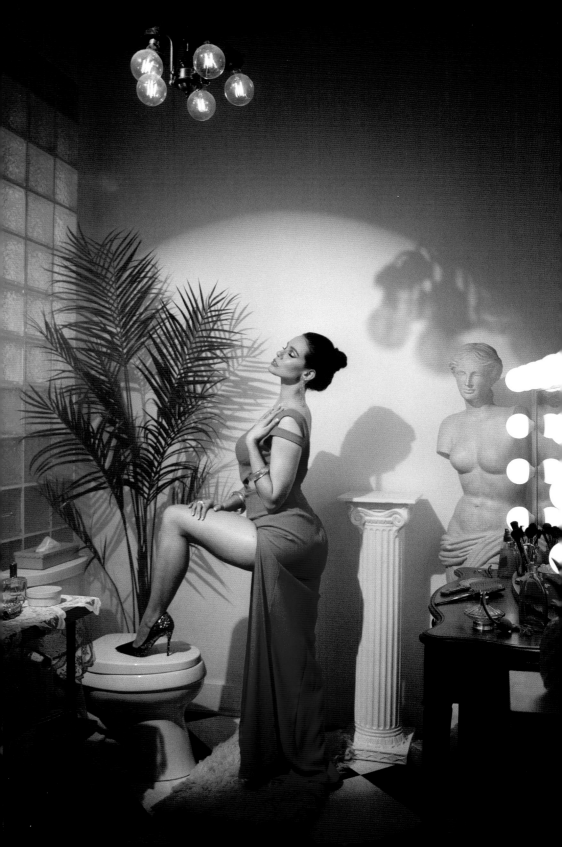

He told me he lived in an upscale shelter for people recovering from addiction, deer on his doorstep. He explained that his wife of thirty-five years had passed away recently, which had sent him into a spiral, and eventually a mental hospital.

At ten songs, I offered a courtesy "Just so you know, this is the tenth song."

It didn't go well.

"But we were just talking," he said, a terror in his eyes.

"Them's the rules," I said, pointing to a sign in the booth that declared songs were worth $20 a tune.

I explained that I was a beautiful naked woman sitting next to him in a semi-private booth. How could this possibly be free? If he had just wanted to "talk," we could've wrapped up much sooner and sat at the bar.

"Oh, you're just here for the money," he said.

"Yes," I replied. "I'm at work."

"I thought we had something special!" he blathered.

And so, the incontinent old man, recently widowed and fresh from the mental hospital, owed me $200. Now, let me guess . . .

The civilians are thinking, *Give the guy a break!*

And the sex workers are screaming, *Get your money, girl!*

Experience has made me wise. You don't come to the strip club to talk to nice girls—you can go to the mall for that, grandpa. You come to the strip club to swim with the sharks. And you sure as hell don't get to hang out in the VIP for free. It wasn't his first time at a strip club. How could I know he wasn't taking *me* for a ride?

While a part of me sympathized, most of me was resolute to get my $200. Maybe if I'd made any other money that night, I would have been willing to cut him

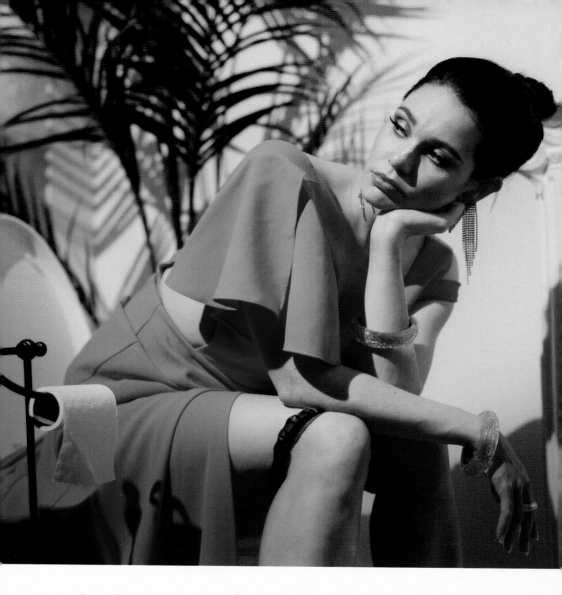

a break. But Piss Guy only had $45 in his wallet, not even enough to cover the four songs during which I'd actually danced. This fact tipped the scale. Procuring a service without paying for it is theft. If I gave him a discount, I would be discounting myself.

So, I led Piss Guy to the ATM, and when he had technical difficulties at the machine, I helped him press the right buttons to take his money out. Because when you've danced for a man who's pissed his pants, you've earned every damn cent.

My Peers

When I first started doing outreach work, I was nervous. I'd applied for a peer outreach worker position at Maggie's, Canada's longest-running sex worker advocacy organization, because I had a deep yearning to be more involved in our community. I'd never worked the street or known anyone who had engaged in outdoor sex work. I felt sheltered.

At most, street-based outdoor sex work accounts for 20 per cent of the overall trade. While those who work outdoors are a minority in the sex industry, they are, by far, the most vulnerable to violence—both from clientele and from law enforcement. Black, Indigenous, and other people of colour; LGBTQ+ folks, especially trans women; the precariously housed or homeless; drug users; the disabled and neurodivergent; and those who are in and out of the justice system are disproportionately represented in street sex work. As far as the whorearchy is concerned— that is, the class hierarchy within sex work—you've got your high-class independent escorts at the top, and street-based sex workers on the bottom.

In Canada, the federal law against "public communication for the purposes of engaging in prostitution" accounts for 90 per cent of all sex work-related charges—and excessively targets outdoor sex workers. That's why sex workers like me—white cisgendered women who work indoors and cater to a well-heeled clientele—can comfortably trust that the cops will turn a "blind eye" to our work.

When I started my training at Maggie's, I was so naive. As my new peers and I discussed the police, I wondered aloud if it were possible to create some sort of coalition with law enforcement.

"Ha, working with the cops—that's rich."

"The police would rather get freebies than help us!"

"They'll threaten you with jail time just to get a free blow job."

"*That happens?*" I asked, an innocent, ignorant, privileged little child.

"Of course it does!"

"Journalists should be covering this!" I said, indignant.

"Oh, no one cares about us," came the response. "No one believes us."

Sex worker street outreach isn't a daytime gig. I worked the trans stroll at 2 a.m. after my Saturday night stripping shift. My outreach partner was Miss M, a sixty-something streetwise wonder known and beloved by all, who suggested I keep my earnings hidden in a money belt during our shift. Luckily for me, I'd found an old, discarded stripper ankle wallet in the locker room donation bin.

The locker room donation bin, it must be said, was a wonder of collective stripper-ware re-distribution. Lightly worn shoes, outfits, and bandanas were tossed in the bin to be accessed by all. On my first week, I snatched a black pair of Pleasers from the bin in my size. All they needed was a trip to the cobbler to replace the broken ankle clasps, and $15 later, I had my perfect shoes. They lasted me my entire career.

When I became an outreach worker, I had to figure out how to do outreach with my strip club peers. Since the donation bin was a well-established self-regulating sharing scheme, I placed another inconspicuous bin on the edge of a mirrored counter where the girls did their

makeup. When no one was looking, I filled the bin with tampons, condoms, and lube, all supplied by Maggie's. Not only were dancers taking from the bin, but I was happily surprised to discover they were leaving goodies as well. Unopened lipsticks, half-used perfumes, more condoms. I rejoiced: the system was working.

One day the bin disappeared. I assume it was discarded by the club's owner, who probably felt dancers should pay for their tampons at the front desk.

The first time Miss M and I went out together, Miss M called to say that she'd gotten on the wrong bus. Would I mind waiting another twenty minutes? For Miss M, anything.

I sat across the street on the grass of Allan Gardens, slurping down a Don Wan meal with chopsticks. The street was mostly vacant. The stroll, however, was bumping, and I was eager to get started.

Miss M arrived, gasping, apologizing profusely.

"Let's get to work!" she said, leading the way. We charged up the stroll with our names on lanyards and kitbags in tow.

"Maggie's outreach!" Miss M called cheerfully to every worker. "Ya need any supplies? Condoms, pipes?"

We had safer sex kits, crack kits, meth kits, needle kits. Sometimes they'd take a kit, but mostly they asked:

"Do you have any water?"

"What about food?"

"Maybe a pair of winter gloves?"

Doing outreach gave us an opportunity to find out exactly what street sex workers needed. Harm reduction is essential, but it's nice to have water and granola bars on hand, too. Gloves, scarves, and hats for those long winter nights are even nicer!

Sometimes, when I couldn't get a hold of Miss M, I worked the stroll with Saharla, a beautiful Black trans woman. If I wanted to get out of the club a little early, we'd meet at Fran's, the local 24-hour diner, and share a meal. If I was on a roll at the club and wanted to meet a little later, that was all right, too. She lived nearby and was easygoing. Besides, it's sex worker code to never get in the way of a peer's money.

Saharla knew people on the stroll. One evening, I found her chatting on the corner with two working women, old friends. Both were sitting pretty on a wooden rail and smoking cigarettes, one eye always on the passing cars that slowed to give us a look. Saharla could point out which cars were driven by regulars, which were driven by undercover cops—and which undercover cops were regulars. One of the chatting women was a dead ringer for Paris Hilton, blonde and blinged out. A car approached, she jumped into the vehicle's passenger seat, and off they went.

"Lucky bitch," her friend said jokingly. "I don't feel like working tonight. I'm just gonna sit here and play it cool. If they want me, they'll come to me. I'm not doing shit."

I laughed and shook my head.

"I literally just got outta my shift down at Tomcat's," I told her, "and said the exact same thing to myself."

Whether it's on the street or in the club, the hotel room or the parlour, the incall or the dungeon, the hustle is the same. The whorearchy divides us, but we are all equals. Doesn't matter if you're making bank at the top or working to survive on the bottom: *a whore is a whore.*

One evening, Miss M and I approached a woman standing by an empty storefront.

"Hi," I said. "We're with Maggie's outreach."

"Oh, I'm fine," the beautifully made-up woman quickly replied. "I'm a dental hygienist. I do this for fun."

"Awesome!" I said, merrily taken aback. "Good luck and have a great night."

"Let us know if you need anything," Miss M said as we walked away. "We're here every Saturday!"

"God bless you!" the woman called back to us with a wave.

The sad reality of peer outreach work is that death, too, becomes a peer. With uncanny regularity, we experience the sudden loss of people we saw just last week, people we worked with, people with whom we shared stories and hearty laughs.

I started outreach work feeling like a privileged outsider, but quickly found common ground with my sex-working sisters. I had just published

the first edition of *Modern Whore*, and I was happily surprised, honoured, and a little embarrassed when our program manager announced that she would be buying copies of the book for every single peer and for Maggie's to have on hand for our service users. The peers were excited, and shared how much they loved the book.

After one of our weekly peer meetings, Amanda, a sweet woman with street-based experience, pulled the book out of her bag and said, "It makes me feel like I don't have to be ashamed of myself." My eyes welled up and so did hers. Within a few months, she was gone.

Everyone knew Miss M, and to know Miss M was to love Miss M. She was kind, funny, and a talented teller of tales. Once we finished the first round of our route, I'd pass her a container of Don Wan's food and we'd sit and chat.

Miss M was the same age as my mother. She asked about my mom, asked if she was good. I told her my mother was very good.

"You're lucky," she said. "My mother made it clear she didn't want me around. That I was unwanted. A mistake."

I winced at every word.

"Ah, it's okay," she said. "Just the way it was."

She told me about the son she was very proud of, his house and family in the suburbs. They didn't talk much.

Miss M started hooking at seventeen at the Royal York Hotel. A young, stunning Black girl.

"Back then," she said, "they had a separate entrance for the hookers. They knew what was going on. And I was pretty, believe it or not. Very pretty, and *very* popular."

I believed it. My grandmother worked at the Royal York Hotel, too, as a cleaner. So did my great-grandmother. Imagine—had they ever crossed paths?

Miss M had worked the streets but, "I never did anything for less than a hundred," she said. "Too much pride. Just couldn't do it."

She advised me to make as much money as I could while I was still young. "Nobody wants to buy pussy off an old lady, trust me!"

But her most important lesson? "Never let a man manage your money. He starts doing that and then he wants more. And then, he's beating you."

I'd walk Miss M to the stop and wait with her till the streetcar arrived. It was usually around then she'd ask, "Hey, can I borrow a twenty? I'm good for it!" For Miss M, anything. I'd roll up my pants, look over my shoulder, and fish out a $20 bill or two from my tattered ankle money belt. Next time I'd see her, whether it was at outreach or at Maggie's, she'd have the money owed in hand.

"See," she'd say. "I'm a woman of my word!"

"Yes, you are," I'd say, smiling. Never doubting her for a second.

Surrounded by family, Miss M passed away on November 9, 2020.

A peer loved by all.

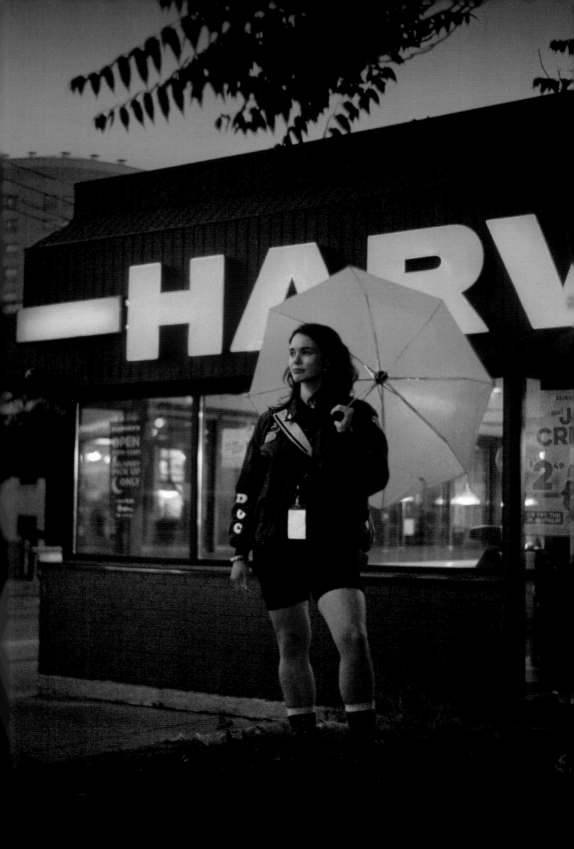

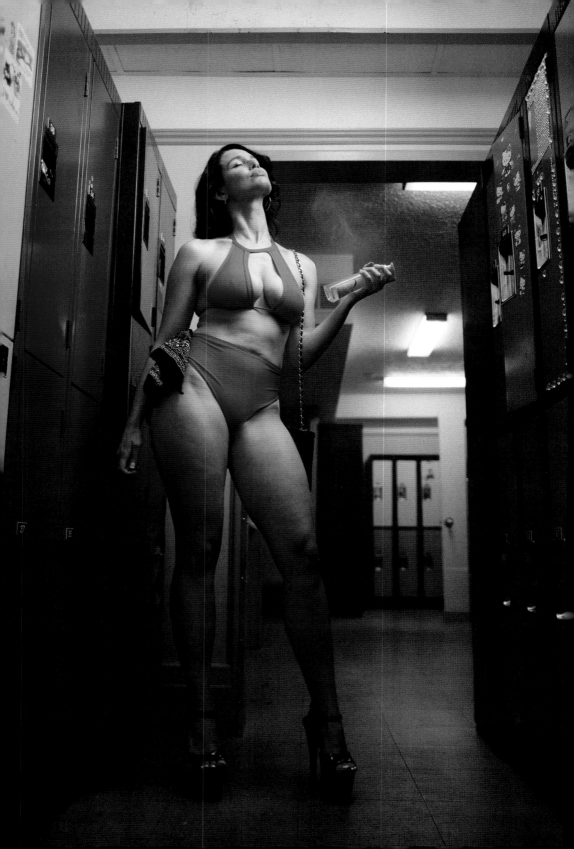

NO PROBLEM

Joe had been a regular since the beginning of my stripping career. He was an enthusiastic *underspender*, someone who liked me very much but would only take me up for two songs. Short and round, sporting a thick moustache and a thicker musk, Joe didn't speak English, with the exception of a few phrases: "I love you," "Thank you," "No problem," "Okay," "Very beautiful," "Finish," and "Next time." Every word was delivered with a beaming smile and a twinkle in his eye. Genuine devotion transcended the impediments of language.

In the VIP booth, Joe gripped my flesh with a mix of panic, passion, and desperation. For six minutes, he inhaled me like his life depended on it. As he stole away from the club with a bit of my essence, he always left me with a bit of his, too. After two dances with Joe, I reeked of his familiar bouquet of sweat and cologne. His moustache would leave me with a blotch of red-hot rashes across my chest. A splash of cold water and a heavy spray-down of perfume usually did the trick.

Joe and a friend always sat in the same stage-side seats in the corner of the club. When I danced, Joe would blow me kisses, drop $5 bills at my feet, or even jump up and lay down on the stage with a bill in his mouth. Giggling as I rode him in front of the audience, he'd smile proudly and say, "Very beautiful, thank you."

A true patron of the arts.

During one performance, Joe and his friend, a younger man, gesticulated wildly that I *needed* to come visit them after my show. "Okay, fine!" I laughed from the stage.

Joe's friend was a salsa teacher, and I sat squished between the two.

"He talks about you all the time," the young man said. "You are the best dancer up there."

"That's a nice thing to hear from a dance teacher!" I said.

"It's true," he replied. "And Joe says he'll never go up with anyone else. Just you. He doesn't want to waste his time."

I looked at Joe like an old friend as he smiled shyly, nodding his head, intermittently saying, "I love you" and "Very beautiful," his hand on my thigh. He spoke to the salsa teacher and translation services were offered.

"He says he will go to the washroom now and then go for a dance with you."

"No problem," I said mischievously.

As I patiently awaited Joe's return, the salsa teacher stood up to teach me some moves—arm in arm, upstaging the dancer performing next to us, attracting attention from the rest of the crowd. Delight with a side of shame. When Joe returned, we eagerly went upstairs, this time for five songs. A hundred, I could do.

The next few times I saw Joe, we re-enacted this ritual: him and the salsa teacher summoning me from the stage, him going to the washroom, us going up for five songs—until the language barrier stopped us in our tracks.

One night, Joe was getting particularly handsy in the booth, and I was getting frustrated. I always informed him of song count as soon as a new one started, just so there were no misunderstandings. This time, I was counting down to five, wanting to get the hell out of there.

"This is the end of the fifth song," I said, hopping off. It turned out he wanted another one.

"No problem!" he said. His catch-all response to everything.

When I told him to stop fingering my butthole and swatted away his hands, his response was "No problem!" It was amazing how far we'd come in three years without ever really talking to one another.

He went for the seventh song. I was surprised but kept going. Money is money.

"Okay, finish," he said with a big grin on his face. "Thank you."

He gave me five $20s.

"No," I said. "Seven."

"No problem," he said, reluctantly reaching into his wallet for one more $20.

"No," I said. "One more. You owe me for seven songs."

"No problem," he said, again with a smile. "Next time."

"No next time," I said, standing my ground. I pointed to the service button in the booth. It meant I would be calling security if we *did* have a problem. "You owe me twenty dollars now."

"No problem," he repeated in a lower octave. "Next time."

He became livid. His "No problem" went from jovial to vitriolic. He reached into his wallet and pulled out two $5 bills. I took the liberty of reaching in and taking two more. The money was mine.

"Finished," he gritted out angrily, and left.

I shrugged. Don't come into the club, get a dance, and expect a discount—especially without asking first. I could have cut him some slack, but he shouldn't have been trying to play stink finger with my butthole, either.

Joe disappeared. A month later, right before the pandemic struck, he was back—back to his stage-side seat in the corner, back to tipping me with a five in his mouth onstage, back to telling me he loved me and that I was very beautiful, back to paying me $100 for lap dances, and back to respecting my boundaries. No problem.

STREET

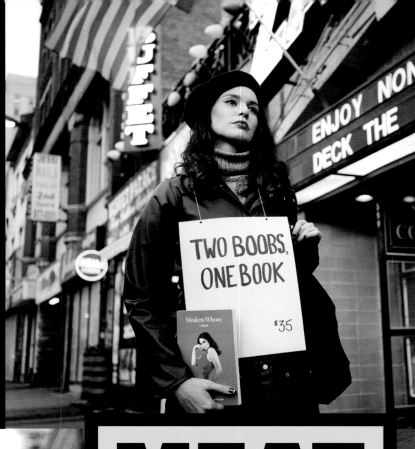

TWO BOOBS, ONE BOOK

$35

MEAT

PROSE FOR BANKER BROS

$35

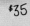

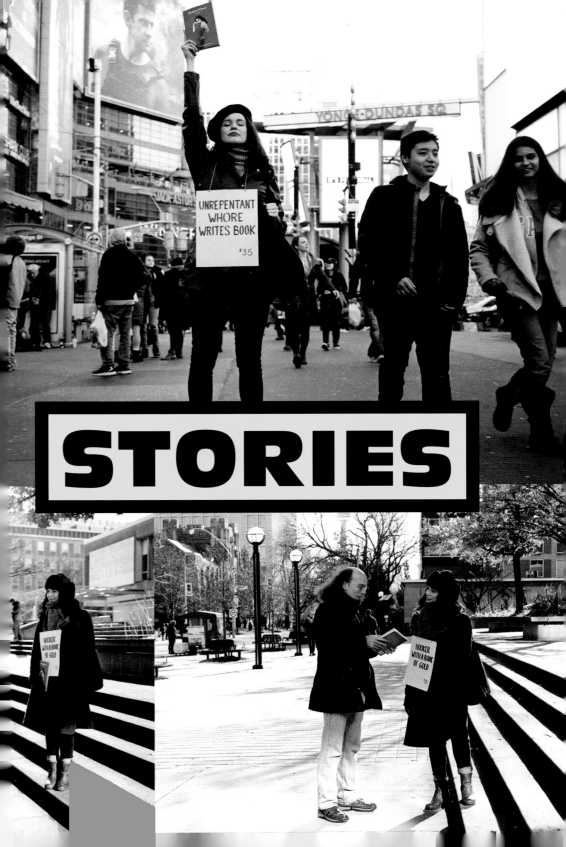

UNREPENTANT
WHORE
WRITES BOOK

$35

STORIES

HOOKER
WITH A BOOK
OF GOLD

HOOKER
WITH A BOOK
OF GOLD

$35

All these girls have to wait for is a man with $70 and an itchy cock. I have to wait for someone with $3 *who reads literature*.
—Crad Kilodney, *Excrement* (1988)

Writing and whoring—selling a body or a body of work—what's the difference?

Toronto, December 1983. Crad Kilodney, the legendary self-described "failed writer," is selling his self-published book, *Terminal Ward*, from a vacant storefront on the Yonge Street strip, somewhere between Gerrard and Dundas. Hanging from his neck each day is a handwritten sign, and today's placard reads, "Pleasant Bedtime Reading."

Other notable signs include "Books for Clueless Twits" and "Literature for Mindless Blobs." In his memoir, *Excrement*, Crad writes, "I choose my most provocative or insulting signs to wear when I'm in my most aggressive moods because deep down I want to strangle these people."

This—writing and selling his wares in the street, getting accosted by drunks, ignored by the masses, and making very few sales—is his full-time job. Crad comes back every day to sell his books, published by his personal imprint, Charnel House. By the end of his life, he'll have written more than thirty books, and spent seventeen years selling them out on the street.

Like writing, sex work is a game of endurance. Whether in the club or on the street, scribbling in a journal or revising the last draft of a manuscript, the writer and the whore must learn to "stick it out" and be patient with the process.

For me, being on the street is like treading water: the object is to expend the minimum amount of energy and hold out as long as you can. This is why I don't solicit people. I keep my mouth shut and just stand there waiting for someone to stop.

Crad's philosophy on selling his work sounds a lot like how I approach my hustle at the strip club: stand there, look pretty, and wait for a man to approach me. Sure, I could probably make more money if I hopped from table to table asking, "Where ya from? Want a blowie?" but I'm looking to conserve my mental and emotional resources, not expend them on timewasters. If you want me, come get me. I'm not casting my pearls to swine. Quality over quantity, baby.

My introduction to Crad was through my boyfriend's dad's book collection. He'd bought a few original works from Crad himself back in the '80s when he was a University of Toronto student. I read *Bang Heads Here, Suffering Bastards* first. "The Story of a Man with a Broken Toaster," about the tragic end that can befall teachers who dole out passing grades willy-nilly, gripped me by the throat. *This is the kind of writer I want to be!* I thought. I read more, voraciously, and while much of his writing struck me as in need of a good editor, I deeply appreciated Crad's do-it-yourself approach to publishing. That he was part of what inspired Nicole and me to self-publish the first edition of *Modern Whore* would be an understatement.

Nicole's father, Dan Bazuin, used to co-run a famous little bookstore in the Village called This Ain't the Rosedale Library, one of the few shops that sold Crad's books. When I expressed my new-found love of his work to Nicole, she told me Dan and Crad were friends. She'd actually met him a couple times. *Wowee!*

I eventually got my hands on more of Crad's work by trading copies with Pete, the strip club's night-shift front desk guy, who had also bought books directly from the author. Thanks to him, I read Crad's memoirs, *Putrid Scum*, *Excrement*, and the short story collection *I Chewed Mrs. Ewing's Raw Guts and Other Stories*. In exchange, he got my copies of *Terminal Ward* and *Suburban Chicken Strangling Stories*. It felt like dealing contraband. Tomcat's, of course, was the perfect setting for our clandestine Crad book club.

Not everyone is cut out for the hustle of the writer or the whore. For

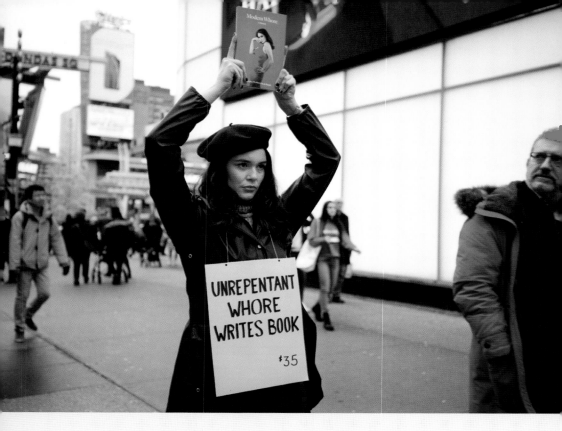

those who are, it can feel like a matter of life or death. Many writers feel they don't have any other options—they must write, *or they will die*. Have you ever met a more miserable workforce? Writers love waxing poetic about the tortuous miseries of writing. Is there such a thing as a happy writer? At least I *like* whoring.

Whoring is a means of survival, yes. When faced with the option of working more hours for less money with no control over their schedule, the sex worker may feel "forced" to preserve their dignity and return to whoring. For some, whoring is simply a means to an end: a way to pay the bills, put food on the table, and keep the lights on. For others, whoring is vocational: a calling, a connection to one's higher purpose, the thing they are meant to do in this life.

Evidently, Crad's resiliency and determination to make it as a living writer—which is to say, both a full-time writer, and one who was also alive—suggest writing was his calling.

Whenever I considered giving up on the street, several thoughts hit me: I imagined myself in the future as another failed writer about whom it would be asked (as it was about every flash in the pan), "Whatever became of him?" I hated to think of myself as being cast into the hell of whatever-be came-of. Then I thought of all the lousy jobs I'd had before walking out on all that to become a full-time writer. I couldn't go back to another shit job; neither could I work up any enthusiasm for a better job requiring some commitment. All I wanted to do was write.

Writing is a calling for me, too; whoring is somewhere between occupational and vocational. Sex work is my job, the thing I do to pay my bills—and, it must be said, the frequent subject of my work—so that maybe, one day, writing—perhaps about something else!—can be my full-time job. May a whore dream?

Sex work puts the mind, body, and soul on display—as does writing. Writers and sex workers are public figures ripe for dissection. We peddle our guts for a living, our incredibly intimate bodies of work for sale, whether it's on Yonge Street, at the strip club, or on the shelves of Chapters Indigo. Buy my story. Buy my body.

For the writers who claim their lives are misery, we, the reader, only validate and glorify that pain. We support their addictions, feed their demons, because they give us what we want: their body of work. Is the reader exploitative, then? Are you, dear reader, a dirty john?

In early 2014, Nicole told me Crad was sick with cancer. Did I want to go with her and Dan to visit him in the hospital? I felt starstruck and intimidated by the notion, so I said no. A few months later, after reading yet another one of his books, I mustered up the courage and gave Nicole a ring: I was ready to visit Crad. Too late, came the response. He was dead. Seventeen years on the street and thirty-three books later: gone. I was gutted.

How stupid I was. In Crad's name, I vowed I would never hesitate to visit someone—let alone a hero—on their deathbed. He would have liked me, I think. Street meat, just like him.

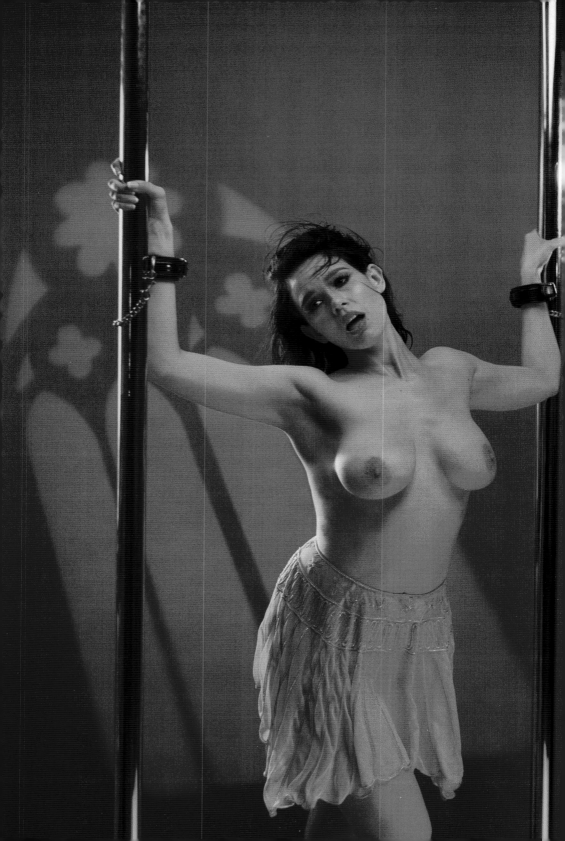

Sweet Agatha

The Story of Saint Agatha, c. 231-c. 251 AD, Italy

Saint Agatha was a virgin martyr, one of the original saints of the Catholic pantheon. At fifteen, she refused the sexual advances of a Roman magistrate and was punished with imprisonment. She was devoted to Jesus Christ at a time when Christians were put to death, so the magistrate used the state to punish Agatha for saying no. For this mortal sin of maintaining personal boundaries, Agatha endured a litany of abuses. She was stretched on a rack with iron hooks; burned with torches; raked over glass and hot coals. Most famously, her breasts were cut off with pincers in the public square.

After each punishment, the scorned magistrate would ask Agatha if she'd given up her faith in Christ. That is, was she finally ready to have sex with him? Each time, she prayed for the courage to stay true to herself and to God. Finally, the magistrate sentenced Agatha to be burned at the stake—but an unexpected earthquake saved her from that fate.

Having endured five years of tortuous incarceration, Agatha prayed for death and was granted her wish. She was twenty years old.

Saint Agatha is the patron saint of rape and torture survivors, breast cancer patients, and wetnurses. She also offers protection from natural disasters, particularly fire. She is often depicted with a pair of pincers, or holding her severed breasts on a silver platter. Her feast is celebrated on February 5.

The Story of Saint Agatha, 2003, Toronto

When Agatha was fifteen, waiting for the bus in winter meant waiting in the dark. She was an overachiever in those days. After school, she engaged in every extracurricular she could try out for, and if she didn't have practice, she got her homework done at the library. Her conservative family had high expectations for her: straight As, star athlete, virgin till marriage. She was a good girl. She did what she was told.

Her Catholic school uniform consisted of a tight white button-up shirt, knee-high socks, and kilt: candy for perverts. Standing alone at the

bus shelter did little to protect her from the cold and bluster of a Canadian winter, and the bus was always running twenty minutes late.

One frigid night after basketball practice, a black suv slowed down in front of the stop. A man in a suit, hair greased back with a wide, toothy grin, rolled down the passenger-side window.

"Hey," he shouted, both friendly and fast, "you want a ride?"

"No thanks," Agatha said.

"You sure?"

"Yeah, I'm good," Agatha said.

"Please?" he begged. "Get in the car."

"No," she said, alarmed yet obliged to be polite. "Thanks, though."

"Why not?" he pushed. "You're going to freeze out here. Just trust me, okay? I'll get you home, I promise."

"Wait . . ." Something jiggled Agatha's memory. She'd seen this man on the news before. She leaned in closer to the suv. "Aren't you—"

The suited man chuckled. "Yes, I'm Mr. Ontario. I run the provincial government. You caught me. Now come on in and let me drive you home."

Agatha looked around. Hundreds of cars whizzed by, but there was no one on foot within earshot. North Toronto was a wasteland. She still couldn't see the blue lights of the bus in the distance, and she couldn't feel her fingers. Her bare legs in the sub-zero weather were on the verge of frostbite. Despite her discomfort, she would never jump into a car with a stranger—but was the premier a stranger? *I think my mom voted for him*, she thought.

"Don't make me beg! I'm just trying to help you." He reached over and opened the door with his hand.

"Okay, fine," Agatha said, shivering, relinquishing herself to the front seat of his suv.

"Atta girl," he said, locking the doors. "Wanna give me a blow job?"

When Agatha woke up, she was on his basement floor. Cold cement against her swollen face, her hands and legs bound. Blood in her mouth. She felt like a stranger in her own body.

In a dark corner, a floating red ember lit up bright. A backdrop of hanging smoke.

"Well . . ." A smouldering voice emerged from the haze. "She's awake."

"What . . . happened?" Agatha asked, her voice an unfamiliar crackle of sound.

"*What happened?*" the premier snickered. "You solicited me, don't you remember? This province has a real problem with underage prostitution," he said, emerging from his dark corner and walking towards her.

"Disgusting. Sad, really." He shook his head. "And what will your parents say? What a shame."

Agatha trembled and sobbed. Solicited him? What did that even mean?

"I just wanted to drive you home," he said, taking her chin in his hands, bringing his face close to hers. "And all I wanted in return was a blow job. Oh, little girl," he pouted, taking a pull on his cigarette and blowing the smoke in her face. "No one says no to the premier."

He let go of her and walked towards a wall of hanging tools, reaching for a pair of garden shears. With the cigarette in his mouth, he clasped the handles with both hands and thrust them together, over and over again. Laughing maniacally.

"*Snip, snip, snip,*" he sang.

"You can't do this," she cried.

"Oh, but I can," he said, putting the pincers back on the wall, walking back towards her.

"This is against the law," she said.

"I AM THE LAW," he shouted, backhanding her right cheek.

Agatha shrieked.

With her face pressed against the cold cement, wet with her tears, she whispered, "I'm . . . going . . . to tell."

The premier brought his face real close to hers, and suddenly pressed his burning cigarette into her back. While Agatha screamed, he said: "And no one will believe you."

How much time passed in that basement, Agatha couldn't tell. Recurring mental blackouts saved her from remembering the worst of the

premier's abuse. Over and over again, he'd hurt her, then ask for a blow job. Her conservative upbringing wouldn't let her do it. She was saving herself for true love, after all.

She looked around the room—a barren, grey, sociopathic man-cave—and wondered, *Would anyone come and save me?* How many burns did she have to endure on her body, how many bruises and bloody wounds, just for saying no? She missed her extracurriculars. She missed her homework. She even missed the bus. She wanted nothing more than to go home. At long last, it finally occurred to her: she had teeth. Agatha, the good girl, the overachiever, the straight-A student: *she had teeth.* She had the power to bite the premier's pecker right off. If Agatha ever wanted true love, she'd have to be alive to see the day—she'd have to learn how to save herself.

Agatha resolved to consent to the premier's request as soon as he returned from Queen's Park.

Agatha heard the basement door open, the premier's heavy gait stepping hard on every creaky wooden step. She kneeled obediently, eager to get this over with.

"I'm ready," she said.

"*You are?*" he asked, surprised. "What's changed, my Agatha?"

"I want to leave," she said, not lying. "I know there's only one way."

The premier unbuckled his belt and unzipped his dress pants.

"Good girl," he said. "I knew you'd come around. Here, let Daddy untie you."

Almost lovingly, he snipped the rope with his garden shears and released Agatha's swollen, purple wrists. Everything was sore—her arms, her chest, her back, her shoulders, but freedom was so close. As feeling returned to her limbs, the premier revealed his tiny, cheesy, blond stump. His size, at least, was unintimidating. A relief. Like chewing a Cheeto. She opened her mouth.

"Oh, yes," he said. "Make it sloppy."

Agatha gave him what he wanted, at first. He needed to relax into the expectation that she wasn't going to maim him. She just didn't expect

him to relax *that* fast. It had been a minute, maybe two, when she felt the rush of the premier's ejaculate hit the back of her throat. In his bliss, he clung to the crown of her head. That's when Agatha chowed down as hard she humanly could. His moans turned to screams. Now, blood hit the back of her throat. His Cheeto dismembered, the premier toppled to the concrete floor, blood spewing from his crotch, and passed out. Twitching.

In one movement, Agatha reached for the garden shears and freed her ankles from their binds. She ran for the exit at the top of the stairs, proof in hand. She opened the door onto a spacious kitchen with impeccable interior design. A blonde mother baking a pie, two teenage boys fighting over chocolate milk in the fridge. A normal domestic scene. The family froze in horror as they beheld her, a teenage girl covered in blood and semen, the premier's dismembered penis in her hand.

One would be forgiven for assuming it was a finger. Agatha threw the bloody stub down like a football in this clean, unsuspecting politician's family kitchen. The wife was shocked. Agatha knew these weren't her people. She didn't vote for them.

In silence, Agatha walked out the front door to catch the bus. Late as always.

The Story of Saint Agatha, 2014, The Farm

When I worked as an organic farm intern in St. Agatha, Ontario, I felt compelled to look up the namesake of the town. What a revelation! Agatha's story resonated deep inside my body. Here I was, a former sex worker and sexual assault survivor, atoning for my whorish sins by literally hoeing the land. Her land!

I had nothing to atone for, of course, and neither did Agatha. But the days were as long as the rows we weeded, and the sky as wide as my imagination. Lonely hoeing accompanied by singsong made the back-breaking labour bearable. As I thought about Agatha and what we'd both endured, these words came to me. I sang them as I worked, and before I knew it, the work day was done.

Sing it with me now!

I was walking down the street
At the tender age of fifteen
When a man came catcalling me
He said, "Girl, you look fine
Get into this car of mine,"
And that's when I heard your voice sing:

Agatha, sweet Agatha
To you, I'll always be true
Agatha, sweet Agatha
No matter what they try and do
They could chop off your tits
They could burn you at the stake
They could rake your body o'er the coals
Agatha, sweet Agatha
To you, I'll always be true

I said, "No thanks, I've got a man,"
He said, "You're a little whore,"
And when I came to, I was on his basement floor
I'd been raped, I'd been beaten
My Sunday best dress all in pieces
But then I heard you singing this song:

Agatha, sweet Agatha
To you, I'll always be true
Agatha, sweet Agatha
No matter what they try and do
They could chop off your tits
They could burn you at the stake
They could rake your body o'er the coals
Agatha, sweet Agatha
To you, I'll always be true

When I got home, I told Mom
She said, "Girl, you've always been trouble,
Why are you spreading lies about this man?"
She said, "Look in the mirror,
Look at the clothes that you wear,"
And through my tears, I swear I heard you sing:

Agatha, sweet Agatha
To you, I'll always be true
Agatha, sweet Agatha
No matter what they try and do
They could chop off your tits
They could burn you at the stake
They could rake your body o'er the coals
Agatha, sweet Agatha
To you, I'll always be true

Slow:
I was walking down the street
At the tender age twenty
When a man came catcalling me
I looked him in the eye:
Said, "I'm not afraid to die,
And I know that I'm already free."

TRAUMA PORN

I met Mark and Stavros one warm September evening in 2018. They'd been bike riding about town, and decided, on a whim, to step into the club for a drink. The two were unlikely friends: Mark, a polymath and practising doctor with an engineering degree; and Stavros, a free-wheeling writer and all-around creative spirit. They'd met—where else?—in an improv class.

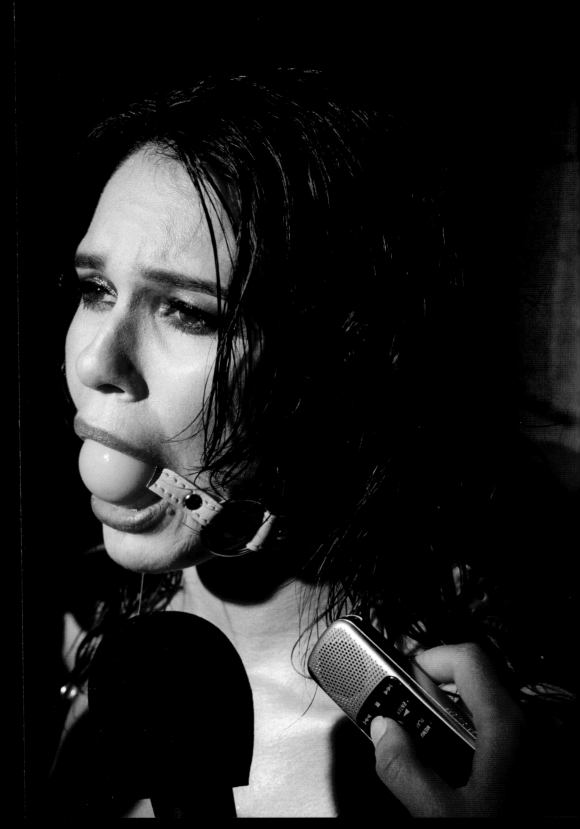

I was more attracted to Stavros because, for starters, he was better looking. He had long, brown, frizzy hair, a big warm smile, and a non-judgemental rock 'n' roll attitude that always bodes well with strippers. Mark was blond and hard; smart, to be sure, but with a sense of humour that came off cold. At their table, one round of beers became two, three, then four. The floor was empty. While some strippers self-impose a three-song limit for sitting with clients, I could afford to give Mark and Stavros more of my free time. It was either sit with them, enjoy the complimentary drinks and good times, or sit alone in a corner, waiting for a spender to show. I chose good times.

The flaw of the hyper-intellectual is a need to promote the mind at the expense of the flesh. Mark was an "I don't usually do this" type of client, the kind who offers unsolicited paternal platitudes like "You're better than this" and "You could do anything, so why are you here?" Because I choose to promote my body, the unwitting misogynist believes I must not be very smart.

When a sex worker is asked to relive their bad experiences for a client's entertainment, what they're being asked for is *trauma porn*. These clients are so hungry for an "authentic" story that they never consider the possibility of triggering the storyteller's PTSD. Or they do—and they just don't care.

"What's the worst thing that's ever happened to you?" is a disturbing thing to ask any person, let alone a person at work. So why is the question asked so often of sex workers, and why do clients feel entitled to the answer?

"I'm at work" never satisfies this type of man's curiosity, and that says a lot about him. For men like Mark, sex work is not work but, at best, a means of attaining his validation, and at worst, a never-ending cycle of abuse and re-traumatization. Never in his wildest fantasies could he imagine we only do sex work for the money. No. There must be a *reason*. Men like Mark are more interested in my gaping emotional wound than my pussy. They want to hear my sordid sob story, not my dreams. And so, the question is asked over drinks, in a manner so casual it is difficult to collect oneself and react.

"Who touched you?" Mark asked. "What happened in your childhood to bring you here?"

A flabbergasting query amid the camaraderie I thought the three of us shared.

"That's an incredibly inappropriate question," I replied.

"C'mon," he said. "Something must have happened. Women don't just become strippers."

"Man, I thought we were having fun," I said. "Do you really want me to relive my trauma for your entertainment?"

I turned my attention to the much more chill Stavros, and when I looked at Mark again, the blood had drained from his face. Suddenly, he said, "You know what? Let's go to the vip."

"Now?" I asked, surprised. I guess I could forgive the question if it meant getting paid. He rushed me upstairs. We arrived in the booth, a quiet and pleathered confessional.

"Look, I don't want a dance," he said. "I want to apologize."

He handed me $200 for ten songs, enough to cover half an hour of penance.

"Talking about my trauma? That's an extra."

This offering made him worthy of mercy from my side of the booth. He took a deep breath.

"The only reason I asked you that question is because I was sexually abused as a child," he said. "And I wanted to know if you were, too. I understand now that it was a deeply insensitive question to ask, especially at work. I'm sorry."

Apology accepted, but I'm no counsellor. He'd unburdened himself, and I now had to carry his trauma and somehow continue to shake my ass for money for the rest of the night. He wanted us to "understand each other," but only under his stated assumption that *women don't just become strippers*. That, despite our dramatic differences professionally, we were, in fact, quite similar people. A doctor relating to a stripper? Wow, I should be so honoured.

People who have survived childhood sexual abuse work in every industry imaginable—Mark was living proof. Not all strippers are sexual assault survivors, and not all sexual assault survivors are strippers.

Then there's the guy who popped the question mid-lap dance.

"So," he began, a wickedly curious grin on his face. "What's the worst thing that's ever happened to you here?"

"Well," I said, spinning around to look him straight in the eyes. "Rape."

"But—it's not rape if you pay for it," he blurted. Gasped. Covered his mouth. "I can't believe I just said that!" he said. "I'm so sorry."

"No, no," I said, readjusting on his lap to face him directly. "I'm glad you said it. I think a lot of people, somewhere in their heart of hearts, actually believe that sex workers deserve to get raped."

His phone was sitting on the ledge of the booth. A text message lit up the background of his screen: him, his wife and toddler in matching jerseys, sharing a happy moment at the baseball game.

"Yeah, that's not okay. Here," he said, handing me a few more twenties than were owed and running off.

When our job is imagined to be a cavalcade of traumatic events, what's the harm in picking one particularly gory tale to entertain the audience? They assume we are so desensitized to our own trauma—why else, of course, would we be working in a place like this?—that it's all a funny joke, that we're all just one *ha-ha just kidding* away from being a dead hooker punchline. The entitlement to our trauma, disguised as casual, innocent curiosity, hits as hard as a slur. To his credit, at least this client realized the folly of his comment; the dissonance between his heart and mind.

"Is this for your spank bank, you sick fuck?"

Mouth agape, *It's not rape if* . . . No, buddy: it's rape. No ifs. It's rape. It's rape if it's paid for, it's rape if it's free. If it's sex without consent, it's rape. Accepting payment for a sexual service is not consent. A client pays for our time, not to violate our souls. Sex work is not paid rape.

Sex work is the only work where rape is considered "theft of services," and not what it actually is.

The service provided here is a lap dance. What kind of pervert wants to hear a traumatizing story while getting dry-humped by a stripper? What the hell kind of answer are you expecting?

He sat at the bar wide-eyed and interested. I performed my moody Doors set—"L.A. Woman," followed by "Light My Fire," topped off with the peppy "Love Her Madly," guaranteed to give any boomer a boner—and he never took his eyes off me.

I made a beeline for him as soon as I finished my set and he happily got me my drink, a Mill Street Stock Ale. He was kind, articulate, and funny, a salt-and-pepper businessman in Saturday night casuals. Yes, we'd go upstairs, he assured me. He just wanted to finish his beer first. Our banter was solid. The regular potential was strong with this one.

And then he, with a Cheshire Cat smirk that gave him away, asked: "So, what's the worst thing that's happened to you here?"

"Uh . . ." I cocked my head. "Rape?"

"Rape? No," he said. "That doesn't happen here."

"It does," I corrected, "and it happened to me."

"So then, why are you still here?" he asked. "Why work in a place where that's happened to you?"

Yeah, guy. Cool question, bro. It's like, *If you feel unsafe outside, why leave the house?*

"Because the pros of working here outweigh the cons," I told him. "And I know what to do next time something like that happens."

"But what about security?" he asked, perplexed. "What happened? How could that happen here?"

(Don't make me relive my trauma, you pervy reader. Suffice it to say, I did give this guy a quick rundown of my rape.)

"Oh, that's disturbing," he said. "I'm sorry that happened to you. And still, *you came back?*"

"I took a week off to process it." I said. "Eventually talked to my bosses. One of them assured me it would never happen again. The other told me it was my fault."

"Jesus," he said.

"I mean, that's not most clients. It was an isolated incident. Most guys are fine. So, uh," I ungracefully pivoted with a flashy grin. "Wanna go upstairs now?"

"No, definitely not, not after that story. I am *thoroughly* turned off now." He looked away from me and sipped his beer. My blood boiled.

"Then why'd you ask?"

"I didn't think you'd been raped! You don't look like the type."

The type.

"The type?" I replied. "Every woman's been raped to some extent. I'm sorry my rape story turned you off. Next time," I said, slamming down my empty bottle of Stock Ale, "don't ask."

> # "How could such a smart man ask me such a stupid question?"

I shook my head in disbelief, got up, went to the locker room, put my clothes on, hopped in a taxi, and fumed all the way home. Reliving my trauma for free? You fucker.

It's easy to blame the victim if she returns to the scene of the crime. Am I expected to apologize for not being the perfect victim? Apologize for surviving? For returning to a workplace where I'd built a solid support system? Should I feel bad for being unbroken, happy, and comfortable enough to share my stories?

The perfect victim, as virginal as she is violated, does not exist. Imagine having the entitlement of a client who thinks they know how sex workers should process their trauma, without even paying us a cent! At least pay our therapy bills, you dink!

And then there's Malcolm. That rare myth of a man who pays women "just to talk." Yeah, Malcolm. Young, handsome, and alone on a Sunday night, he didn't want to go to the VIP. (He said he liked me too much. Red flag.) Instead, we tucked ourselves away in the corner of the club usually reserved for bachelor parties and stags. Malcolm wanted to know why a girl like me chose to "manipulate" men for their money.

He was a waste of time until he said, "I would literally pay you two thousand dollars to sit and talk to me about why you do this."

Well, then! Pay up, piggy! Malcolm reeked of that particular brand of misogyny recently divorced men get when they've been financially eviscerated by their ex-wives. I earned my money that night. He asked all the questions you might expect: "Were you abused as a child?" "Did your father fuck you up?" And, assuming only misandrists become strippers, out to exact revenge on men through their wallets: "Why do you hate men so much? Why are you trying to control us with your body, which you know is our weakness?"

I like this "client as victim" idea. It's cute and so adorably out of touch. When a client is "exploited" by a sex worker, the worst that can happen is that they lose their money. When a sex worker is exploited by a client, the worst that can happen is that they lose their life. Often, sex workers can't tell their friends, their family, their partners, their employers, their schools, or their landlords what they do for money, for fear of discrimination, harassment, excommunication, eviction, dismissal, removal of children, divorce, abuse, theft, rape, murder. *And you're the victim because you walked into a strip club?*

Attributing a pathology to our motivation to do a job—a well-paying, flexible, fun, and stimulating job—is peak entitled client. We do not do our jobs to manipulate men, or to exact revenge, or to relive our trauma. Sex workers do our jobs for one reason, and one reason only: for the money.

I preached the sermon to end all sermons to Malcolm. Man got his money's worth. You want my gaping wound, you want my sob story, you want to know who touched me?

"Well, then! Pay up, piggy!"

MIND FLOG

I wouldn't say I had a problem. I just had a history of getting drunk and hitting my head. I woke up with a black eye, a pair of swollen lips, and a nearly broken nose after smashing my face into an ATM on Boxing Day in 2017. I blame drinking—from the pitcher—the most deliciously dangerous vegan Baileys I'd ever made. I woke up on the bathroom floor of the Trump Tower hotel bar to the fire department prying open the door. I blame the idiotic finance guys who plied me with free drinks. In 2016, I woke up in a hospital in San Francisco covered in vomit, and when I asked the doctor what happened, he said: "Well, when they found you on the floor of the sushi restaurant, they decided to call an ambulance." I don't remember

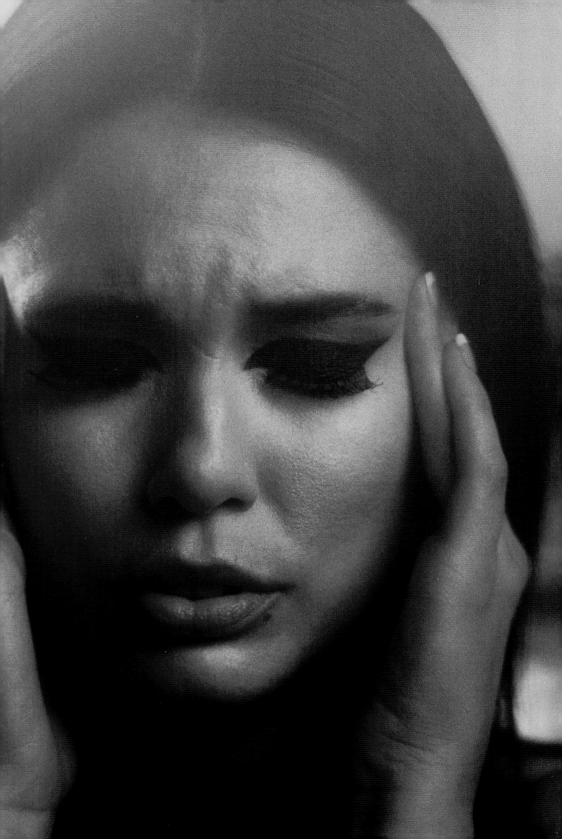

a sushi restaurant, but I do remember the bar in Haight-Ashbury and the Golden State Warriors NBA Finals game that packed the house and the $5 beer-and-a-shot special and the guy beside me who said, as men continuously bought my drinks, "You're the most popular girl at this bar tonight!" And I do, of course, have a clear recollection of a $5,000 medical bill that I received by mail on my return to Canada.

And then, the seizures. On a summer evening, I met a beautiful woman at Grossman's Tavern. We made out passionately and, at the end of the night, she asked if I wanted to come with her to an after-hours club. I made my way with her to the crowded, smoke-filled Kensington Market speakeasy, where we kissed in a dark corner on a couch. She reached into her pocket and opened her wallet.

"Wanna do MDMA?" she asked.

"Sure." I shrugged. *Why not?*

I took the pill—and suddenly remembered I needed to be up in a matter of hours to visit my sick elderly auntie at the convalescent home for her birthday. There was no getting out of this one. I departed abruptly and returned home, wired as all hell, and tried to get two hours of sleep. In the morning, I was unable to put words together. I felt very strange. But my brother and I walked over to the home with a little cake and visited my auntie, right on time.

"I'm not feeling well," I told her.

"I can tell," she said.

As we departed the home, I pointed up at the sun in the sky and screamed, "AHHHHH!!!!" and then fell onto the pavement, convulsing. I don't remember this. I remember the hospital and the blood in my mouth and my poor little brother by my side, fear-riddled and grateful as I woke up. He'd never seen anyone have a seizure before, and I'd never had one. When the doctor arrived, he said the reason for my seizure was not the MDMA but sleep deprivation.

My driver's licence was suspended, which was a shame, because at twenty-five I'd just learned to drive. After work at the farm, I had gotten used to driving my boyfriend's Ford Ranger once a week to an acting class in nearby Stratford. Driving alone in a truck on country roads was

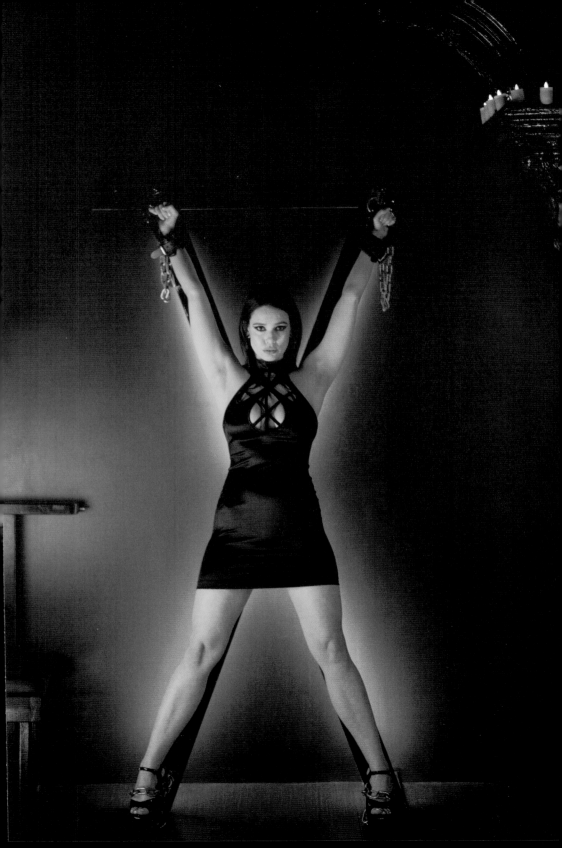

such a delightful pleasure, one I was sorry to give up. In order to have my licence reinstated, I was evaluated by a doctor. He filled out a form regarding my drug and alcohol consumption to pass along to the Ministry of Transportation. One of the questions he asked was "How many times have you been blackout drunk?"

"Like, including high school?" I asked.

"Yes," he said.

"Ten, maybe?" I lowballed. I figured it may have been twenty times, maybe more.

"Whoa," he said, writing the number down. "I can't unhear that."

"Wait, is that high?" I asked.

"Yeah, definitely," he said.

I was shocked. Then I wondered if some people, like me, were simply more predisposed to blacking out. Or was it that I drank to get drunk?

I never did Molly again. Easy. I'm a happy girl, anyways. I don't need a happy pill. The next time I had a seizure, I was in Montreal for the *Modern Whore* book launch. I went out partying with some sex workers, and next thing I knew, I was sitting in the office above a bar at a conference table, snorting coke with the owner.

I wasn't a big coke user, but sure, I'd done a line or two in my time. Can I call myself a stripper if a man hasn't done a line off my ass? Once, in the club bathroom washing my hands, one of the dancers called out to me from her stall.

"Hey Sophia," she crooned like a siren. "Do you do drugs?"

"I, uh, smoke weed," I said, a bashful teenager.

"No, silly. Real drugs."

"Ummmm . . ."

"Come in here and do coke with me!" she commanded.

I shrugged and entered the stall. She passed me a key to dip into the baggie. I sniffed, she sniffed, I sniffed again, and so did she.

"I do this to feel normal," she laughed. "I did too much and now I can't stop. Don't do drugs, kids!"

Coked up, I got onstage and gave the best performance of my life. For weeks afterwards, I wondered if I needed coke to be a good dancer.

I doubted myself constantly. Thankfully, I didn't do it again at work, and eventually the cravings dissipated.

On that visit to Montreal, I got home around 5 a.m. and woke up at 10 a.m. At brunch with my boyfriend, I couldn't string words together. I wasn't making any sense. I couldn't hold a thought. I was terrible company. After a long walk, we popped into a large bustling café. I went to the washroom. Fifteen minutes later, my partner was thinking, *Wow, Instagram must be really exciting today*, when a server approached the table.

"Um, I think your girlfriend is having an overdose in the washroom."

He ran over. Paramedics had already arrived. There I was, twitching, covered in blood, slumped at the bottom of the bathroom stall. I'd apparently taken a dump, pulled my pants up, had a seizure, and smashed my shoulder and face into the wall. I woke up on a gurney inside the ambulance, that familiar taste of blood in my mouth. Again, even though the doctors knew I'd been on coke the night before, the official diagnosis was sleep deprivation.

I couldn't move my right arm. I'd activated some pre-existing tendonitis and required physiotherapy, which was essential—that arm was my pole arm, and without it, I wouldn't be able to work.

Before that trip to Montreal, I was being considered for the only promotion available to a stripper at my club: feature girl. The position meant more money per show, with four mandatory shows a night. Maurice had asked if I was interested, and I said yes. Now, with my arm (and face! I'd been left with a gaping wound on my forehead, black eyes, and my broken glasses had jabbed right into my nose), I couldn't work for weeks. I was no longer being considered for the position.

A few days later, Nicole and I flew to Vancouver for our next book launch. I primed and powdered and layered the foundation on top of my black eyes and forehead wound in the Vancouver Public Library bathroom, until there was no sign of my injury. No one noticed, I don't think. And then, the opportunity of a lifetime: after the Vancouver launch I was L.A. bound, for an all-expenses-paid *Playboy* photo shoot. I explained the situation to the makeup artist on set and she almost cried. All this from doing coke? It could happen to anyone.

The photo shoot went swimmingly, but still. I vowed to never do cocaine again, which was also easy. I'm not an uppers kind of gal, anyway. I don't need a drug that makes it even easier for me to talk about myself. And clearly the risks of sleep deprivation were something I needed to heed. If I was tired, no more partying—I was putting me to bed. Sure, nights might be a little different, might end a little earlier, and hell, I might even lose business at the club by saying no to certain drugs, but if the risk was having another seizure, then the answer was an easy *no*.

Drinking was a little different. I love drinking. I love the loosening of inhibitions, disrobing my limitations. I love the slump of relaxation, that slackening of boundaries. Drinking means I can be a loud show-off, incredibly confident, always leaping, never looking.

It goes without saying that the strip club is a booze-drenched environment. Firstly, it's a bar. Secondly, it's a pick-up line: "Can I buy you a drink?" Thirdly, it's a vibe. The wild and crazy stripper is not sober. She's a shot-taking, line-ripping, mentally unstable firecracker, and the best fuck of your life. She lives, works, and plays hard and fast, and never says no to a good time.

I've always had a hard time saying no to fun. I always want another drink. I always want another adventure. I love the unknown. The thrill of not knowing what will happen on any given night is what lures every stripper back to the club. The element of surprise is exciting, but the uncertainty—well, it's stressful, and it does take a toll. Drinking helps.

I drank on average five drinks per shift and sometimes upwards of twelve. I know this because I began tracking my drink consumption. I didn't think I had a "problem," I just thought I was consuming a lot of extra calories and resolved to do a thirty-second plank for every drink consumed. I was doing a lot of planks. I had also, admittedly, been spooked by an incredible *Mother Jones* article by Stephanie Mencimer, "Did Drinking Give Me Breast Cancer?" Ever have that feeling when you know you should stop doing something that is actively hurting you, but you don't actually think you can do it?

Stop drinking? I thought. *Couldn't be me.*

When I met awesome, fun, creative people, only to discover they were sober, my reaction was always one of deep reverence and awe.

How?! I wondered. *How can you be sober in a society drenched in booze?* How does a person say no to a good time when every interaction is initiated by "Wanna grab drinks?" To me, sober people were superhuman. Deep inside myself, especially as I began tracking my drinking and seeing a true reflection of my dependency, I hoped that, one day, I could be that strong. I regularly practised yoga, after all. I had been a mix of vegan and vegetarian for many years. I cared about my health and wanted to be the best version of myself. I knew that alcohol was holding me back, but sobriety seemed both impossible and unrealistic.

At the club, my shifts often began at Don Wan's table with an answer to the question "Ya wanna drink?" Drinks were the reason many dancers sat with Don. On any given early evening, we'd be at his table, laughing and chit-chatting, when Don would suddenly burst out: "Shot?" And the girls would exclaim, "Yeah!" and we'd have a little party and bring life to a dead room.

April 4, 2019 was an unseasonably warm spring day. I picked my bike up from the shop after a tune-up and she rode like a dream. I'd been drinking all day, casually. You know, like a bohemian. At lunch, with a cartoonist. At a café, reading a book. At dinner, over great food with even greater friends. In between meetings I squeezed in a little tipsy shopping around Kensington Market, happily procuring myself some treasures. It was with mild horror that I remembered that I'd removed my panniers for the bike repair and would be forced to ride home with the bag dangling from my handlebars.

Around ten in the evening, full of Chinese food and drunk from the sake, I hopped on my bike and sped off, full speed into the night. Somewhere along College Street, heading west, the bag that dangled on my bars tangled in the front wheel, bringing me to an abrupt stop. I was launched headfirst into the pavement.

I woke up at Toronto Western Hospital, my boyfriend by my side. I'd apparently called him three times in a row to let him know.

"Hey, something happened," I'd said. "I fell off my bike. I'm at the hospital."

"Okay," he'd said, "I'm on my way."

We hung up. I called again.

"Hey, something happened. I fell off my bike. I'm at the hospital."

"Yeah—I know. I'm on my way."

"Oh, okay. See you soon."

Click. And then:

"Hey, something happened—"

"I know. I'm on my way. You've already called me twice."

"Oh. Okay. Bye."

At the hospital, I asked my boyfriend the same questions over and over again. He wrote the answers on a piece of paper and when I asked, pointed to them:

"What happened?"

You were out to dinner with Nicole and Dave. A bag got tangled in the front wheel of your bike and you fell on the street. Someone called the ambulance for you.

"Does Nicole know?"

Yes.

"Where's my bike?"

Locked up outside.

The doctor arrived with the diagnosis: concussion. A traumatic brain injury. I was referred to a concussion clinic, where I would have weekly appointments for the next twelve weeks. It was 6 a.m. My boyfriend drove me home in his Ford Ranger, my twisted bike thrown in the back, the sun rising pink and orange in the sky, the light too bright for my eyes. Every bump in the road felt like my brain was bouncing against the inside of my skull. Every sound was too loud. I was in a sensitive state of bewilderment. I crawled into bed, shades drawn, and bawled my eyes out.

For six weeks I slept, read, and smoked weed—doctor's orders. I was sensitive to light, to sound, to motion. I got used to wearing earplugs outside—without them, a siren could knock me off my feet. Nausea was a constant, especially when I looked at my phone. Pounding headaches. Losing my balance. Tired. All. The. Time. Once I could manage to walk more than a block, I scanned the landscape for places to sit, pillars and

poles upon which I could lean. Rest. Breathe. Go on. I spent those six weeks frustrated by my lack of progress. I desperately wanted to go back to being active, and I desperately needed to work. My brain had other ideas.

Nicole and I had been planning to shoot a short film based on *Modern Whore* for years. The script was written, the crew was hired, and the locations were secured. Prior to my concussion, we were a month away from shooting. A month after the concussion, it was clear I needed more time. With a goal to shoot as soon as we could, I took care of my body with a rigid diligence that made drinking a non-starter. My brain felt soft and fragile, and the idea of soaking it in poison verged on self-harm. And, anyway, there was nothing to celebrate, no occasion to drink to, no reason to imbibe, not until this film was shot—then, I figured, it'd be safe to have a drink.

The three-day shoot arrived just as my six weeks of recovery were ending and I did it. Bright lights, long nights—not to mention the emotional labour of re-enacting my own rape! I was in nearly every single scene. *And I did it.* I was six weeks sober, and my brain and body rewarded me with this incredible feat of strength. I didn't want to stop.

Can I go another month sober? I asked myself. *Fuck it*, I replied. *Let's try!*

That week, I got on my bike for the first time since the accident. You can take away my driver's licence, but you'll never take away my bicycle. Sure, the first ride was a little shaky; overstimulating, too. But it was exhilarating, challenging, invigorating. A little freedom between my legs. Ever so grateful to be alive, to feel the wind in my hair—under a robust new helmet, of course. When I got home, I crawled into bed and slept for twenty hours. The ride was worth every moment.

I was doing so well, I figured, *What the hell—let's go back to the club!* Sober. Let's go back to the club sober. I could do it, right? *Right?*

Before my inaugural no-drink shift, I put in my food order with Don Wan and informed him I wouldn't be imbibing tonight. Better, I figured, to

establish the boundary beforehand. The night started off well. When I came down the stairs, teetering on my eight-inch heels, there sat Don and four pounds of food, just for me. Stir-fry, noodles, hot and sour soup, and my favourite, fried tofu skin. *Mmm.* Melissa, an off-duty dancer, sat next to him.

"Do you want a drink?" she gently asked.

"*No!*" Don roared. "She's not drinking! She's the cheapest date ever, a sober vegan—I love it!"

He offered me a Perrier. I was relieved I wouldn't have to "stand my ground." As a serious cyclist himself—a true MAMIL, a middle-aged man in lycra—Don had endured his own bike-related concussions. He understood and respected my boundaries. There were many fond reunions at his table with the other dancers that night, who asked excited questions about my recovery. A waitress pulled me aside and tearfully told me she was glad I was okay.

"We were all so worried about you," she said.

My heart felt full, warm, and grateful. I truly loved my co-workers and felt loved by them.

Don was ready to head home, so he encouraged me to get my one stage show of the night over with so he could watch. Cool with me— the later the performance, the higher the pressure, and I wanted to get out of there fairly early, anyway. I was a freelancer now. I had to pay to work—a bummer, to be sure, but it meant I was only obligated to be on the clock for four hours, and I could come in any night of the week. Unlike the schedule girls, who picked their shifts in advance, had to be there for seven hours and do three shows, I only had to perform one. Freelance was perfect for concussion recovery; 7–11 was a great shift.

In the mood for disco, I picked "Spank" by Jimmy Bo Horne, "You Make Me Feel (Mighty Real)" by Sylvester, and "More Than a Woman," by the Bee Gees.

A solid room for 7:30. My timing was right. The men ate it up and I didn't skip a beat. I went gentle with the spins and slowed my routine down, garnering applause after every song, especially the third. Nothing makes me feel more gracefully feminine than slow dancing to the Bee Gees.

But I was shy when I got offstage, almost as if I'd forgotten how to do my job. Who should I talk to first? Who was the best bet? I walked over to Don's table, all smiles. The gang was swatting me away, since there were several men in this room who clearly wanted to give me their money.

"*Who?*" I asked them in desperation, "*Who?!*" I felt unable to make the choice myself, all my energy zapped by the performance.

"*Him!*" They pointed to a man directly behind me. I turned around and saw a middle-aged man looking at me with kind, lusty eyes.

"Hi!" I exclaimed, surprised.

"Hi," he responded. "Would you like to go upstairs for a dance?"

Jackpot.

He came in his pants during the third song and gave me $140 for my time. *Fantastic!*

Back on the floor, I got lucky and spotted a beloved regular. Always nursing a Diet Coke and lemon, Jerry was both the smartest and the soberest man at Tomcat's. When I told him I was recovering from a concussion, he told me to join the club: he'd had thirteen. *Thirteen!* When you've had one brain injury, he explained, it's a lot easier to get another. He also reminded me that while I was doing well enough to work at six weeks, my brain was still going to take a year to heal. Jerry was pleased and proud to hear about the sobriety.

I mused: "If it takes the brain a year to heal itself, maybe I should take a year off drinking."

"That would be very good for your brain," he replied.

The flashing lights of the club were beginning to bother me. The cacophony of music and Jerry's voice mashed incoherently, and I struggled to focus on his words. I heard him but I couldn't *hear* him. My head hurt. I asked if we could go upstairs, sorry to rush him. He didn't mind at all. In the VIP, Jerry handed me $300, and massaged my neck and shoulders for the next half-hour, before I hopped on his lap for a slow, passionate dance. Pure bliss.

Finally, I could go home. 11 p.m. Financially secure—and sober. I freakin' did it.

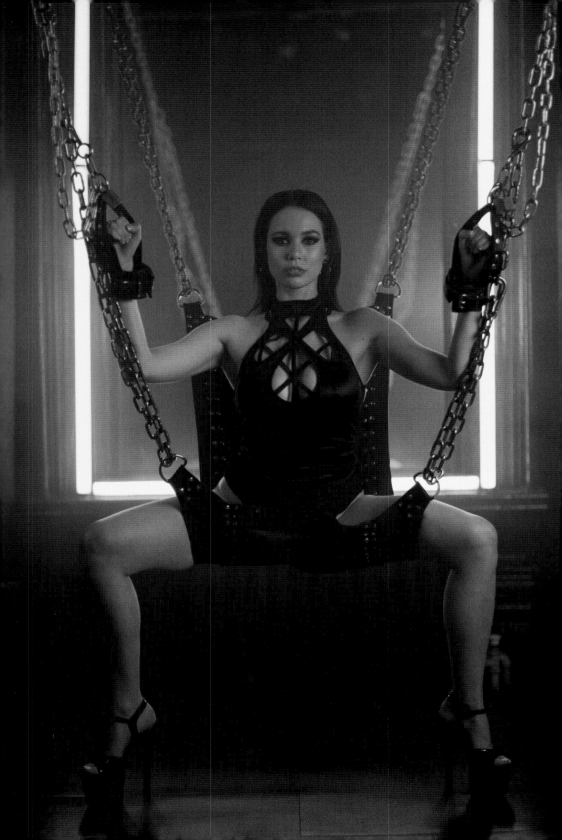

A year? Me? A year? Can I? Me? I asked myself.

 Fuck it, I replied. *We've come this far. Let's do it.*

Not every client was sober-supportive. One customer got mad at me for ordering water. To be fair, water cost $8 at my club, and I suppose he figured if he was spending that kind of money, it better be to loosen me up.

"I'm not getting water for you," he said. "That's not a drink."

And this was from a guy who'd also suffered a concussion. In fact, many of the men who were most adamantly against my not drinking were men who'd hit their own heads, somewhere between their teens and early adulthood, and were told to get back on the ice. Men who were forced to ignore their own symptoms, to "man up." Men who suffered from post-concussion symptoms like anger and depression but didn't know why. And here these men were telling me to do the same thing: man up, get drunk, numb the pain.

These kinds of men don't want to contribute to my well-being, but to my downfall. I am grateful for the hard-won lesson that if a man is pushing my boundaries on the floor, he will almost certainly push my boundaries in the VIP. I'll pass.

I suppose I wasn't fully "sober"—I still smoked weed. It was the only way I could do the job. Stripping while sober-sober, without any weed, well—let's call it excruciating. Weed alleviated my nausea, slowed down and improved my performances—I could really feel the music fresh out of the smoking room—and made me more curious about humanity. I was interested in deep conversations only, and the right client was always game. The ones who weren't, the others could have. Weed made me a better sex worker.

It also made me a lazy sex worker. I spent untold hours in the smoking room on "break." I gave up on hustling because I didn't have the energy to invest in new clients, to risk being rejected. Post-concussion, I relied heavily on my regulars to keep me afloat.

A few months after the concussion, I went to a neurologist appointment. We discussed my seizures and brain injury, as well as what I wanted to do with my life. Dr. Slegr was happy to hear I was sober.

"You want to write another book, don't you?" she asked. "You know alcohol can cause seizures, right?"

Another seizure could mean hitting my head again. Another concussion could damage my brain beyond repair. I already knew what it was like to lose my brain. To lose control over my life. I couldn't risk it.

"Yes," I said, the tears welling up in my eyes, the fear of God in my heart. "Yes, I want to write another book."

Writing books or drinking. The decision—a no-brainer.

At the doctor's behest, I did a routine EEG test and the result was a surprise: genetic epilepsy—I was epileptic. A few more appointments, consultations, and a second opinion were required to determine whether I needed to be on seizure medication for the rest of my life.

Their conclusion: stay on the straight and narrow, and if you don't have another seizure, you won't need the medication; the moment you have another seizure, you're getting on the medication.

You want to write another book, don't you?

The words bounced between my ears. I didn't have a choice. I'd found my higher power: I believed in my brain. I would never drink again. It's a challenge to listen to a body when one must ignore it to survive. When that survival—one's work—is made less challenging by a gradual loss of consciousness. But the injured brain, seated firmly in the body, won't stand for it. The injured brain holds the flogger. "Go on," it dares the body, "try me." There is no body without the brain. The body must respect the brain and vice versa. Submit. Establishing boundaries protects the sanctity of both. Nurture the injured brain, or else Master will dole out another flogging: nausea, dizziness, fog, fatigue, loss of balance, sensitivity to light, to sound.

When we don't follow through on our commitments to ourselves, we are our own timewasters. I'd made a commitment to myself to not get blackout drunk and hit my head, and wake up in a hospital or who knows where. "Yes" pushes the limits. "No" maintains the boundary. I thought I needed to say yes to every experience, every adventure. Turns out saying no meant staying true to me, my journey, and my purpose in life. My adventure. Fully conscious.

Sobriety didn't dramatically change my life. It was as if there was a room filled with boxes—boxes chock-full of stowed-away hurts and trauma. Not drinking, I could see inside, to keep what I needed, discard what I didn't, and mourn what I'd lost.

Sometimes I'd get cravings—not to drink, but for total, utter, complete dissolution. Unconsciousness. Not suicidal, but a deep dark desire to disappear into nothingness. Float in space, bodiless. Just temporarily. Isn't that what drunkenness is? Losing control? I found myself bingeing on sweets to fill the void. In these moments, I'd polish off a tub of ice cream, no problem, and still want more. Still feel empty.

But the truth was that my life *had* improved dramatically since the accident, since the choice to become sober. The best part was no hangovers, no wasted days. A new-found productivity; renewed creative energy. A gratefulness for life after being so close to losing mine.

One night in the smoking room, I said: "I feel like I needed to hit my head."

"Don't ever say that about yourself," shot back Flora, a veteran stripper. Her boyfriend was also recovering from a concussion. "No one needs to get hurt to learn a lesson."

I hope you never need to hit your head, dear reader, to make a necessary change in your life.

You want to write another book, don't you?

Yes. Yes, I do.

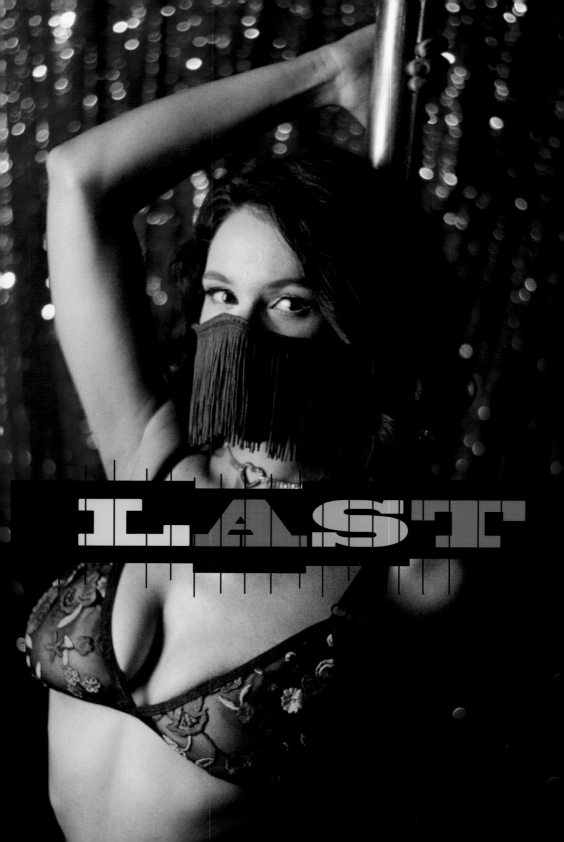

In elementary school, Bruce and I crank-called our teachers from his garage. We smoked cigarettes. We listened to Rage Against the Machine.

I went to Bruce's funeral on March 14, 2020. He was thirty-three.

The service was held at the same church where we all had our First Communions, Confirmations, and Confessions. I hopped in a cab and arrived a few minutes after 9:00 a.m., the funeral already in progress. I didn't know funerals started on time. I slunk into a pew and looked around the gaping room.

I saw the ghost of our music teacher, Mr. Merlo, gesticulating wildly in the corner of the church, conducting his child choir. I saw him in his army regalia, the costume he turned out every Christmas Mass, performing like he was the star of the show, the baby in the manger; a slim, white, bald man with blue eyes, licking the corners of his mouth, wearing pants tight enough to show his bulge. On more than one occasion, I saw Mr. Merlo give that bulge a conspicuous itch in front of us students. I never liked the guy much, myself.

NIGHT

The priest officiating the funeral gestured impotently about "these crazy times," in reference to the current raging pandemic. Where there had been sadness and tears of loss, anger began to rise in me. Anger that this man had a pulpit and a congregation, a stage and an audience, to riff on whatever the hell was on his mind. Wearing robes, with all the authority of a diddler playing dress-up.

The time had come for us to shake hands with our neighbours and say, "Peace be with you." No talk of the pandemic. No alternatives

proposed. No discussion of social distancing in this room of seventy-five or so people—we hadn't yet reached the point where funerals were held via Zoom. Only talk of "these crazy times." I extended my elbow to my pew-fellows as a joke, and when the elbow was not returned, I quickly reached out a hand. Tough crowd.

I spied my old classmate Nadine strutting up the aisle and I waved to get her attention. Her eyebrows raised in recognition and she snuck into my pew, giving me a warm hug. I hadn't seen her since we were twelve, but she looked exactly the same.

"We'd like to ask all the Catholics in the room to join us for Communion," the priest said, still talking.

"You gonna go up?" she asked.

"Naw," I said.

"Me neither. I think I'll go out for a smoke."

"Yeah! Let's do that," I stage-whispered, shuffling to the church steps outside.

Nadine pulled out a cigarette, and I pulled out my weed pen.

"I was thinking," she said, "of all the people from elementary, you and I are the most alike."

We didn't end up suburban squares. We sowed our wild oats. We learned how to hustle. We were also both Irish twins, with siblings less than fourteen months younger than us. Our younger brothers—mine, George; hers, Andy—were in the same class. They'd gotten into a fight once. Andy kneed my brother in the stomach in the schoolyard, in win-tertime, after he'd drunk a carton of milk. Poor little George barfed the steaming milk onto the melting snow. First, I laughed. Older-sister instinct. Then, I intervened. Took matters into my own hands. Did I beat Andy up? Hell no. I ran to the principal.

"Remember Mr. D?" Nadine asked. "Remember when people were ragging on you for that?"

"Do I ever," I said. "I even wrote about it in my book. You know, it took me years to realize it wasn't my fault he got suspended."

"And yet, that's what people were saying. So dumb. Remember Mr. Merlo?" she asked, taking a hit of my weed pen. I knew it was risky to

share with the pandemic in the air, but this was my "last day" before self-isolation, and I wanted to feel normal just one more time.

"Of course," I said. "He's dead."

"Yeah, well, my son goes to the school now, and guess what? They gave him a plaque. They gave a pedophile a plaque."

"*What?*" I said. "I knew he was weird, but I didn't know that."

Her eyes widened.

"Remember when he would give us private lessons for our recorder solos? He touched me, on my thighs, here and here. My sister, too. Even my brother knew about his reputation."

"Holy fuck, and now he's got a plaque?"

"It's fucked, right?"

I seethed as we re-entered the church, the holy sanctum of pedophilic power. Mass was finished.

Holding court at the back of the empty church was our French teacher and tormentor, a woman I will call *The Madame*. The Madame pulled me out of class in grade 7 to say no one would respect me in the clothes I wore. She called me "dirty" in front of the class, and made a spectacle of the muck beneath my fingernails. The Madame didn't let her girl students wear makeup, inspecting our faces daily, and often screamed at us for no reason. When I enrolled in French Immersion in high school, I found it difficult to learn without someone constantly yelling at me, and promptly dropped out of the program.

"I'm a hugger," The Madame announced, imploring her thirty-something-year-old former students to come hither. "Sorry if that's not PC!"

Even in the middle of a pandemic, I thought, *you haven't changed a bit.*

I reluctantly entered her circle like a child, and she asked us one by one what we were up to these days. She got to me.

"Hmm," I said, looking up suspiciously at the vaulted ceilings, "I don't think I can talk about it in a church."

"What? Why?" she replied. "What are you doing?"

"I'm a writer," I said.

"But why wouldn't you be allowed to say you're a writer in a church?"

A voice chirped from outside the circle: "Maybe it's *what* she writes about, Mom."

Ah yes, our tormentor's hot daughter, who'd occasionally choreographed our Spring Concert dance routines. Her sass was a welcome respite, and it always filled us with joy to see her talk back to her mother, our teacher.

I took the opportunity to break off with a few others.

Outside on the church steps, The Madame caught up with me.

"So, have you been published?" she asked.

"Yeah!" Nadine cut in. "She wrote a book and I can't wait to read it!"

"Oh, really!" The Madame exclaimed, as someone else grabbed her focus.

"*Nadine!*" I laughed. "I can't believe I'm about to tell her the name of my book. Outside of a church!"

I was filled with a perverse excitement. This woman had fucked with me for years. Now I could finally return the favour.

"So," The Madame asked, her attention now solely on me, "what's your book called, Andrea?"

I inhaled.

"It's called *Modern Whore*."

Before the schoolteacher could respond, her daughter shouted from the opposite end of the church steps: "That's AWESOME! I'm looking it up as soon as we get in the car!"

"Oh!" The Madame said with an uncomfortable smile. "That's great." And then, after a moment of reflection: "You know, Andrea. You were rambunctious then, and you're rambunctious now. I always said I love teaching individuals."

Uh-huh.

As the group disbanded and The Madame and her daughter departed, Nadine said, "My mom was asking about you, and so was Andy. They live in the plaza over there, you should come over, just for a little bit."

Self-isolation from tomorrow. Last day of social exposure. *Fuck it! Let's go!*

A few doors down from the church, we walked up the stairs above a store. Nadine called out to her mom that I had arrived. We hugged. Then, two little boys approached me: one, Lincoln, Nadine's son; the other, Aiden, a little younger, her nephew. Nadine called out to Andy, who appeared and looked . . . exactly the same. He asked how George was doing.

"The same," I said with a smile.

"Andy," Nadine commanded. "Get her a dime."

He rolled his eyes but obeyed the order. He went back to his room, and she followed. I stood with the two kids in the kitchen. Aiden did a handstand.

"Whoa," I said. "That's pretty good!"

"Can you do that?" he asked.

"*Pfft*," I said. "Yeah."

So, I tried, and then all three of us were doing handstands in the kitchen while grandma watched TV in the living room. Lincoln grabbed my wide-brimmed hat and wore it on his kid-sized head. It fell right above his glasses.

"Oh, you look so good!" I said.

Nadine returned with a baggie and a fat nug as a parting gift, and announced that she'd be walking me out. I said my byes and, as I was leaving, Aiden shouted, "WAIT!"

I stopped midway down the dark steps. He ran down to me, bag of Skittles in hand.

"Do you want some candy?" he asked.

"Sure!" I said, reaching out my hand. "Thank you!"

"Bye!" he replied, running back up the stairs.

Nadine walked me to the church. We said our goodbyes, too. Despite the sad circumstances, I felt strangely joyful. Doing handstands with kids and telling The Madame I'd written a book called *Modern Whore*, Bruce would have been proud. Munching on a handful of Skittles, I made my way to my mom's house feeling pretty life-affirmed.

I walked past my elementary school—the one with the pedophile plaque—and the convenience store where I stole my first jawbreaker

and bought Sailor Moon cards and all my Spice Girls swag. I walked past the daycare run by nuns I'd attended throughout my childhood, and the playground where a boy sang "Pretty Woman" to me in his most earnest baritone in grade 1.

I traced my steps past the corner store—which had been a donut shop, then a Sam's Convenience, then a fried chicken joint, and was now a jerk place—where I used to get catcalled every day on my way home from school.

As I approached the tyrant's zone, I felt equal parts nostalgic and scared. There they were, two men standing out front, just like the men who stood out there when I was ten, eleven, twelve.

Where ya going, princess?

He said it today, but it could have been any day. Catcalled at ten; catcalled at thirty. I paid the men no mind, but internally, I screamed. Some things never change.

At Mom's house, I convened at the small but lively dining room table to inform her, my brother, and my stepdad that I was entering self-isolation tomorrow and would not be coming over again for the foreseeable future. I told them the strip club felt like too high-risk a working environment, and that's why I would be working my last shift at Tomcat's that evening. They understood, lamenting their own cancelled trip to Florida. Hell, I was supposed to be in Texas that week for SXSW, celebrating the *Modern Whore* movie premiere. The pandemic was affecting us all.

The four of us squeezed into my mom's car and they dropped me off at my place, on their way to Costco to pick up more supplies.

That night before work, I showered, got my safer sex and drug kits together for outreach, along with my stripper gear, and hopped on my bike for Tomcat's. I arrived a little later than usual, a few minutes after 8:00 p.m. The freelance fee at Tomcat's was $20 before 8:00; $40 between 8:00 and 9:00, and it got progressively more expensive as the night went on. (As far as freelance fees go, Tomcat's was as cheap as they

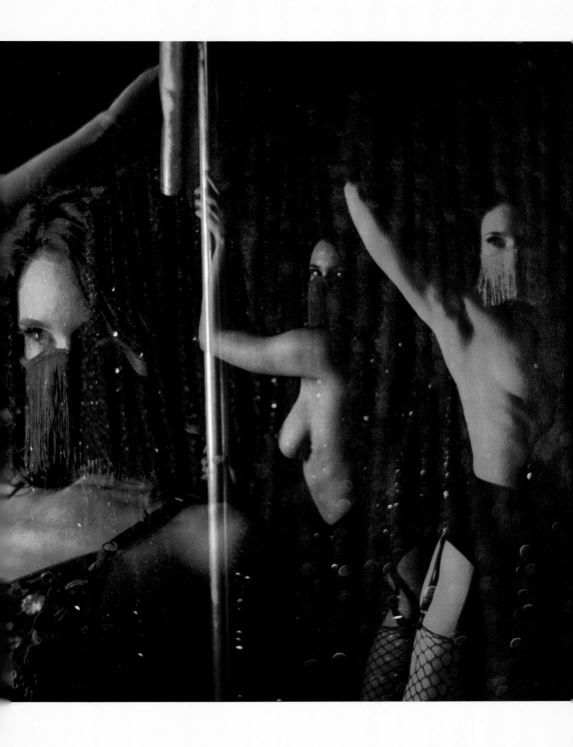

come.) When I dutifully paid the front desk guy my dues, he insisted on asking the DJ if the extra $20 could be waived. It was a kind and unnecessary gesture, but I was grateful. He returned to the locker room waving my $20 bill, and I wondered what I'd done for all that good karma.

I wore a black garter that night because I was bloated as all hell, paired with my favourite, over-worn black and red floral lace two-piece lingerie set. A sexy outfit for a cursed week, because, on top of everything else, I was PMSing. PMS at the club usually found me hiding in a corner mumbling, "If they want me, they'll come find me." I didn't want to be looked at, didn't want to be touched, and I sure as hell didn't want to pretend to be sexy. PMS usually meant I wasn't going to be making very much money.

Downstairs on the floor, Don Wan sat at his table, surrounded by the usual dancers. He'd brought me one of his delicious, home-cooked meals—tonight, a tofu dish. I dug right in with the chopsticks provided. Another dancer, Princess, admitted she'd never had tofu. Don implored her to have some from my container. Was the food mine or Don's to offer? I felt uncomfortable sharing my food during a pandemic, but I didn't feel like being "that" person, so I kept silent. Turned out she didn't like tofu.

Eden nudged me to go for an old guy by the rail. She was just upstairs with him for twenty songs, she said, and he usually went for brunettes, so I'd be a shoo-in. I packed up my dinner and approached, despite it not really being my style to go for rail guys, especially one who hadn't made any eye contact with me. *Fuck it.*

"Hi," I said, catching his attention.

"Oh, hi, listen, I've already spent all my money tonight."

"No problem. Enjoy the show."

I returned to Don's table.

"Dud," I said.

It felt late, an urgency in the air. The women were hungry, and there weren't enough scraps to go around. I spied a man nursing a beer alone at a table by the stage. *Oh, why not!*

"Hi," I said, making my approach.

"Hi," he responded, shuffling upright awkwardly.

"May I take a seat with you?"

"Yeah. Sure."

He wouldn't look me in the eyes, which made it difficult to have a conversation. A faint recollection returned to me. I'd danced for this guy before. He was aggressively handsy. I'd had to cut him off. Maybe it would be different this time.

"So . . . what brings you here tonight?" I asked.

"Relaxation," he mumbled.

"Would you wanna . . . relax upstairs?"

"Too early. Come see me later."

"No problem. Have a great night."

I would not see him later. I returned to Don's table, now empty of dancers—all shooting their shots. Don pointed to a suited man behind him, at the bar.

"You should talk to that guy, he always goes up for a long time. Big spender. Go!"

I took a look. I was so unattracted to everybody. He seemed young and stupid. I couldn't. Another girl approached and quickly snapped him up. I didn't care. I counted nine men and eighteen women working at 10:00 p.m. A 2:1 ratio. Sports had been cancelled two days ago, and I could hear the death bells ringing for the strip joint.

"I'm going to the smoking room," I said, defeated.

I was rolling my joint and ruminating when the DJ came in.

"Okay, Zeke," I said. "How much longer before this place shuts down?"

"Unless the government mandates it, I don't think it'll close at all. And if it does, maybe for a week."

"A week?" I asked. "You really believe that? If we're not allowed to shake hands, how the hell do we give a lap dance? Also, we don't screen these international businessmen for where they've been. We're a hotbed for spreading germs."

"Not really—if everyone is washing their hands, which they're sup-posed to be doing anyway."

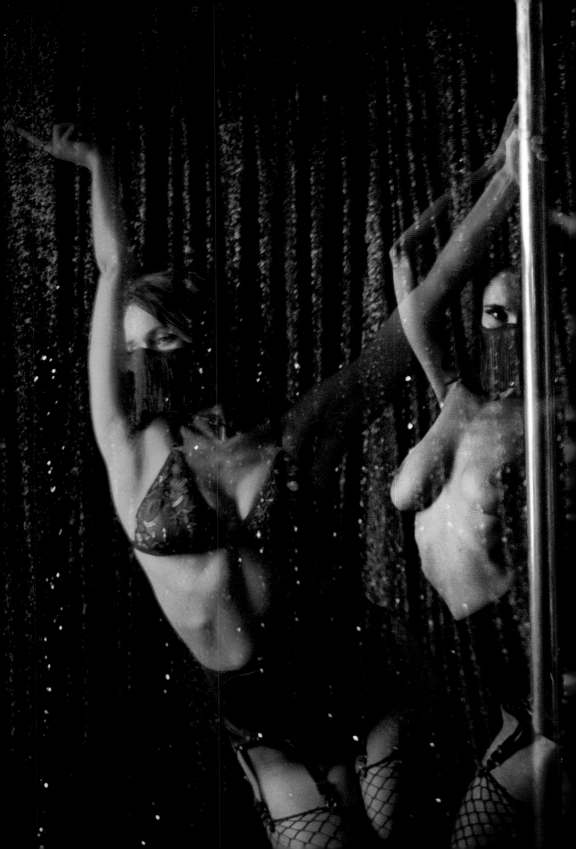

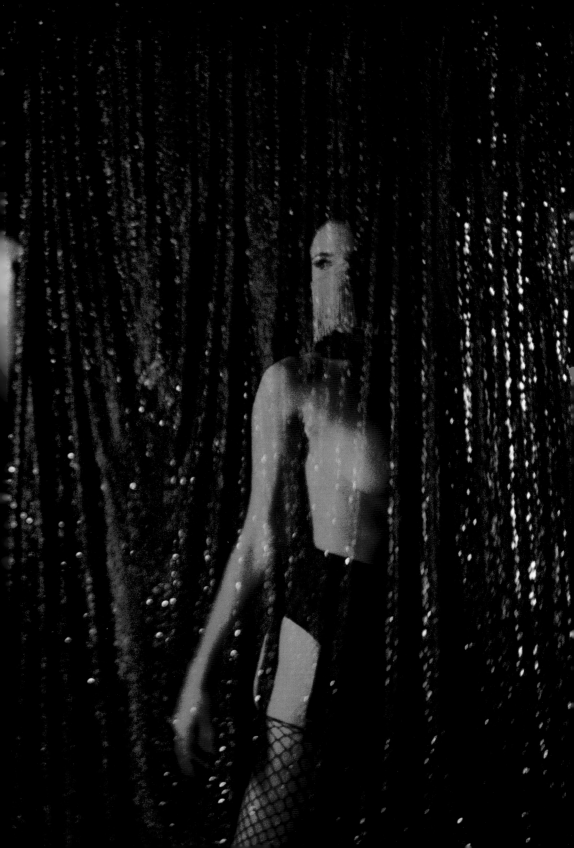

Zeke was usually a voice of reason, but on this we were in complete disagreement.

Princess and Flora entered the room and lit their cigarettes. Princess worked construction as a day job. She showed us pictures of her in her hard hat, surrounded by men. Flora could not contain her pride. When the conversation shifted, she told me she was proud of me, too. It made me feel warm and fuzzy. There's nothing like a veteran stripper's support. Nothing.

I brought up the virus because I couldn't think of anything else, shocked by how blasé most of my co-workers had been about it. Flora was scared, too. But how could we dwell on a subject that threatened to decimate our livelihoods? It was easier not to discuss our fears.

Stoned, I went back downstairs in a better mood, resigned to my fate that I wouldn't be making any money tonight. Zeke approached, just as I returned to Don's table.

"How about a show?"

"Let's do it," I said.

"Disco!" shouted Don as I walked away. I turned around and stuck out my tongue.

Since the dancer onstage was on her last song, I had to think fast. There was one set that always made me feel good, sexy, and engaged: "Barracuda," "Crazy on You," and "Magic Man." Heart was the winner. Sorry, Don—no disco for you.

The room had grown young and boisterous, drunk from early St. Patrick's Day festivities. They hooted and a-hollered during my perfor-mance, and I even got two onstage tippers. The $10 I collected from their mouths went straight into the hands of the DJ. The revellers gave me life up there, but when I got offstage, there were no takers.

I was sitting at Don's table again when I caught a guy making eyes at me—a guy who'd already been upstairs with Eden. A proven spender! Show time!

"Hi!" I said, walking towards him.

"Hello, please take a seat."

"Don't mind if I do," I lied—the man stunk. He was sweaty. His breath

was awful. But if I didn't go upstairs with him, my last night would be a no-money night. I couldn't give up. He asked if I'd like to go to the VIP and I said yes, of course! I sauntered up the stairs proudly as my prey followed. Or was I the prey?

I forgot to ask him to wash or sanitize his hands. On his lap, it was too late—I felt trapped by my own desperation—but as the song count progressed, I felt better and better about my decision. He was soaking wet with sweat, but at least I'd be going home with something.

He ended things on the fourth song. Eighty bucks. I spied two fifties in his wallet. He asked if I could give him change. *Change? Change!? In this economy?* I didn't even know what to say. All I could hear in my head was, JUST GIVE ME THE $20 AS A TIP YOU CRUEL BASTARD!!! He must have read my mind.

"You know what? Here," he said, handing me both fifties. "I usually do five songs anyway. Have a good night."

"Thank you, that's very kind of you," I said graciously. At least I'd be going home with $100. I felt good about that.

It was 1:15 a.m. I had to meet Miss M for outreach at 2:00 and I didn't feel like working anymore. In the locker room, I ate the rest of Don's home-cooked tofu in my big comfy cow slippers. I had given up on the hunt and was ready to roll. As I removed my costume, I sorted through the two-year-old pile in my locker because I had a feeling I wouldn't be back for a while. Under the junk I found a beloved, screen-printed "No Bad Whores, Just Bad Laws" tank top. I packed my baby wipes in preparation for the remote possibility the grocery stores would run out of toilet paper. I grabbed my worn-out black Pleasers—the ones I'd found in the locker room donation bin three years ago—just in case. You never know when you might need a pair of eight-inch stripper heels.

I left everything else: a box of contacts, bottles of water, discarded fishnets, Christmas cards from clients, a tabletop mirror, hair spray, tampons, extra safer sex kits—things I'd be back for, eventually.

On outreach nights, I usually saved some of Don's food for Miss M. Tonight, I'd eaten it all, so I bought a couple of bags of chips from the hotel lobby vending machine. One for me, one for her. I said goodnight

to the girls and asked the front desk guy to help me get my bike out of the closet next to the entrance.

The night was colder than expected. I arrived on the stroll at 2:00 a.m. on the dot, Blue Night streetcars and cop cars cruising by, and waited for Miss M. I knew she was at a stag and doe party for the son of one of our peers. Having insisted she would try to make it out, we'd agreed on a fifteen-minute grace period. I didn't mind the wait.

There was one woman working that I could see, but I wasn't allowed to engage with her until my outreach partner showed up. She was pacing the corner, keeping herself warm. With the virus in the air, part of me was shocked that anyone was working the street tonight, but then I remembered *I* had just been working down the street myself, basically doing the same thing. Surviving.

I leaned on my bike and looked straight ahead into Allan Gardens, at the hundred-year-old greenhouse nestled in a park so important to the city's downtown east side. It was still on a night like this, the dust of the day beginning to settle. Bruce was gone. A pandemic threatened to upend the natural order of the world. The woman on the corner was singing a beautiful, haunting melody that rang through my body. Tears streamed down my face. Goodbye Bruce, goodbye family, goodbye club, goodbye woman on the corner. Letting my eyes cross the street, she was gone. I hoped she was okay. Safe, warm, making money. It was 2:09, and I was still waiting for Miss M.

"Hi," the singing woman reappeared, this time on my corner, walking towards me. "I was wondering if you could spare five dollars for me to take a taxi home."

"Absolutely," I said, relieved to see her, taking a five out of my wallet. I told her I was doing outreach, waiting for my partner to arrive. Did she need any condoms, drug kits, or . . . ?

"Do you have any gloves?" she asked. "I'm cold."

She was wearing a light shawl that was definitely not warm enough on a night like this, and I apologized profusely. No gloves, but then I remembered—

"How about a bag of chips?" I asked.

"Yes!" Her eyes lit up.

"They were for my partner, but I don't think she's going to show up."

"I can do outreach with you," she offered.

"You're so sweet," I said. "You don't have to do that, it's too cold. We should both go home."

"My name is Maryam," she said. "You are so generous. I love you."

We hugged. One last hug.

"I love you, too," I said.

If sex work's taught me anything, it's to never be miserly about love. *I love you* costs nothing and feels like a million bucks.

"Thank you for saving my life tonight," she said as I set off on my ride. "I love you!"

"I love you, too!" I shouted again from my bike, into the night, homeward-bound at last.

"Restless, angry, often fierce, the woman hero forbids the presumption that women are innately selfless, weak, or passive . . . Permitted, like others of her sex, to love and nurture, to comfort, to solace, and to please, the heroic woman specifies these impulses as human, not just female, and endows them with a value that counters their usual debasement. Assuming a position equal to that of the male hero, she challenges the compulsions of aggressivity and conquest, subverts patriarchy's structures, levels hierarchy's endless ranks."

—Lee R. Edwards, *Psyche as Hero* (1984)

femme Vitale

I f the femme fatale is a bold, sexually powerful villainess who destroys men to get what she wants, the femme vitale is her positive opposite: a hero just as bold and sexually powerful, but driven by love and compassion to protect her loved ones and community. The femme vitale is like a Manic Pixie Dream Girl who suddenly realizes she is more than a supporting character in a male protagonist's story. The Dream Girl becomes the Real Woman.

As a millennial, my childhood was blessed with bountiful depictions of this archetype of positive feminine sexuality. I worshipped—and still do, if I'm being honest—the "meatball head" we call Sailor Moon. The teenage Serena wins love by daylight and fights evil by moonlight, and while she's driven by love—and controlled by her emotions!—the femme vitale is no pushover. She never runs from a real fight, battling alongside her badass girl-gang of friends known as the Sailor Scouts.

Another all-important girl-gang of the '90s and early aughts? Oh, just a little group called the Spice Girls, fuelled entirely by Girl Power, friendship, self-respect, and freedom. While I loved the quirky individuality of each and every member, my favourite Spice was Ginger.

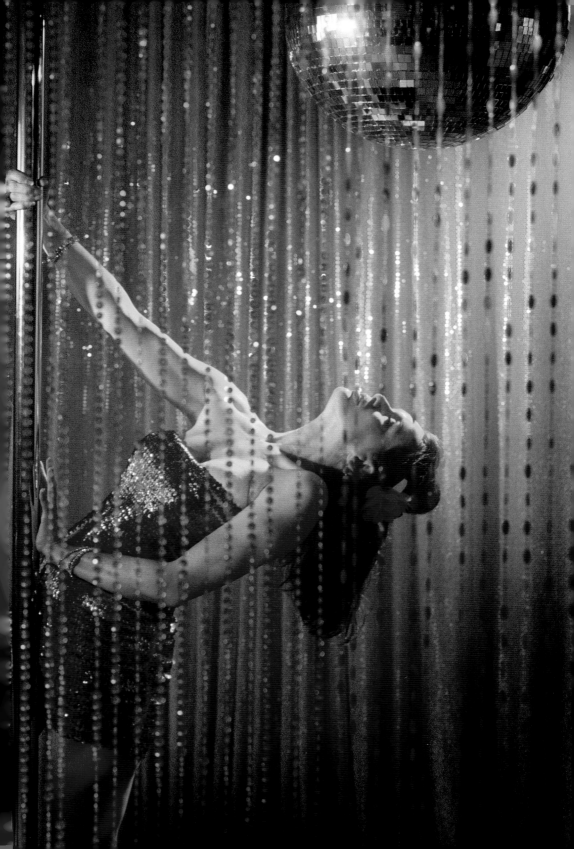

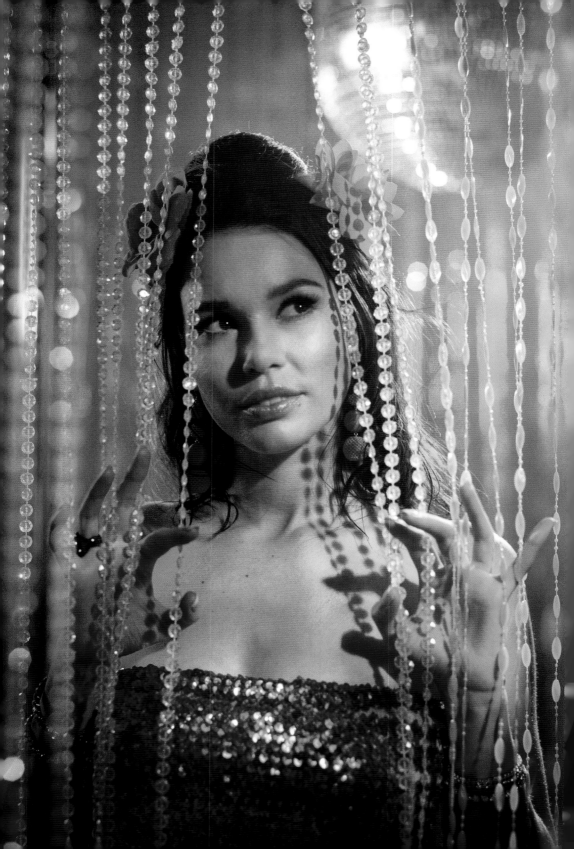

Geri Halliwell was everything I wanted to be when I grew up: vivacious, sexy, smart, playful, funny, big-breasted, outspoken, and independent. Now *that* is some big femme vitale energy.

Speaking of big-breasted, the archetype of positive feminine sexuality isn't limited to the heroes of my childhood—an ageless beauty like Dolly Parton exhibits these same qualities to a т. A superstar in every sense of the word, Dolly is all warmth, love, and compassion; creatively talented, beautiful, and funny. She is—the perfect woman? She is—wait for it—the femme vitale.

When it comes to depictions of sex workers, we are often either villains or victims. Rarely do we get to be the heroes of our own journeys. Heroes fundamentally arise out of struggle, like weeds in a garden plot— undesirable and always at risk of being uprooted. The sex worker is the weed, wild and unwanted, and the garden plot is the patriarchy. As someone who has both whored and weeded for a living, I know the definition of a "weed" is purely subjective. The only difference between a weed and a cultivated plant is a shift in perspective—a recognition of our wild, untamed beauty, and a decision to give us space to make the garden plot a better, more inclusive place for all. The patriarchy keeps trying to destroy us, and we insist on growing back stronger.

Fighting against insurmountable odds, the sex worker is the ultimate underdog. We lead a fugitive existence. We are constantly overlooked (see: the #MeToo movement). Our identities and lived experiences are obscured, diminished, and devalued. We aren't allowed to speak for ourselves. As such, we can't wait any longer for a hero outside of our movement to fight for our right to exist. How can we trust people of power—the ones with their boots on our necks, continuously plucking us out of their garden—to give us our right to freedom?

Our heroes are sex workers themselves. We are the only ones we can rely on to fight for and achieve sex worker rights. And by harnessing the positive sexual power of the femme vitale, I believe we'll win.

Tomcat's closed on March 16, 2020, along with everything else. The pandemic had a massive impact on the sex industry, both creeping and

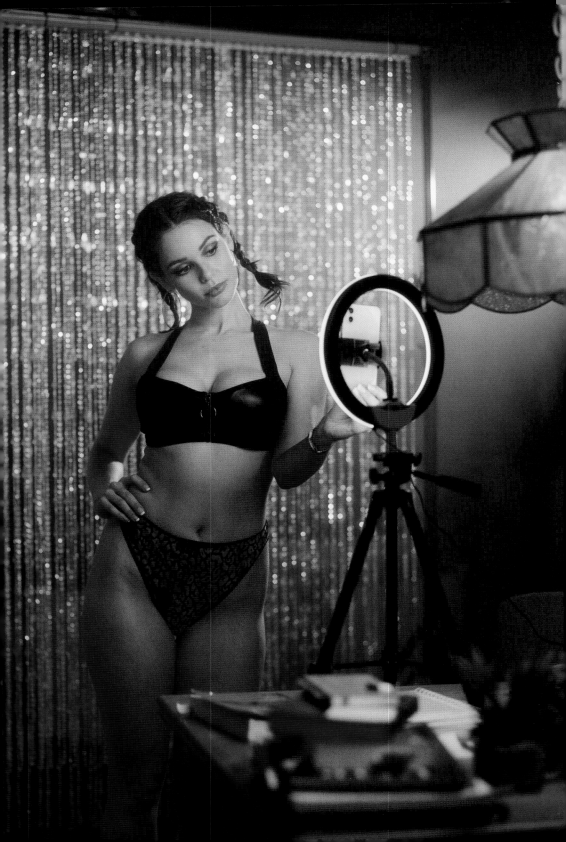

immediate. A slow January and February at the club was business as usual, with family men paying off holiday bills and reserving the canned romance of Valentine's Day for their partners. But as COVID-19 spread, it was clear the strip club, without taking precautions, could easily become a breeding ground for disease. Sadly, it meant the club was dead.

It wasn't just strippers who watched their clientele fade into thin air. Most in-person service providers—escorts, dominatrixes, massage attendants, and the like—witnessed their income streams dry up over-night. Sex workers with the capacity to pivot to online work did so in the early days of the pandemic, but this required a litany of privileges: private working space within one's bubble and time away from dependents; the money to invest in filming equipment, like a tripod, ring light, and high-quality camera, not to mention a high-speed internet connection; the patience, motivation, and time to upload a constant stream of new content to their platforms; as well as the gumption to cultivate ever more followers. Working from home was never so exhausting.

For some sex workers, this transition into online labour was smooth and natural, their tireless hard work rewarded with an income that equalled or even surpassed money earned from their previous in-person services. Other sex workers, however, were left behind. With a skillset honed for the in-person experience, developing the technological know-how necessary to pivot during a pandemic, while also being under tremendous financial strain, was too much to bear. If they weren't entitled to government assistance, the difficult decision to continue in-person services was weighed up against the risk of poverty, eviction, and starvation. Faced with the choice between life or death, the heroic sex worker—ever resilient, brilliant, and resourceful—will always find a way to survive.

I, too, had to think fast. With the privilege of access to government support, I didn't feel forced to go back to work. In fact, I felt emboldened to explore the limits of intimacy and sex work in both an online and in-person context.

My online sex work career started when a certain Mr. Miller sent me a message over Twitter, asking if I offered voice services, like reading books. We could certainly work something out, I replied. For $100 a chapter,

Mr. Miller and I met every week over Jitsi (a video conferencing app like Zoom, but encrypted) to read books like *Nightwood* by Djuna Barnes, or critique each other's short stories. It was so much fun, I wondered if anyone else would consider paying me to read with them. Worth a shot!

And so, Hire-A-Muse was born—that's HAM, for short. In addition to reading, I was hired for all sorts of services at a base rate of $100: nude dance videos, creative writing sessions, effusive emails, collaborative comic books. Racier stuff, too, but only with clients I trusted. Paid walks, masked and socially distanced, were reserved for long-time clients.

For me, HAM was my ideal form of sex work: creative, collaborative, and conversational. While I could have been making more money if I went all the way, I enjoyed my little grey area between art and sex work. It made me wonder: where does the artist begin and the sexual service end? When I am paid a fair wage for a creative service that incorporates my sexuality, am I performing the work of an artist or of a sex worker?

Part of the beauty of sex work is that there's a market for everything. If you can dream it, someone wants to buy it. Catering to the nuance of desire means there is an endless appetite, market, audience, and consumer for just about anything. So long as people possess a lust for life, for pleasure, for that vital element that makes life worth living, there will be no "ending" of the "demand" for sex work. If I can make a buck reading a man a book, why wouldn't I? Likewise, if a person can pay their rent—in a pandemic—by masturbating on camera, why shouldn't they?

In-person sex workers weren't the only ones who transitioned into the world of online sex work. Newly unemployed due to the pandemic, many workers across all industries turned to sex work in order to survive. One could say they'd been "forced" into the industry—that is, by a global pandemic, and by a broken capitalist system of vast social, racial, and financial inequality that values profit over people. Can we fault the single mother for starting an OnlyFans when her government can't give her the dignity of a stimulus cheque? Or would we rather watch her starve than witness the incredibly heroic achievement of providing for one's family during an unimaginable catastrophe? Who are *you* rooting for?

A new demographic who never thought they'd turn to sex work did

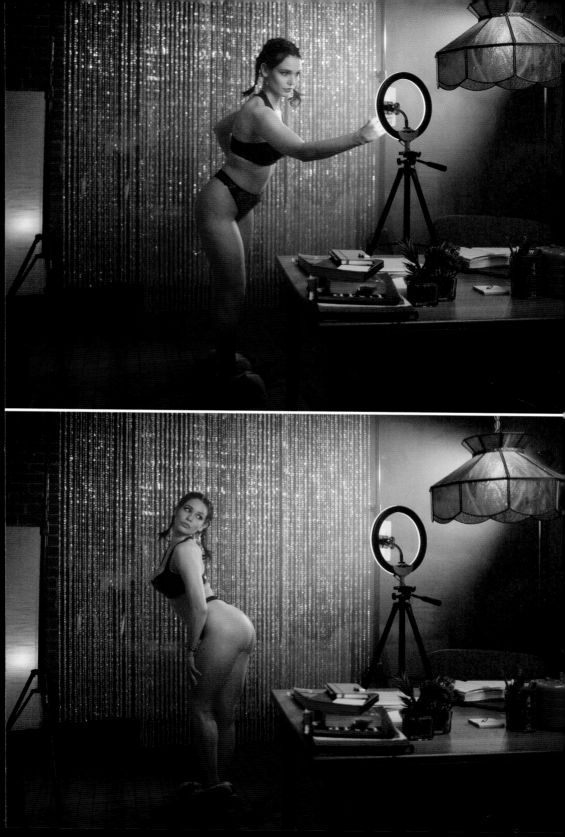

what they had to do—because they didn't have any other options. In survival mode, there's little time to reflect on the implications of sex work stigma, and how something as arbitrary as one's naked body on the internet will affect future career prospects, romantic interests, family relationships, and pretty much every aspect of a person's life.

While sex work has moved progressively more online, the internet remains an unsafe space for sex workers. Since the passing of American bills like FOSTA-SESTA, which persecute websites that apparently "promote" or "facilitate" sex work, any social media post that smacks of sexuality is liable to be deleted, along with the poster's account. This type of censorship doesn't just impact sex workers—even civilians have noticed a crackdown on their hottest thirst traps, along with the surveillance and shadow-banning that comes with being a sexually expressive person on the internet. With fewer and fewer places to safely advertise services, sex workers are limited in how much they can communicate with customers, which impacts their ability to consent. Worst of all, censorship rules stifle conversation between sex workers, which makes the industry less safe for everyone.

The odds have always been stacked against us. And yet—here we are. Alive. Surviving. Never going down without a fight.

I hope the pandemic taught those who didn't understand it before the cost of touch deprivation, and the value of physical intimacy. Which of us hasn't now starved for a loved one's warm embrace? Who hasn't yearned for a normal night out with a fun-loving companion? Those deprived of a good fuck, surely, can imagine the value of simply paying someone to get the job done. As much as the pandemic made a sex worker out of many, perhaps it also made new clients, too.

Touch, intimacy, warmth, pleasure, laughter, relaxation, connection: feeling good is our birthright. Feeling good is the altar upon which the sex worker worships, the service they happily and dutifully provide. A fine calling—making people feel good for a living? *Sounds good to me!* So, why is it still a crime?

Sex work is work. Real work. The world's oldest work, in fact. I want to live in a world where the transferable skills of sex work can be proudly

displayed on a resumé. I want to see our industry governed not by criminal law, but by labour law. I want to witness the rise of unions and sex worker labour leaders—who will be, no doubt, the fiercest, sexiest group of freedom fighters the world has ever seen. I want occupational health and safety for sex workers, and unemployment benefits if we choose to leave the industry. I want sex workers to be protected from exploitation and taken seriously when they call out workplace abuse—and yes, that includes rape and sexual harassment. I want our consent to matter. I want every single sex worker—whether citizen, migrant, or undocumented—to be protected under the law. And I want to see the political will to defend our human rights to dignity, equality, and legal protection, by decriminalizing sex work.

I dream of a world where sex workers thrive, free from the fear of violence, discrimination, and social stigma. A world where our life-giving gifts are recognized and celebrated. A world where the sex worker femme vitale grows like a wildflower, unruly and free.

Despite the odds, we are here. Every sex worker is the hero of their own journey. With the spirit of the femme vitale as our guide, we will use our joy, beauty, creativity, strength, and fierce determination to fight for our right to survive—not just for us, but for the whores that are yet to come. The world needs us. More of us.

We're alive and always will be.

Love is our driver. And we will win.

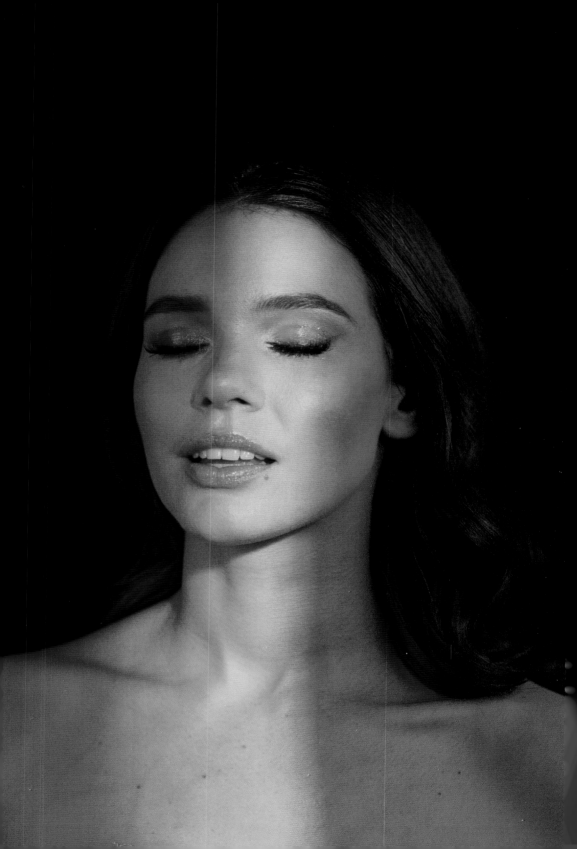

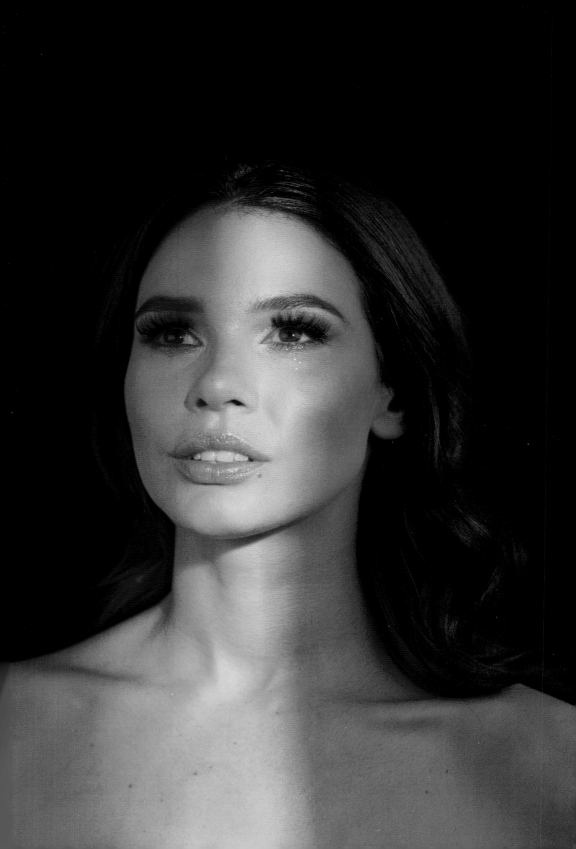

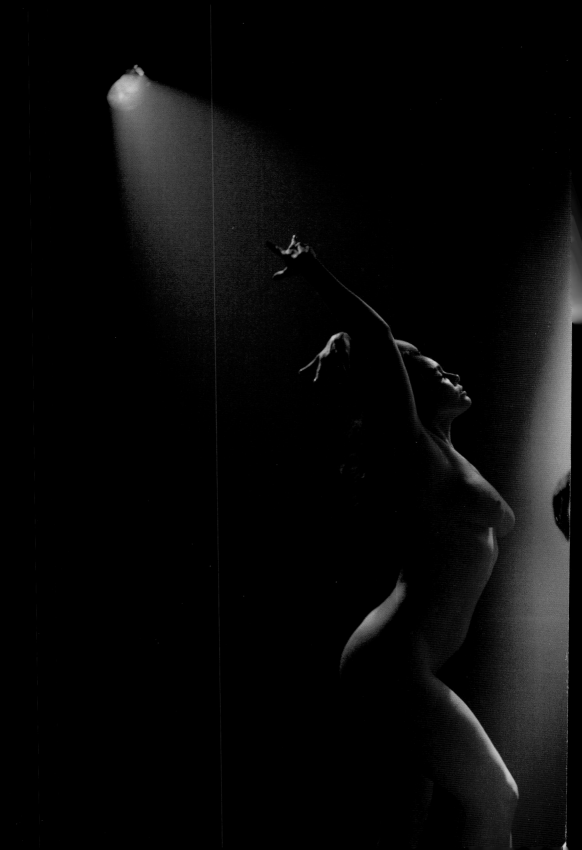

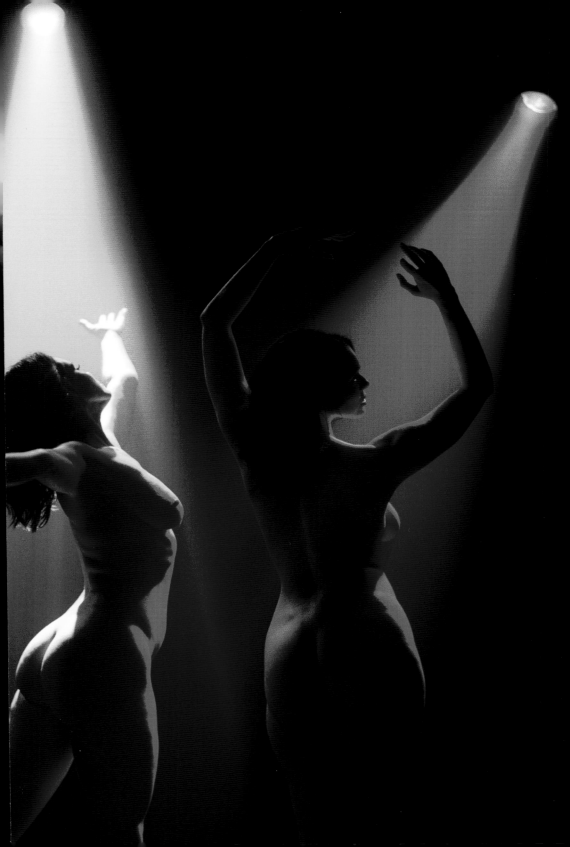

The 7 Secret Superpowers of Sex Workers

1. Sex workers work hard and play hard.
 "I just finished an overnight, let's go for brunch and mimosas—my treat."

2. Sex workers are excellent role models.
 "I get to spend all my time with Mommy because she only has to work a few hours a week."

3. Sex workers know their worth.
 "Fuck for free? I'm not an idiot."

4. Sex workers support each other.
 "Babe, can you see my tampon string?"

5. Sex workers are fiercely independent.
 "Don't ever tell me what to do. Unless we're in bed, Daddy."

6. Sex workers tell it like it is.
 "How many times do I have to tell you that blonde is not your colour?"

7. Sex workers will always survive.
 "At the end of the world, it'll be cockroaches, Keith Richards, and a bunch of horny sex workers."

Acknowledgements

This book has been made possible by the love and support of a vital group of believers. Firstly, we thank our Kickstarter backers, who generously put their financial faith behind this genre-bending project. We are especially grateful to Ron Campbell, Keith Stephen, Odysseus, HT, and Jillian Hollander for their contributions towards the expanded edition of *Modern Whore*.

Strange Light, helmed by Haley Cullingham and Jordan Ginsberg with M&S's Jared Bland, is the perfect home for literary work that defies convention. Haley, it has been an honour and a pleasure to be honed by you. We are grateful, as well, for the incredible Kristin Cochrane, CEO of Penguin Random House Canada, who saw the value of our project and hooked us up with Haley and Strange Light. A match made in heaven!

Love the layout? We do, too! Thanks Lisa Jager for your relentless work and dedication to getting the design just right. The project management prowess of Kim Hesas meant this book got done while we're all still young. Eternal gratitude to the tireless work of the copy and proof editors, Gemma Wain and Trudy Fegan, for meticulously mining this literary smut with the patience of saints.

Modern Whore is nothing without Nicole Bazuin's mind-blowing photography. We are forever indebted to the incomparable Steven McDonnell for his camera, lighting, and emotional support—and for always being game for more *Modern Whore* shenanigans! If you think I look good in this book, it's because of the extraordinary talents of our fabulous hair and makeup contributors: Samara Elster, Paul Langill, Elena Candela, Alex Topp, and Mandee Castorina.

Much of the fashion was provided by Paul Langill, and a special shout-out to Edith Werbel and Elsa, her amazing, lingerie-collecting mother, for providing many of the outfits in this book. A massive thank you to our brilliant art directors Chareese McLaughlin and Noelle Hindi for always making the sets shine, as well as art assistants Kyle McDonnell and Brandon Wilson.

For location support, a warm and appreciative thank you to Dylan Tower at Oasis Aqualounge, Tanya Grossi at The Darling Mansion, Jamie Pichora & Elise Saunders. Equipment for *Modern Whore* was provided by Steven McDonnell, Daniel Shojaei at Ontario Camera, Adam Crosby at Tiny Pictures Inc., and Eugene Scott-Barnard at the Hart House Film Board. We'd also like to thank our Banana Bros: Cesar Ginocchio, Timothy Popowich, Clinton Debogorski, and Adam Golding.

Special thanks to Oliver DesRues, Chester Brown, David Chilton, Laura Rojas, Eldon Garnet, James Gunn, Fan Wu, Kelly Chia, Jack Switzer, Dave Loewen, and my dear friend and DOC co-founder, Ike Prah.

I'd like to also give a warm shout-out to my Maggie's crew: Monica, Sandy, Iman, Saharla, Susan, Jasbina, Jenna, Dani, and Estelle. You're all the very best and I love you so much, always and forever. "We still get paid," baby.

Gratitude forever to my ever-loving mom for being the best woman I could ever aspire to be, George for being the best brother, and my dad & step-Dave for always being supportive of my controversial, far-out ideas. My greatest privilege is being loved by my family. Thank you for letting me be me.

Nicole thanks her love John Fleming, BFF Ted Killin (#KOT forever), her exemplary parents Dan Bazuin & Theresa Poirier, as well as her cool cousins Jay Tettamanti & Brock Poirier.

And thank *you* for reading, too!

Andrea's TOP 10 goals
in Life:

10. be in a Music Video
9. win any award
8. be on Muchmusic/MTV
7. learn to play guitar
6. be in a Movie
5. win Nobel Peace Prize
4. be on Conan O'brien
3. be on SNL
2. meet branden boyd
1. be Prime Minister.

I MUST TRY TO FORFILL THESE
GOALS AT ATLEAST 40 years old.

ABOVE *A list the author made when she was 12 years old. She and her mother had just finished watching an episode of Oprah, which decreed that people who wrote down their long-term goals were more likely to achieve them.*

ABOUT THE CREATORS

Andrea Werhun is a writer and performer based in Toronto. She has worked for years as a Peer Outreach Worker with Maggie's: Toronto Sex Workers' Action Project, the longest running sex worker advocacy organization in Canada. Her not-so-secret dream is to see Canadian sex work decriminalized in her lifetime, and if she has to become the Prime Minister to do it, she will. Just watch her.

Nicole Bazuin is an award-winning filmmaker and inter-disciplinary artist. She directed the acclaimed shorts *Modern Whore* (SXSW) and *Last Night at the Strip Club* (Hot Docs), and the series *This Art Works!* (CBC), and *Climate Talks With Kids* (Bell TV). Nicole's media artworks have been exhibited by the Art Gallery of Ontario and commissioned by Nuit Blanche and Luminato Festival.